The Art of

CHIMERA PUBLISHING

HAMILTON, NEW JERSEY
2003

The Art of Amy Brown

Editors: Norman L. Hood and E. Leta Davis
Graphic Design: Erdir Zat for Chikara Entertainment, Inc.

Limited Edition ISBN: 0-9744612-0-2
Hard Cover ISBN: 0-9744612-1-0
Paperback ISBN: 0-9744612-2-9

Chimera Publishing —Hamilton, New Jersey

Visit our website at www.chimerapublishing.com
E-mail: norm@chimerapublishing.com

Third Printing Paperback
10 9 8 7 6 5 4 3

Printed in China by Regent Publishing Services Limited. E-mail RegentNY2@aol.com
for additional information.

*SPECIAL THANKS TO: Shawn Bergsma for starting me on the faery path, Leta and Norm
for being daring and taking a chance, Darren for putting up with me and doing all of the
computer work, Sadie for doing everything I don't have time to do myself (or don't want to
do), Mom and Dad for baby sitting whenever possible, Kathi for always helping out when
needed, and Greg for just being a goof. I could go on for pages, but instead, thank you to
everyone who has helped out along the way and to all the artists that have inspired me over
the years and continue to do so.*

Amy Brown Fantasy Art Inc.
PO BOX 25364
Federal Way, WA 98093-2364

info@amybrownart.com

To my little faery,
Isabella Rose Wood.

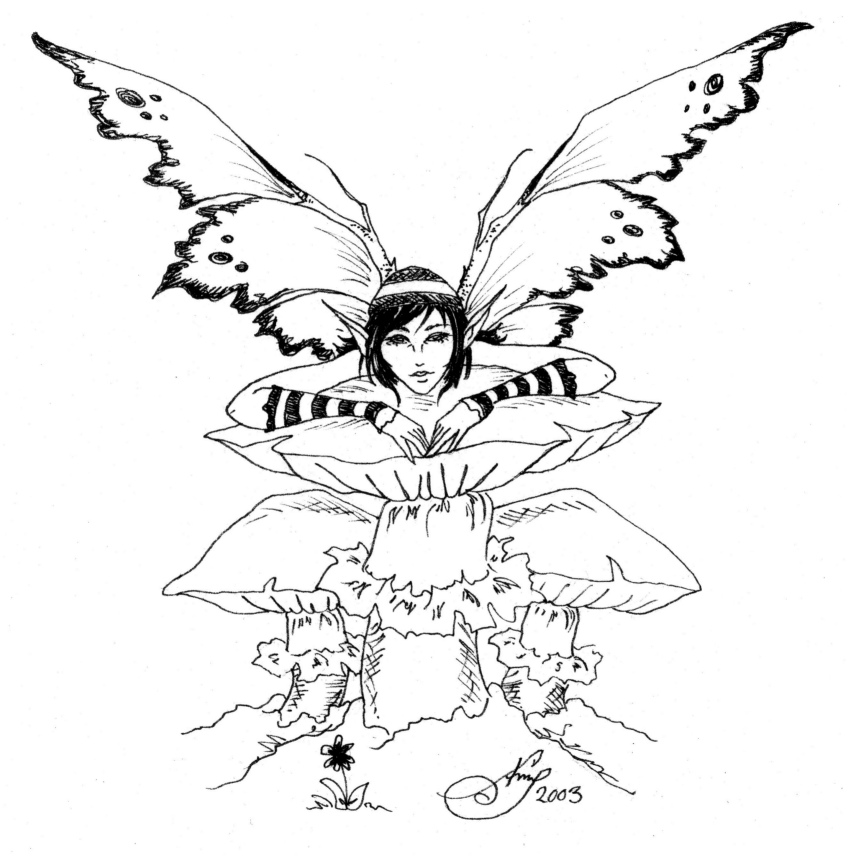

"*Maybe a Little Faery...*"

T HE ENCHANTMENT to be found in a book such as this doesn't begin with the subject matter. It comes from the magical ability of the artist to put pigment on paper in such a manner that you feel as though you're at a window, peeking into a real world. I don't mean that the figures are rendered realistically—take away the wings and pointed ears of Amy Brown's faeries and for the most part, they are still unusual individuals that we would never run across in our own world.

I mean, rather, how the art convinces us that we are privy to an alternate reality.

And consider the medium used to convince us: coloured pigment, ground to a powder and bound with gum arabic, made workable by the addition of water, applied (usually) with a brush to a sheet of thick watercolour paper. In Brown's case, there are occasional coloured pencil accents, or ink outlines.

Hand these same materials to most of us and you'd be lucky to get recognizable subjects, never mind Brown's exquisite renderings. In her hands, a creative alchemy awakes, allowing her to take the elusive and mysterious inhabitants of her imagination and render them into such persuasive two-dimensional images that they are given a vibrant new life in the minds of their viewers.

If that's not magic, I don't know what is.

Brown is forthright about her artistic influences (Brian Froud, Michael Parkes), but doesn't slavishly imitate them. Obviously, her subject matter is related to Froud's faeries, and her designs owe a tip of the hat to Parkes, but those influences are merely her stepping stones to paintings that she makes her own. That's how it works for most good artists, so it isn't much of a surprise.

The surprise comes when weighing the delicate nature of her renderings, the painstaking lay-

ering of washes that it takes to bring the texture of stone and leaves and hair and skin to life, against her passion for her art.

On her website she says:

"Often there are days when I really don't want to paint, I HAVE to paint. The urge to create is almost a wild, living entity trapped inside me, clawing to escape."

And in an e-mail to me as I was preparing this introduction, she told me that images:

"...virtually hammer at my brain to be released."

One would expect rich impasto renderings from such fervent comments. Large canvases with paint dripping from the edges as the artist attacks her work, working against time to tear the images from her mind and capture them in paint. Instead, we get these lovely paintings, full of light and soft warmth, taking half a day or longer to get them just right.

But this apparent dichotomy between the passion of inspiration and the finished work doesn't appear so outlandish once you examine the paintings. Because there are shadows whispering at the edges of the lighter subjects, and some of the subjects themselves are far more worldly than the pretty faeries you'll find elsewhere, in the work of her peers as well as in some of the other paintings in this book. The striped stockings, tattoos, and piercings of these modern cousins are contemporary accoutrements that push happily against the more traditional concept that many people have of faeries.

For example, Brown's "Foxglove" with her purple hair, skimpy dress and the flower tattoos on her thigh would never be mistaken for one of Cicely Mary Barker's Flower Fairies. But that doesn't make this image of a foxglove faery any less valid. This is simply Foxglove on her way to a rave, rather than an afternoon tea.

These aren't all English faeries, either, for which I'm particularly happy. Let the English paint their faeries, while our North American artists provide portraits of those that fit into our landscape. For that reason two of my favourite images in the book include the antlered woman, with her arms folded under a buckskin shawl decorated with feathers; or the regal "Thorn Queen," with her owl and crow companions, who has the look of a Native American princess.

In the same e-mail cited above, Brown mentioned a fondness for my Newford stories and that made me smile when I read her bio because she would fit right in with the motley repertory company that lives out their lives in the backgrounds of my stories.

Though Brown drew and doodled from an early age, it wasn't until she was in her twenties, working as a custom picture framer at a local gallery, that she began to paint seriously. Her employer at the time handed her an empty frame that had been sitting around the shop for months and suggested she paint something to fit it. "Maybe a little faery or something."

Little did her employer know what she had let loose.

Ten years later, prints of Brown's work are available at street fairs and in many shops, and she has an extensive Web site (www.amybrownart.com) with multiple galleries on it featuring some one hundred and forty images at last count.

And she has this book you hold in your hands. There's no need for me to tell your more. The paintings in it have their own eloquent voices and will enlighten you far more in regards to her work than I ever could, or would need to.

Turn the page and see for yourself.

Charles de Lint
Ottawa, Summer 2003

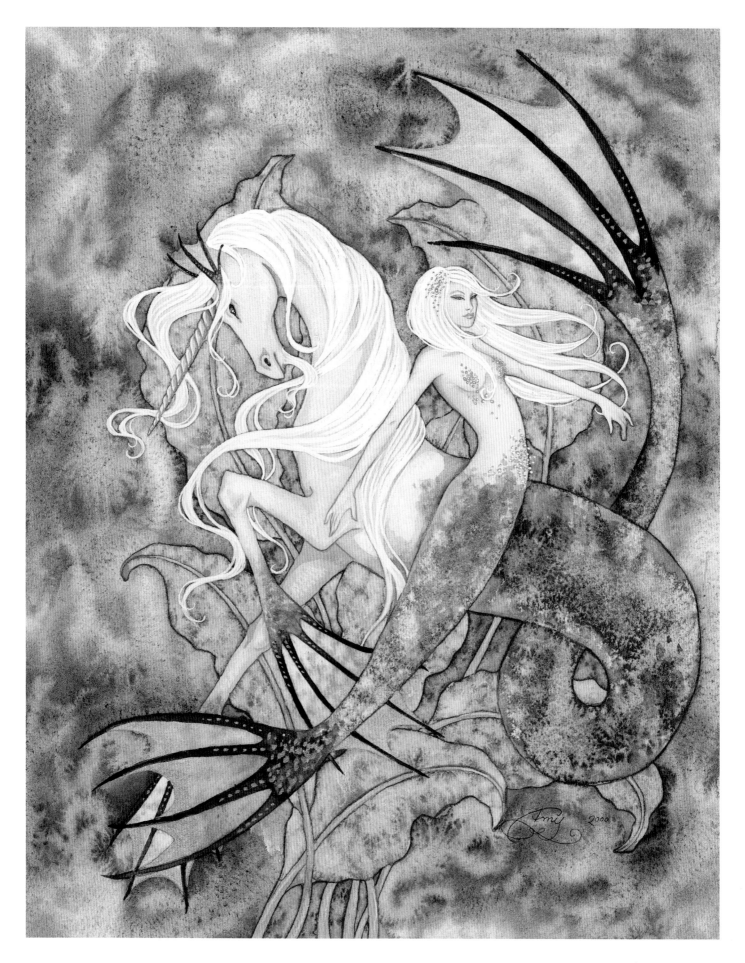

Aquamarine
Aquamarine is one of a series of mermaid paintings named after gemstones.

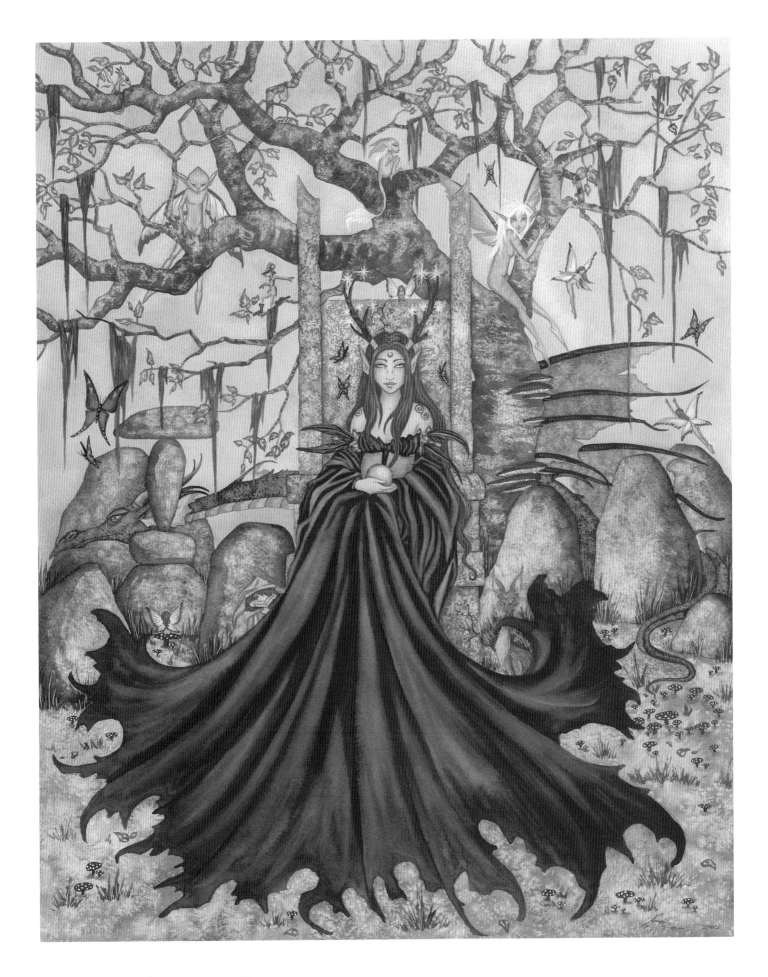

The Autumn Court

The Autumn Court is a piece commissioned for Duirwaigh Gallery's Tribute to Arthur Rackham.

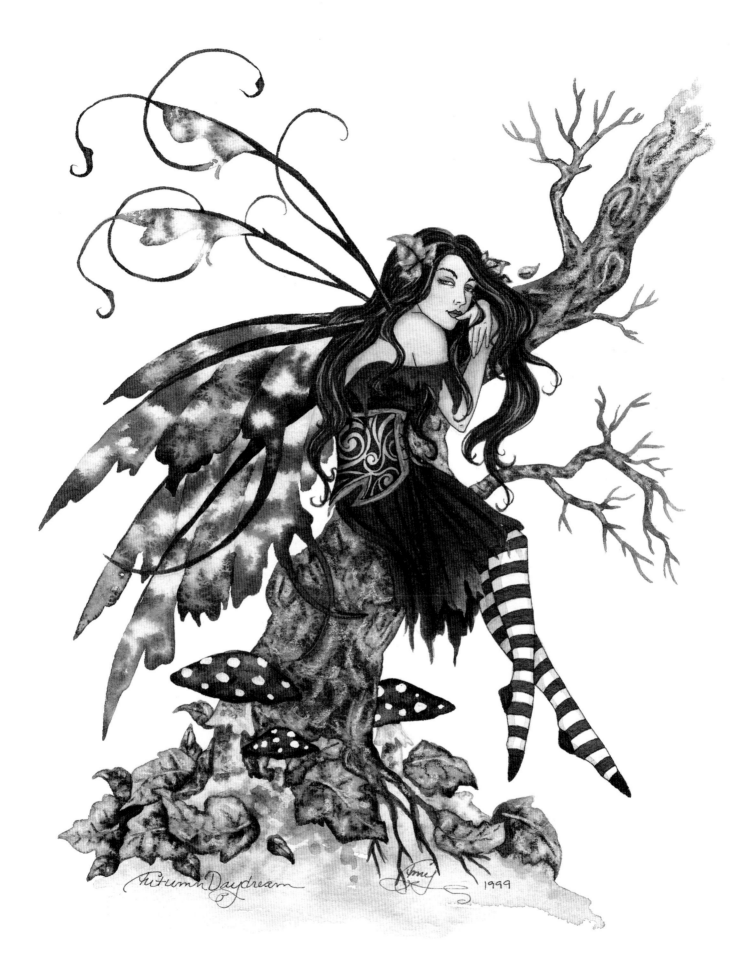

Autumn Daydream

Autumn Daydream was inspired by Alphonse Mucha's 1896 piece, titled "Summer."

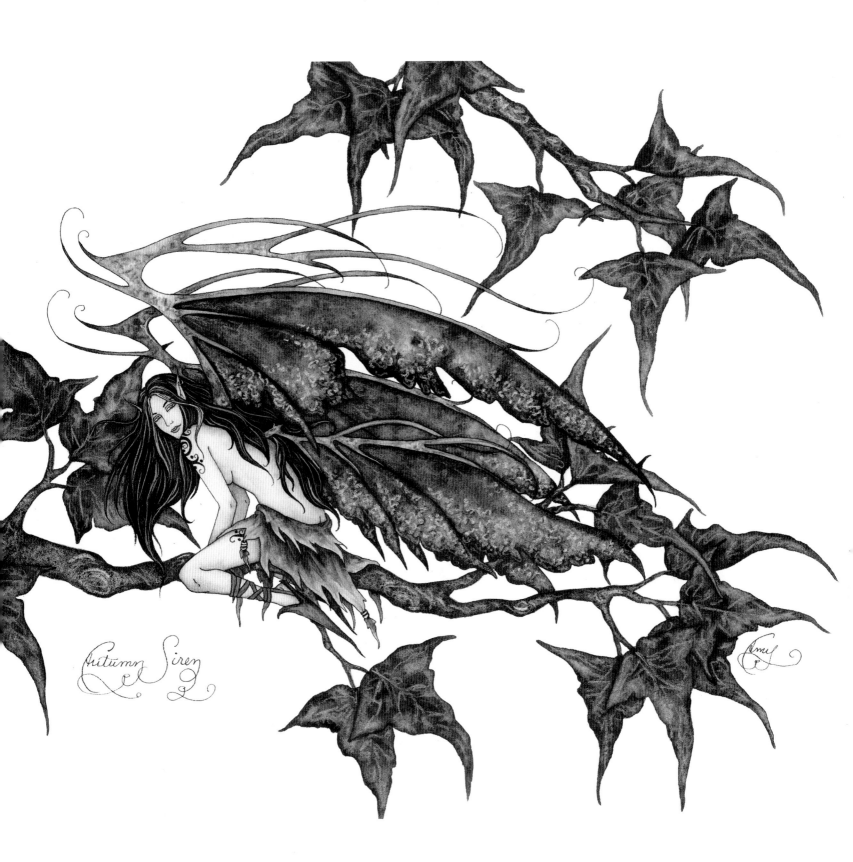

Autumn Siren

Imagine the Autumn Siren lurking among the branches of the tree outside your window...peering down at you as you walk beneath them.

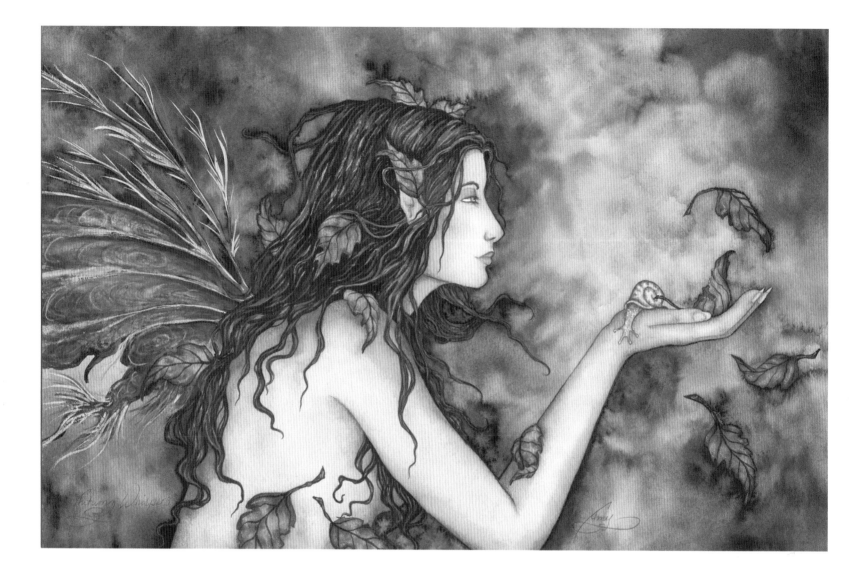

Autumn Whispers

In Autumn Whispers, the faery is whispering secrets to the snail. Why would she be whispering to a snail?
I have no idea.

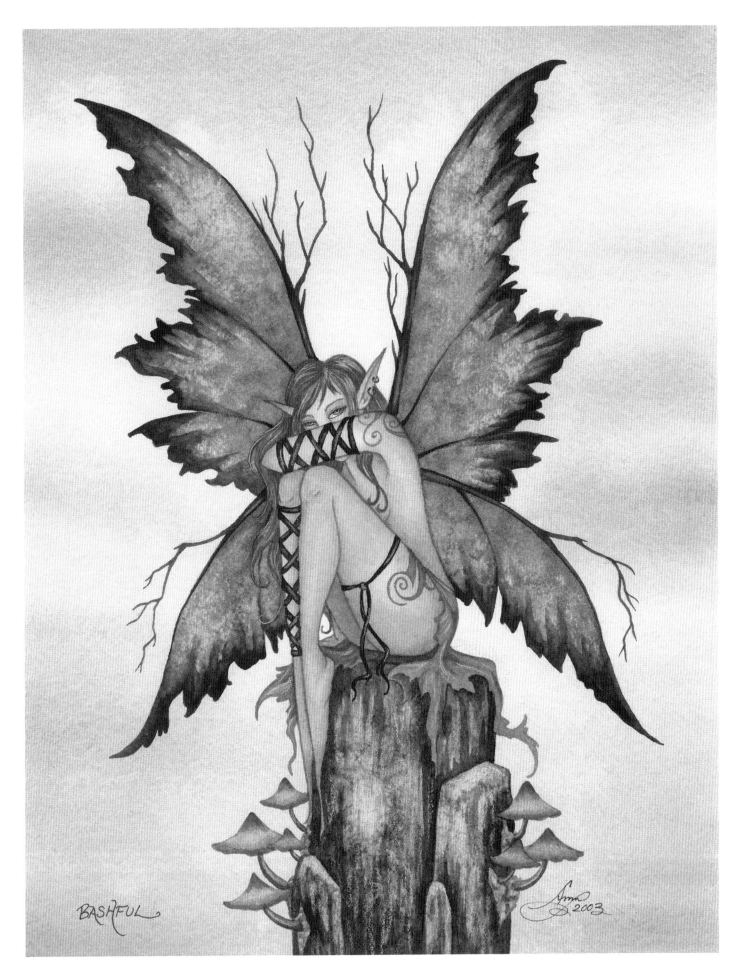

BASHFUL

Bashful

Is she really shy, or is this title a joke? After I finished painting her outfit, I wondered if a bashful faery would wear something so risqué. Perhaps she should have been called "Tease"?

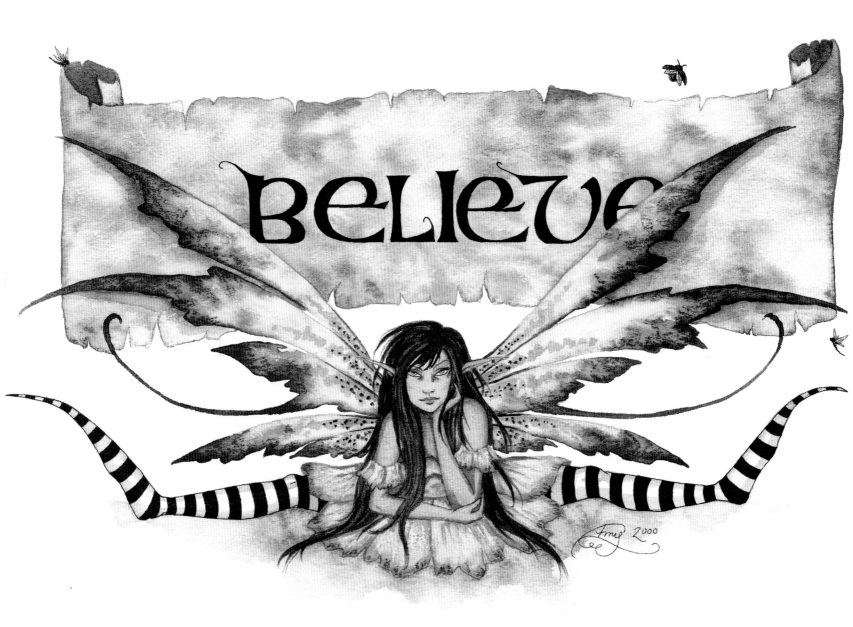

Believe

This little faery means business—believe in faeries OR ELSE!

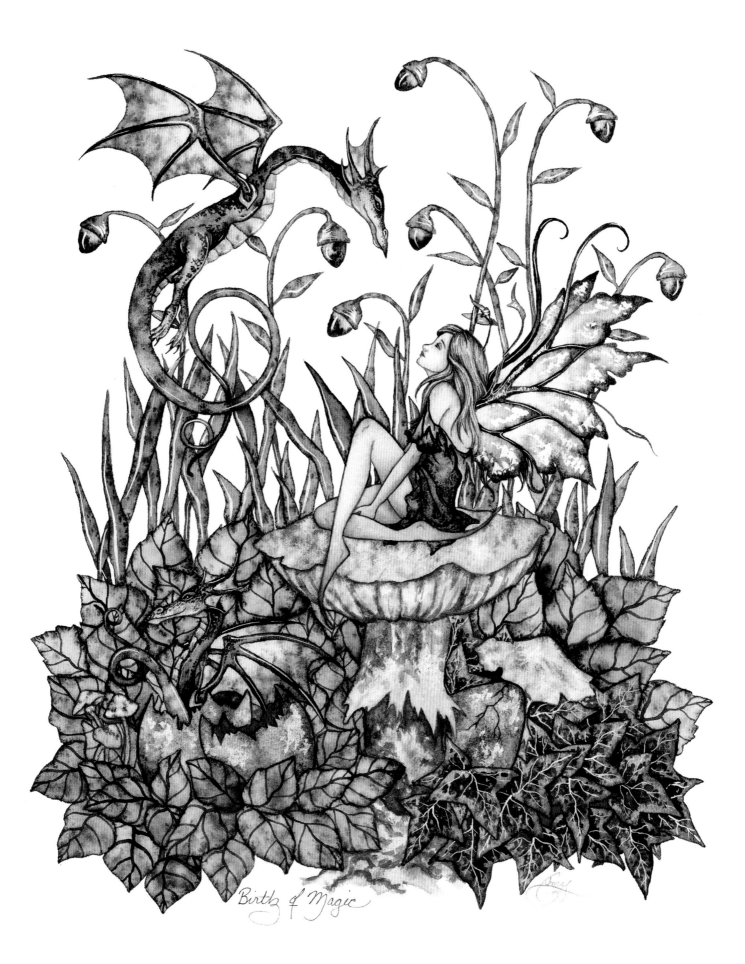

Birth of Magic

A sweet, little faery sits and awaits the birth of new, magical creatures. They slowly break out of their eggs, bright eyed, wings damp and glistening.

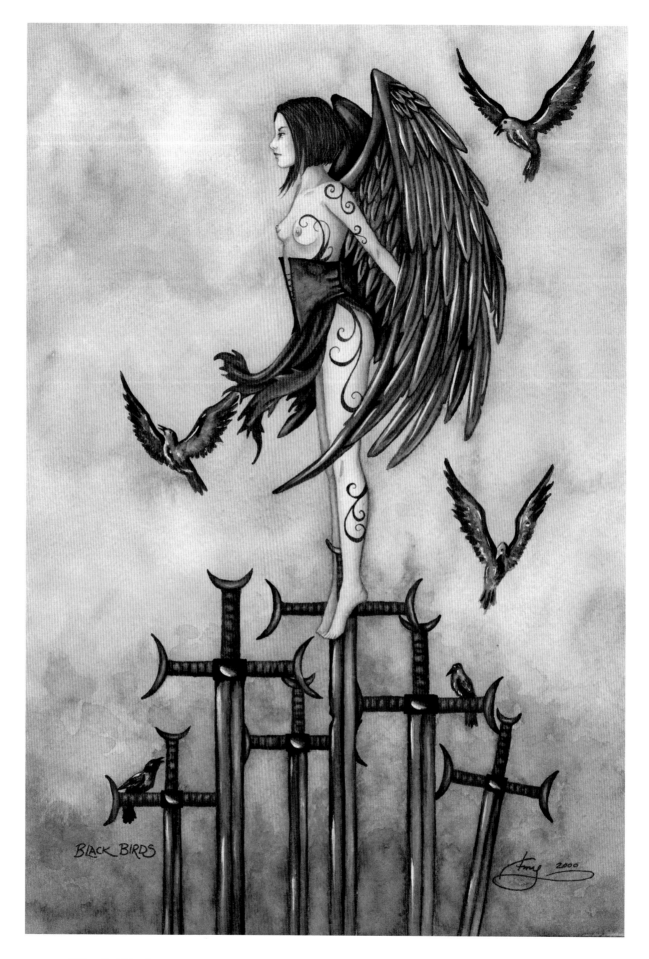

Black Birds

Black Birds was created while I was being heavily inspired by Charles de Lint's book, "Some Place to be Flying." His Crow Girl characters inspired the dark wings.

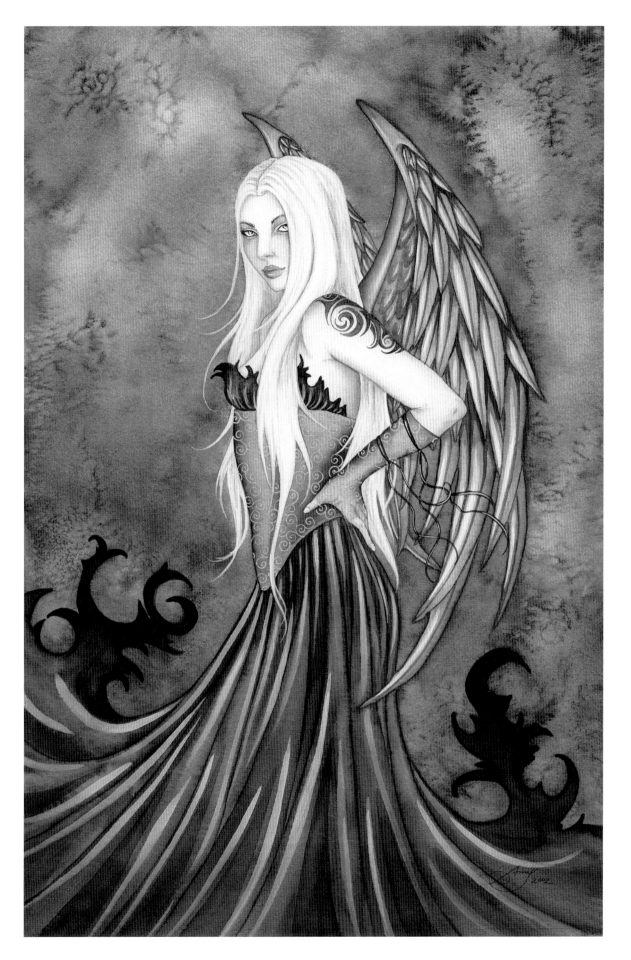

Blue Angel

I was experimenting with colors when painting Blue Angel. I wanted to see how a piece would look if it were painted mainly in blue. The challenge was to make the figure pop out from the background without straying from the strict color scheme.

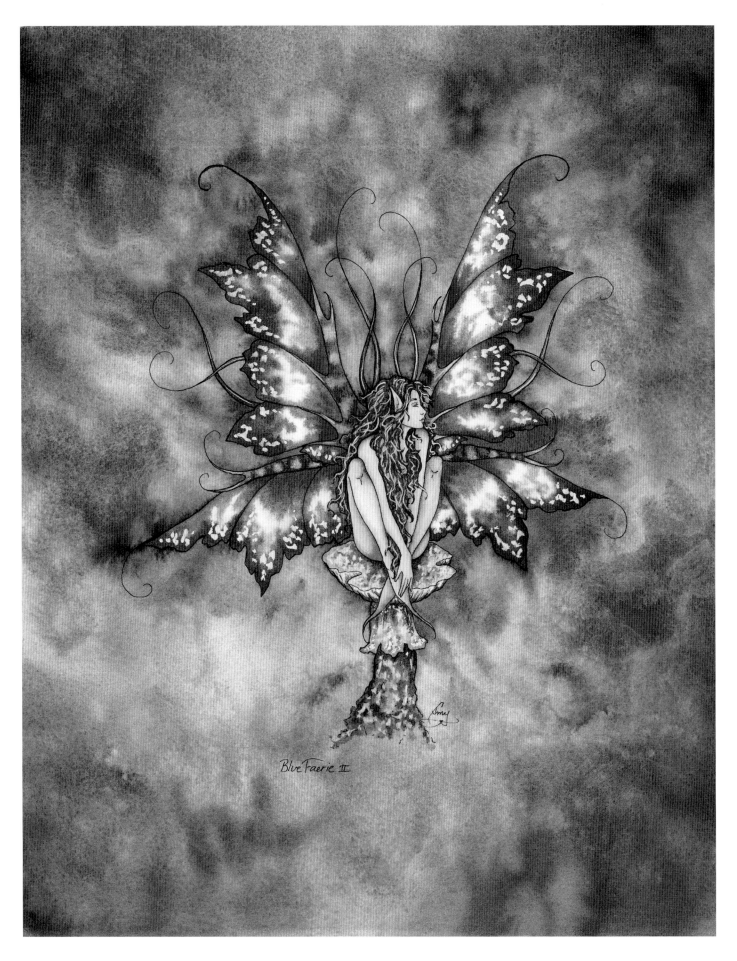

Blue Faerie II.

Blue Faery II

Blue Faery II was partly inspired by Brian Froud's painting, "Melancholic." This faery does not share the melancholy gaze of Brian's piece, but the pose is similar.

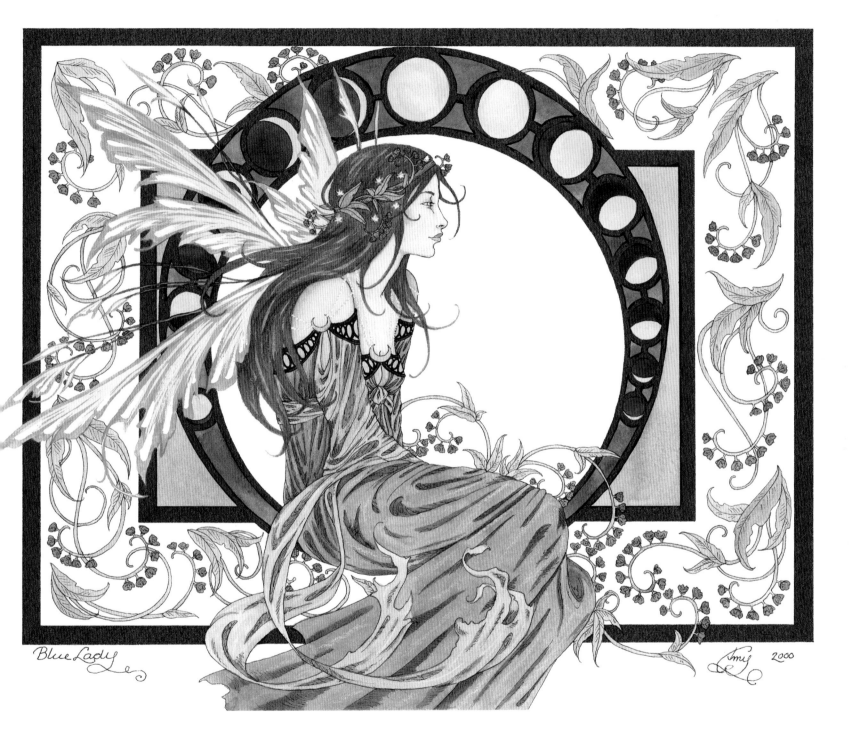

Blue Lady
This piece was inspired by Alphonse Mucha's 1898 piece titled "POETRY."

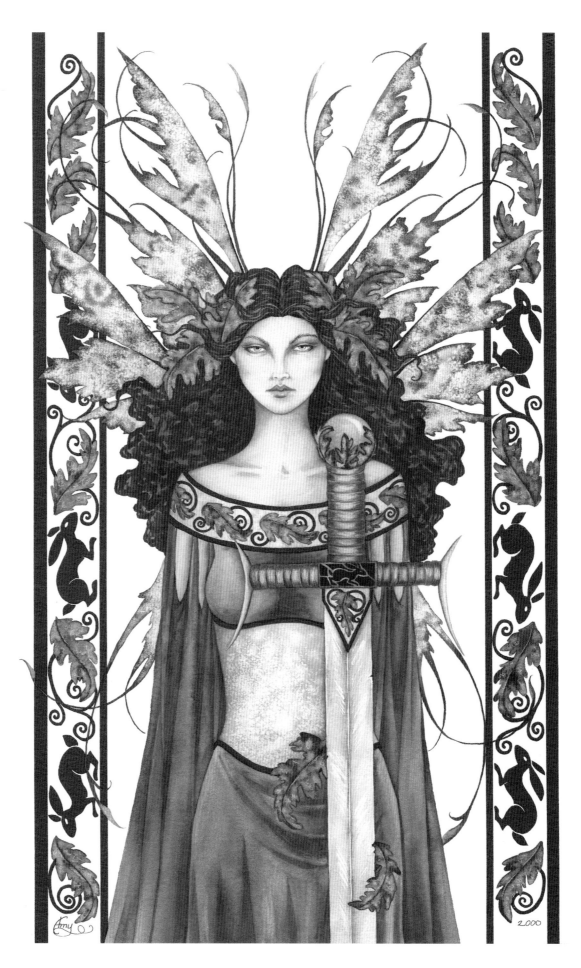

Boadiccea

Boadiccea—the goddess of war. Although her tale ends badly (killing her own offspring so the enemy could not take them), I was inspired by the story of a strong heroine. Also, she had red hair, which is always a plus.

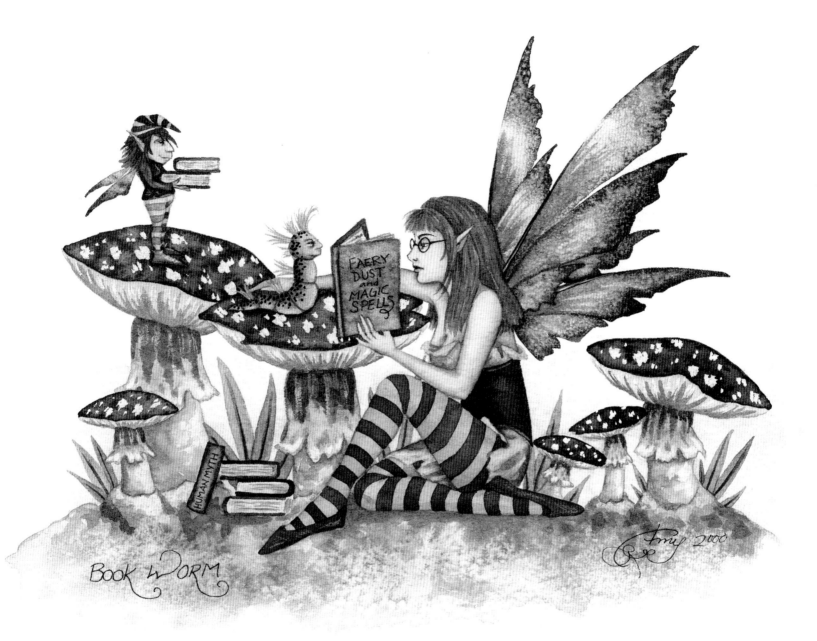

Book Worm

Book Worm...some people say this one looks like me. I admit there are some similarities.

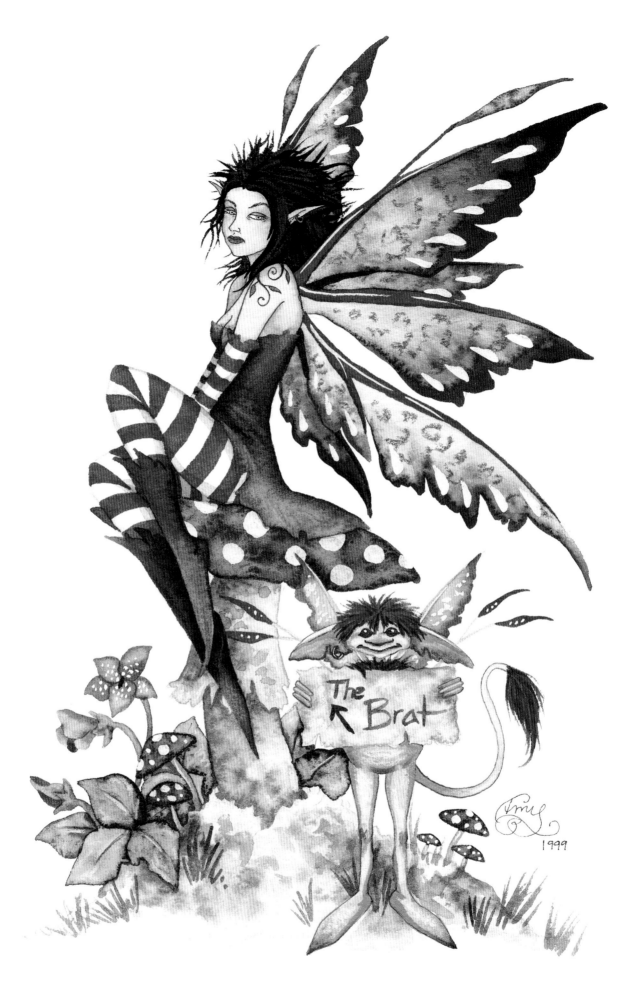

The Brat

The Brat was styled in part after my younger sister...though I have been called a brat several times myself.

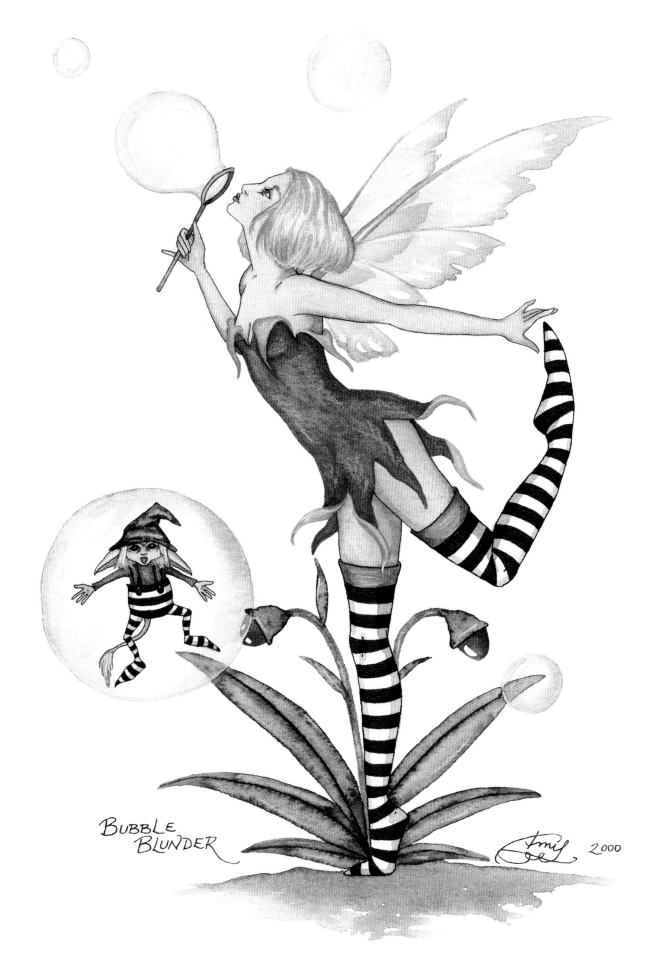

Bubble Blunder

Just a little humor creeping into my work.

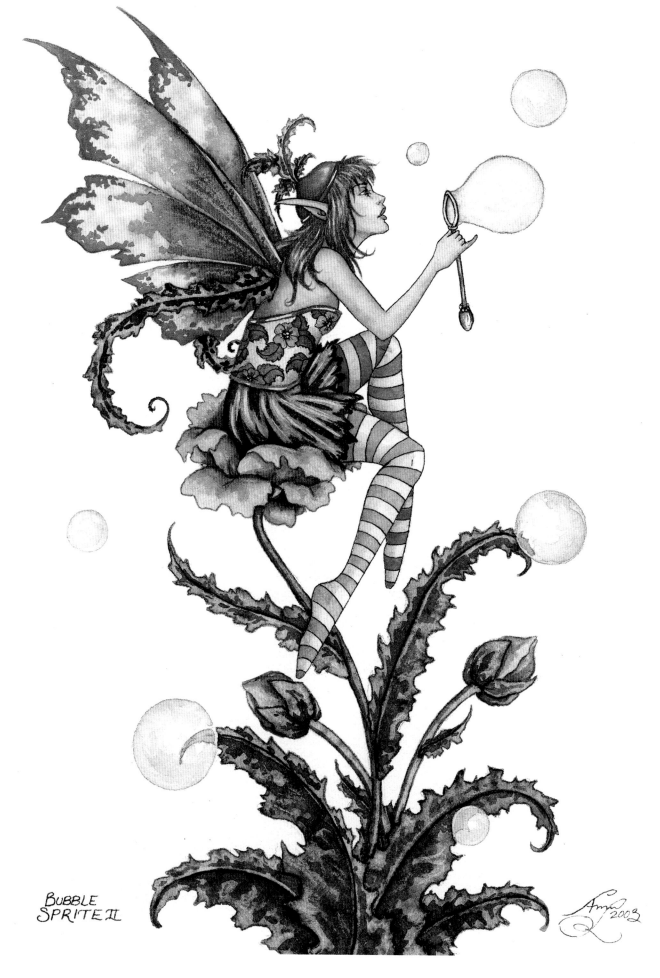

BUBBLE
SPRITE II

Bubble Sprite II
I have several images with the bubble theme. Bubbles fascinate me as they are absolutely perfect and
 beautiful...but only last a short while.

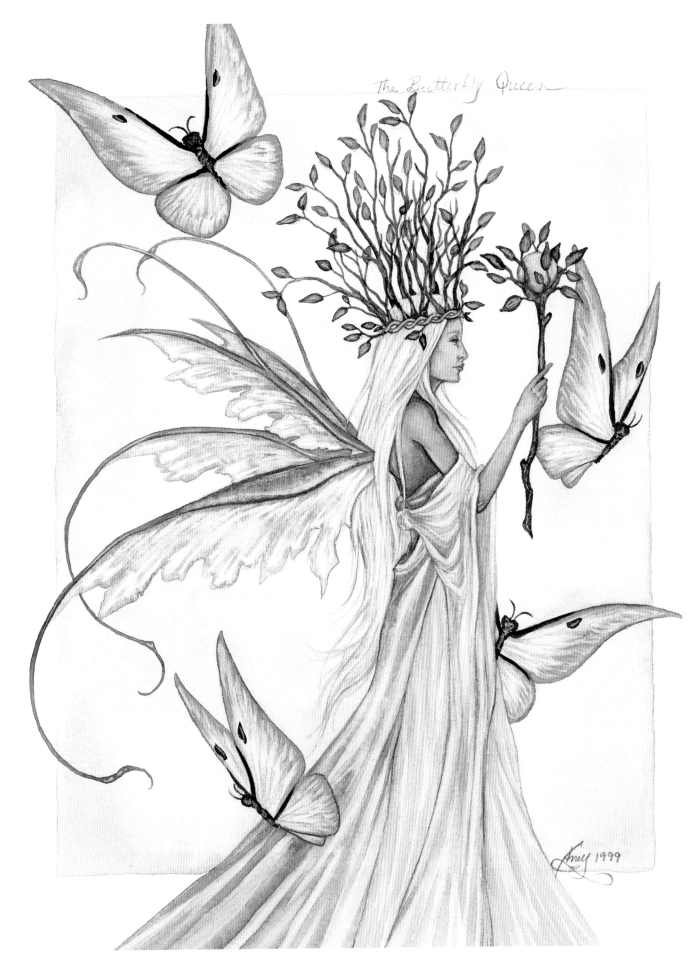

The Butterfly Queen

The Butterfly Queen

The Butterfly Queen was created while I was heavily into butterflies. The same pose was also used in my Moon Tattoo piece.

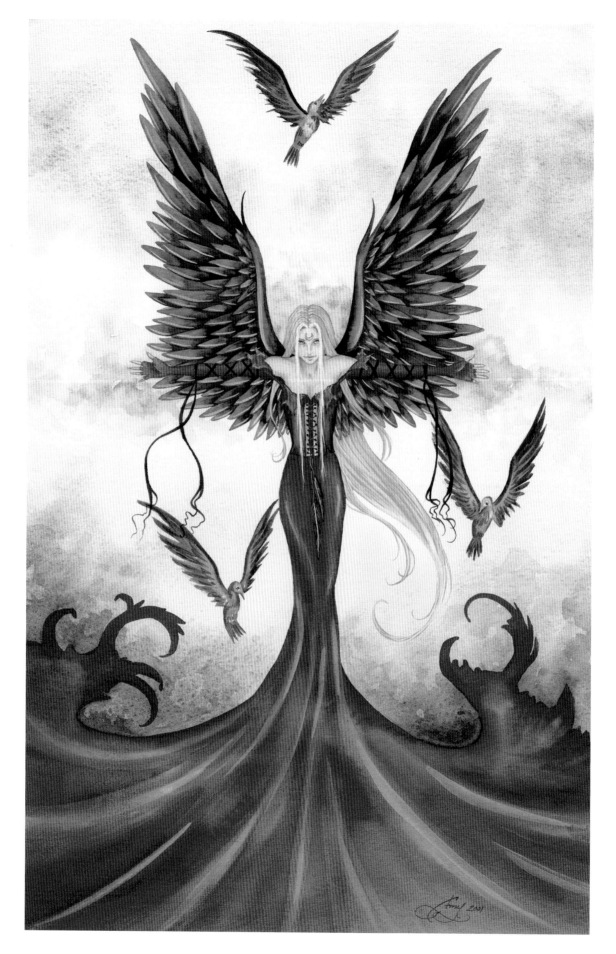

Calling the Crows

I also sometimes call this piece "Calling the Storm," as there is a hint of dark clouds building behind the woman.

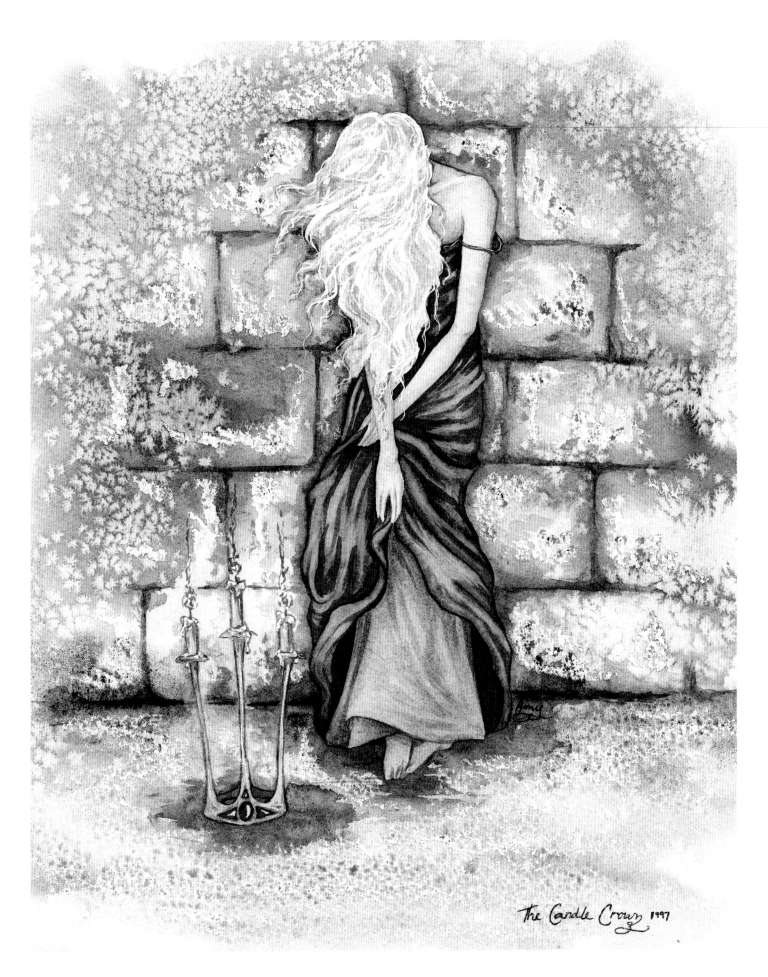

The Candle Crown
The Candle Crown popped into my head out of nowhere. I still do not know what it means.

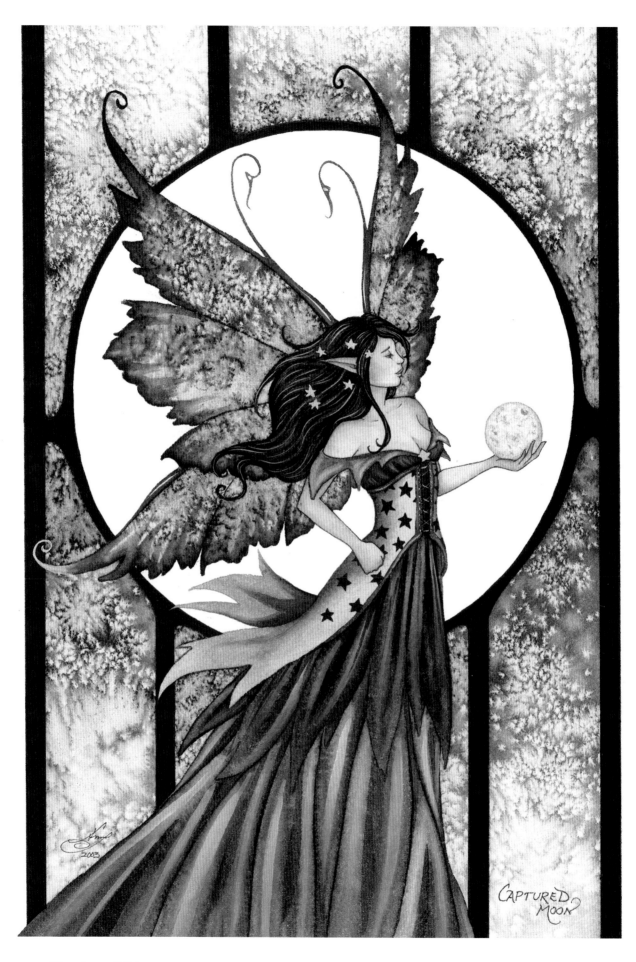

Captured Moon

When I was very young, I fell in love with a book illustrated by Edmund Dulac called The Buried Moon. I checked it out from the library repeatedly. If I remember correctly, the moon came to earth one night in the form of a lovely woman. Goblins captured her and hid her body under a rock. Eventually she was rescued. I keep an eye open to this day for a copy of that book, but have not come across one. Captured Moon is loosely inspired by that story.

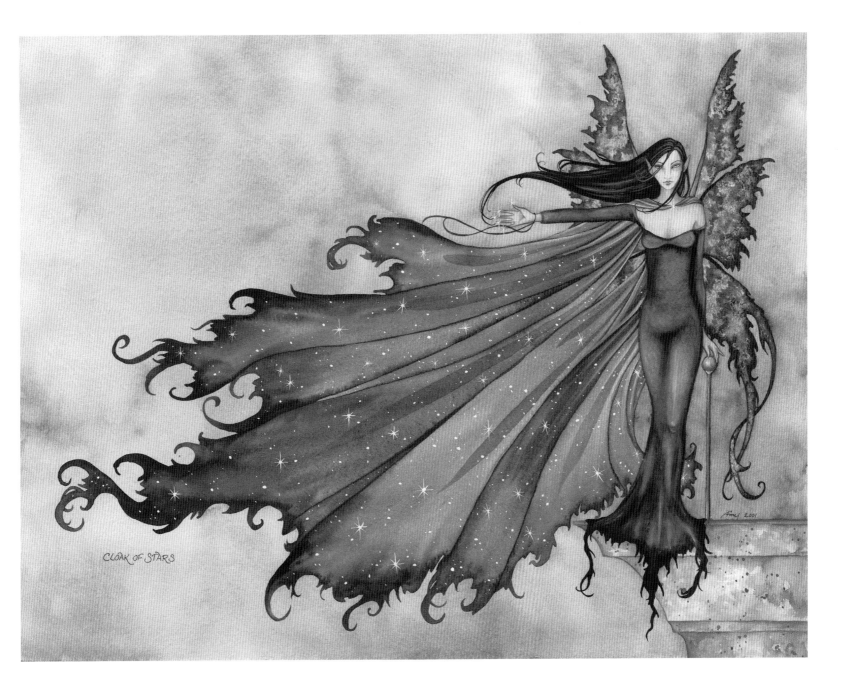

Cloak of Stars

Cloak of Stars is one of my better-known pieces. It was one of the first images in my on going series of faeries inhabiting what seem to be castles in the sky. All are loosely inspired by the works of Michael Parkes.

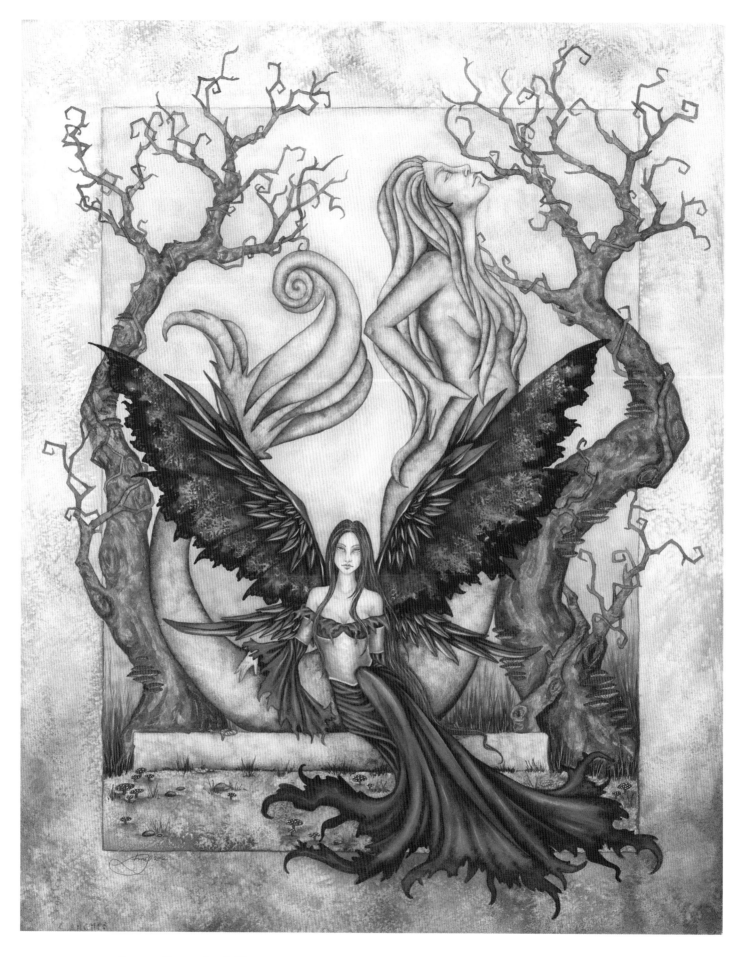

Come Stay Awhile

One day you're lost in your own thoughts, strolling through the woods. The trees gradually become tangled, leafless, and strange. The birds cease their chirping. You find yourself standing in a clearing with a large statue of a mermaid. Lounging at the foot of the statue is a lovely woman, eyes beckoning you to sit and keep her company.

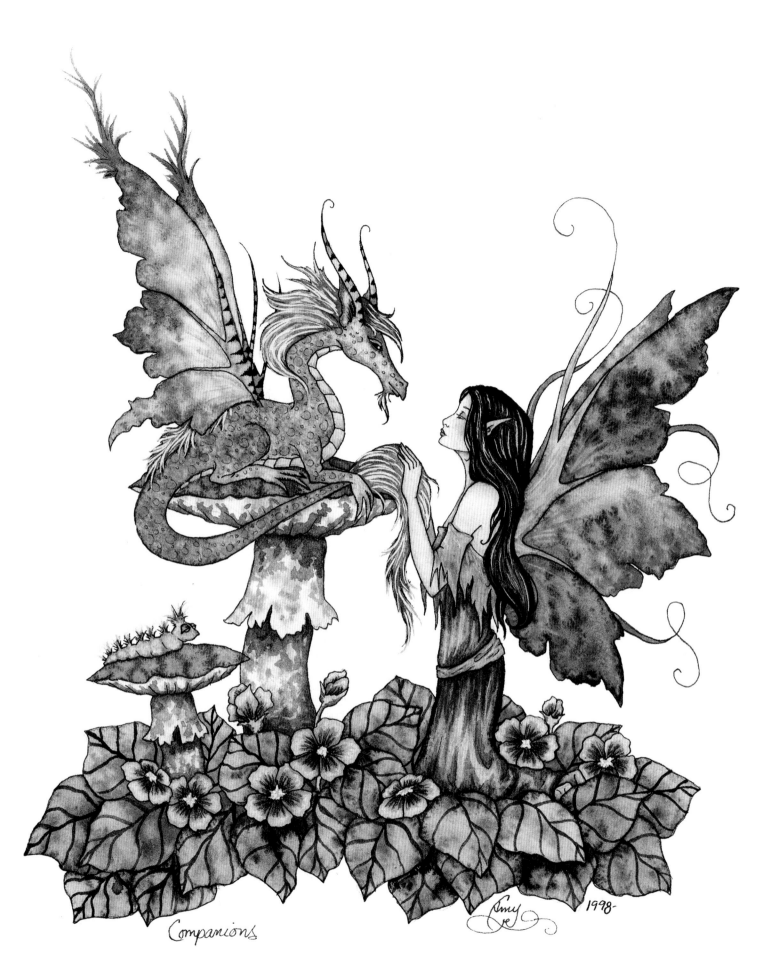

Companions

1998

Companions

Two companions sitting in a patch of primroses. The caterpillar is eavesdropping on their conversation. No one ever suspects the caterpillar. That is why they are often employed as spies.

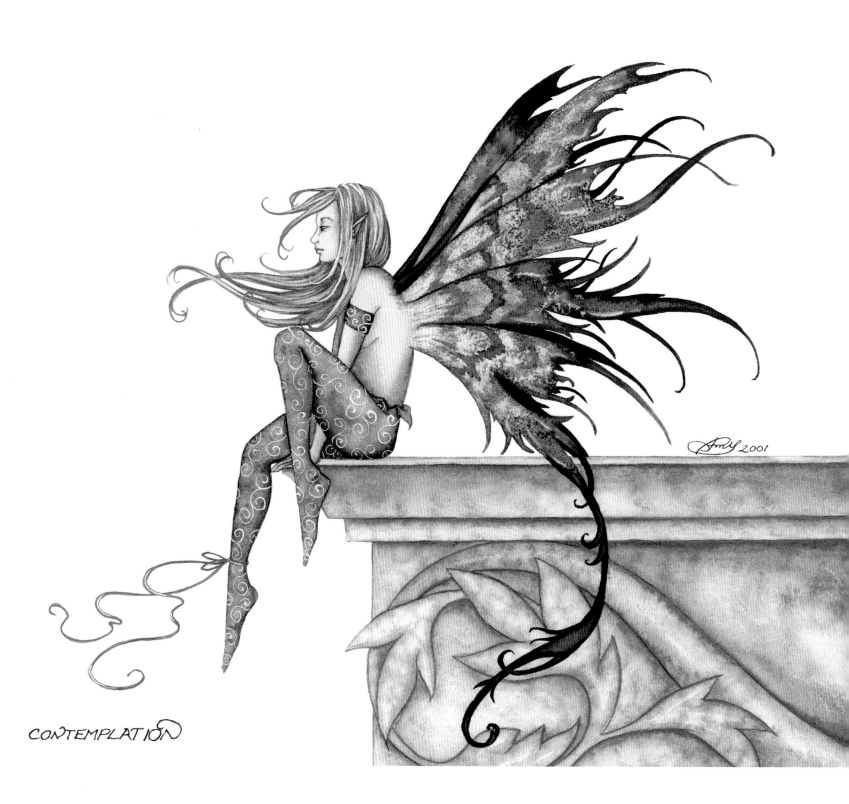

CONTEMPLATION

Contemplation
Contemplation is a simpler version of the faery in Dragon Dreams.

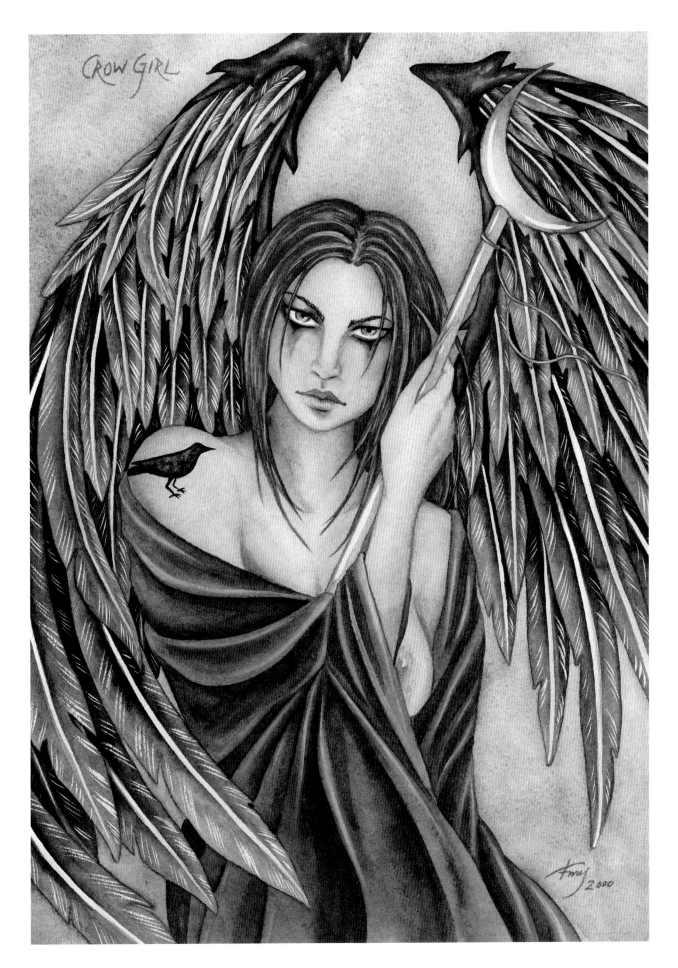

Crow Girl

Crow Girl was inspired by Charles De Lint's writings. I plan to revisit this theme several more times.

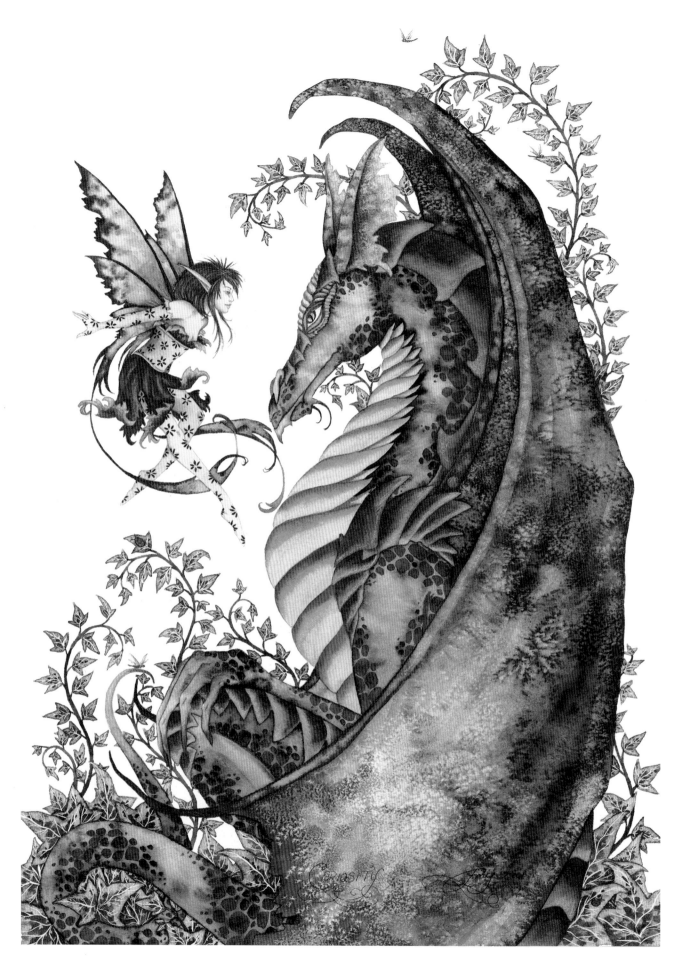

Curiosity

In this piece, I enjoyed playing with wild, bright colors to give the image a sense of playfulness.

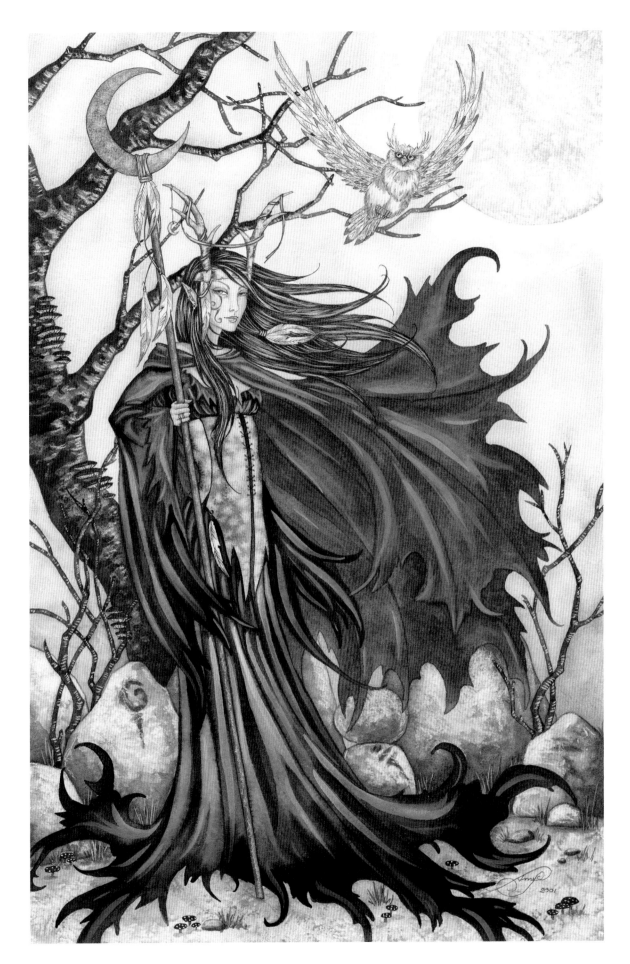

Dark Elf III

Dark Elf III came about after I had received several requests to paint more elves. After this image was completed I went on to paint Night Winds and Wood Elf, which continue the Elvin series.

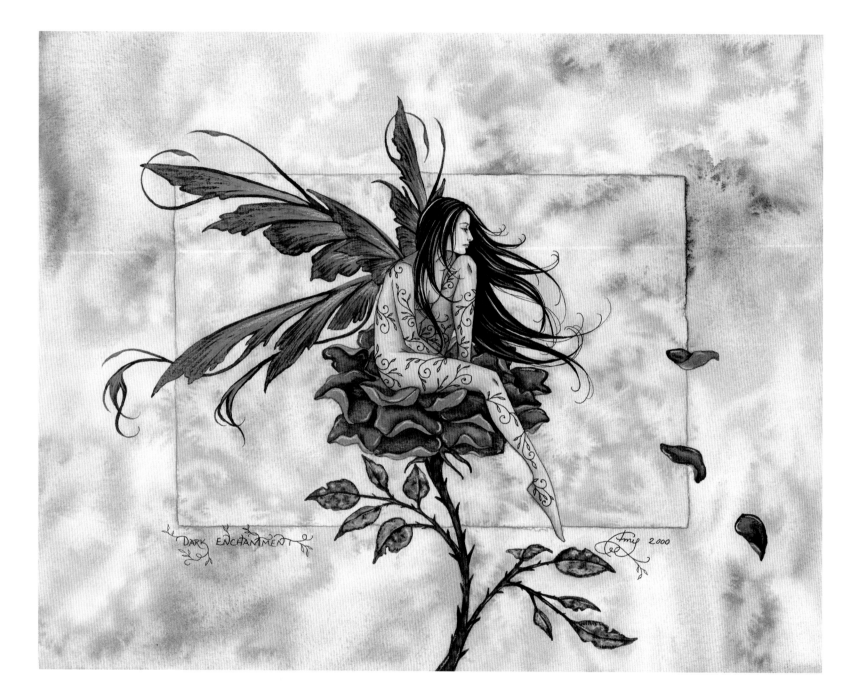

Dark Enchantment

In Dark Enchantment, I was experimenting with different types of borders—this one being very simple, but necessary to break up the monotony of the background.

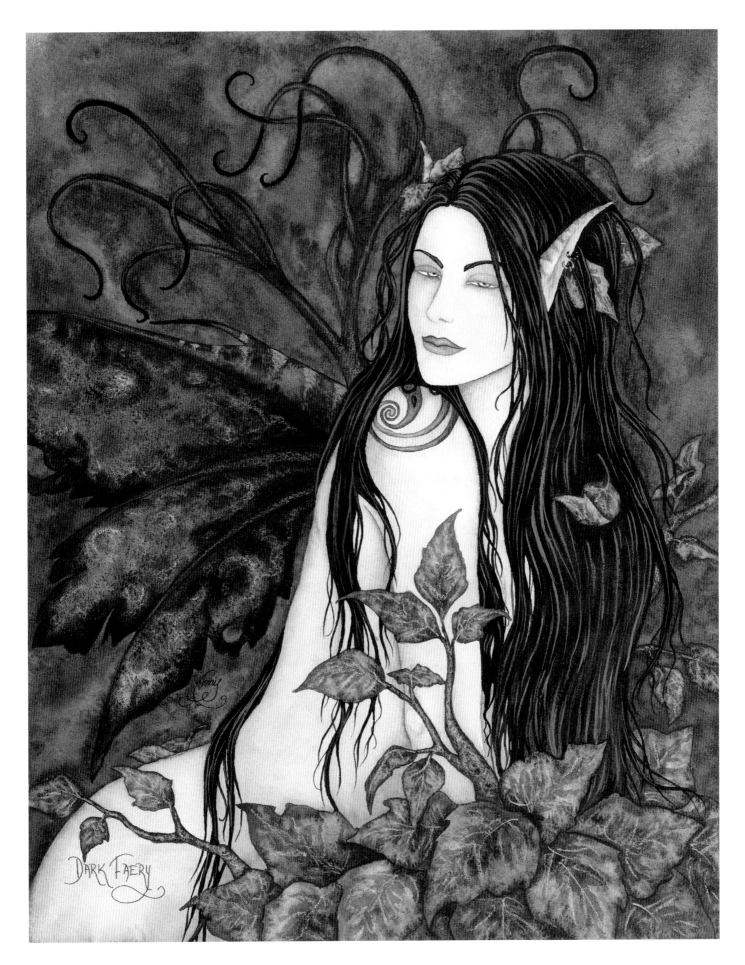

Dark Faery

My favorite faeries are the ones who look a little bit naughty.

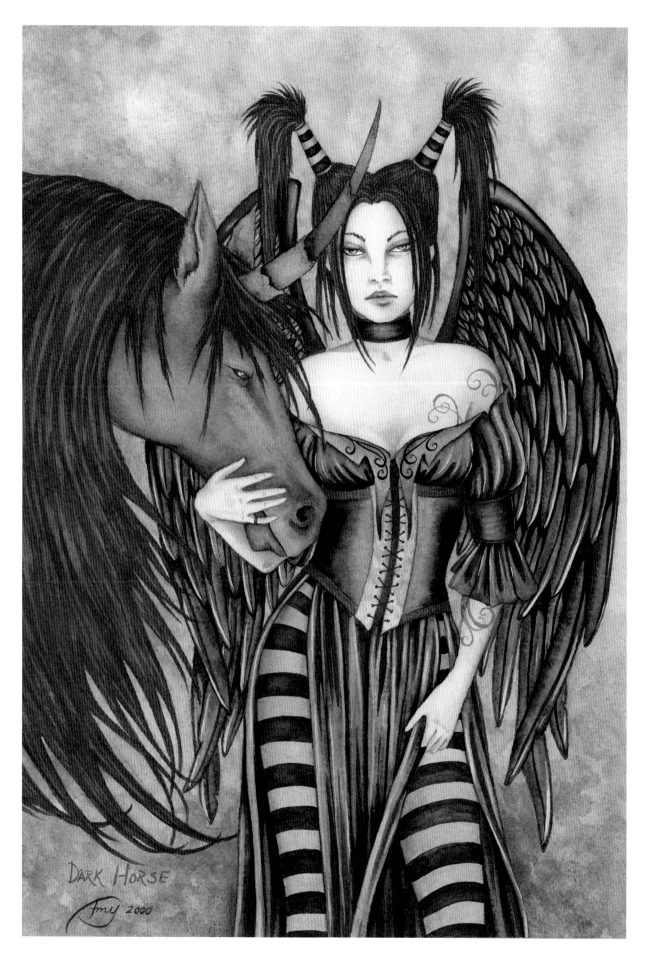

Dark Horse
Dark Horse is one of my favorite pieces. I find her hair amusing.

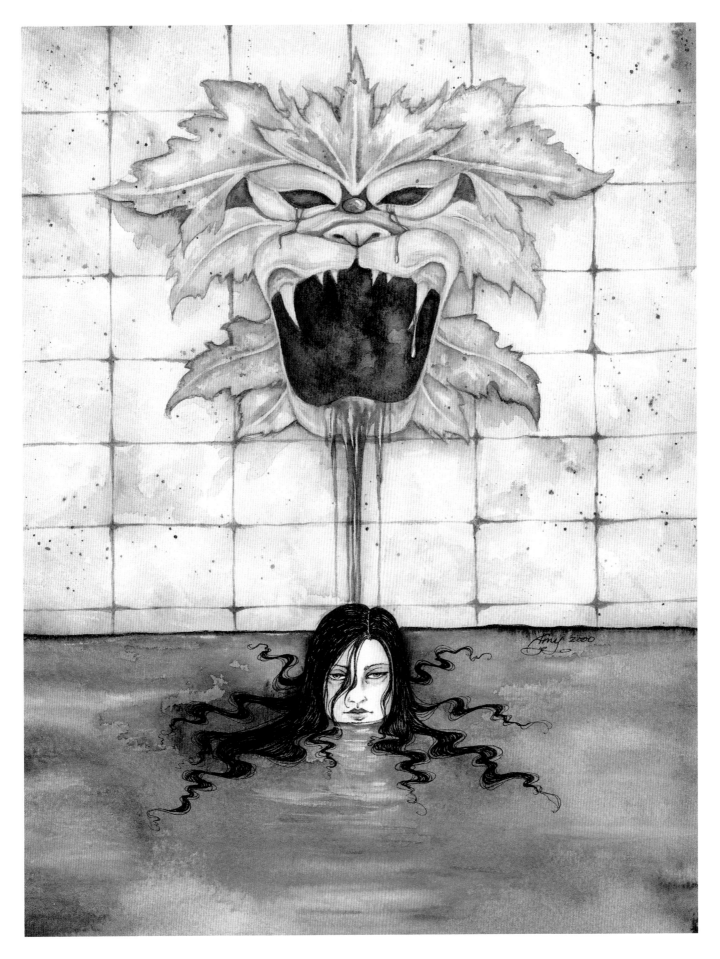

Dark Waters

Dark Waters was inspired by Ciruelo's painting, "Marbled Shower."

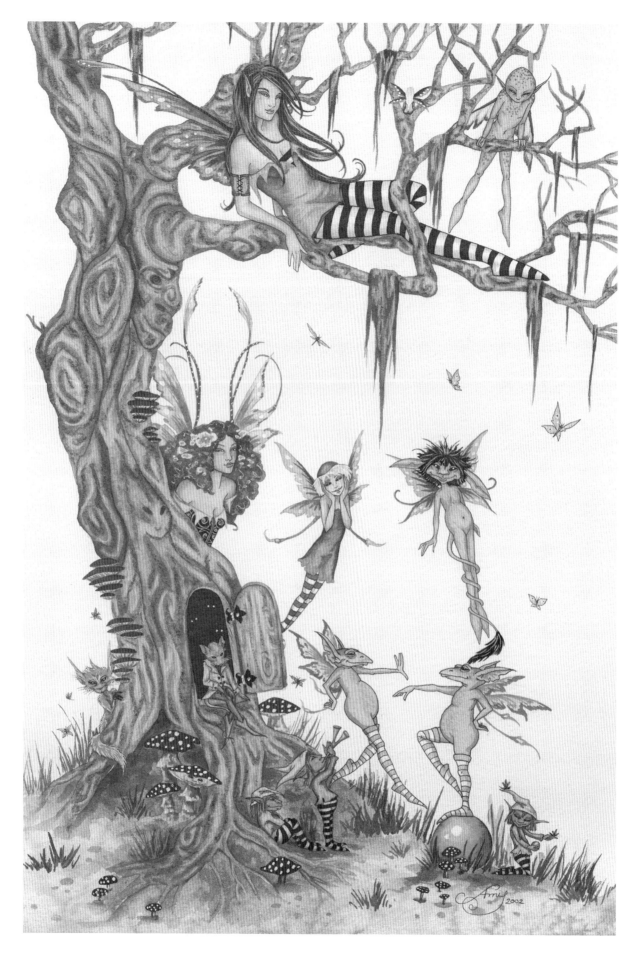

Doormouse's House Warming Party

It took me years to complete Doormouse's House Warming Party. I would work on it a bit, get bored, set it aside...pull it back out several months later and work on it a bit more. It took three years to eventually complete it, thanks to my short attention span.

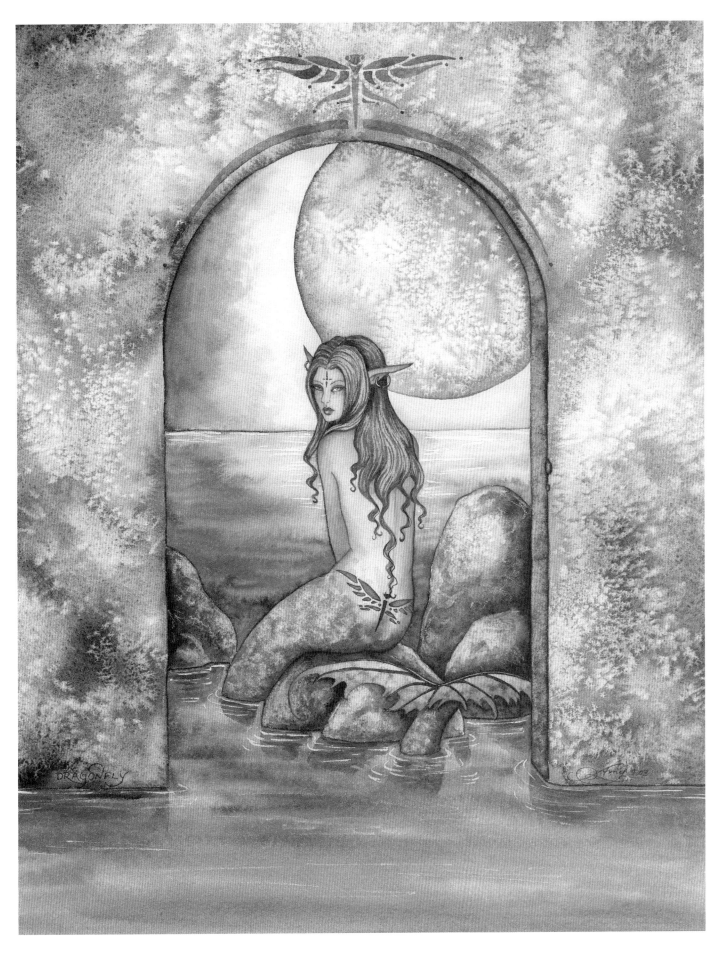

Dragonfly

I often like to paint scenes where it looks like the viewer has suddenly happened upon the character in the painting. In "Dragonfly" a mermaid relaxes on a rock just outside a sunken castle. We view her through one of the castle's doorways. The floor is hidden under several feet of water.

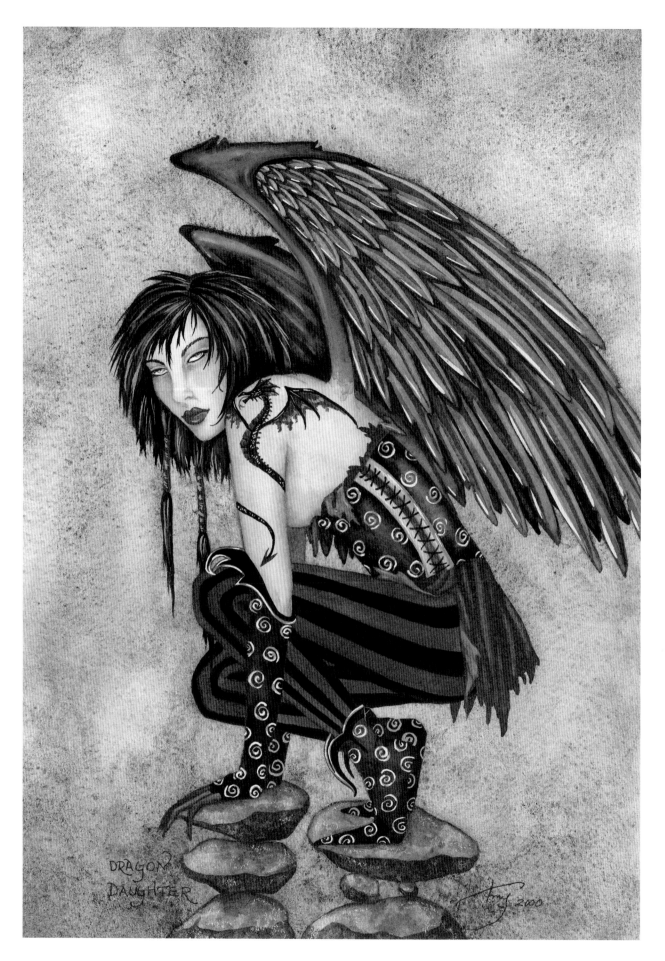

Dragon Daughter

This title refers to her tattoo. It is a symbol of the clan she belongs to.

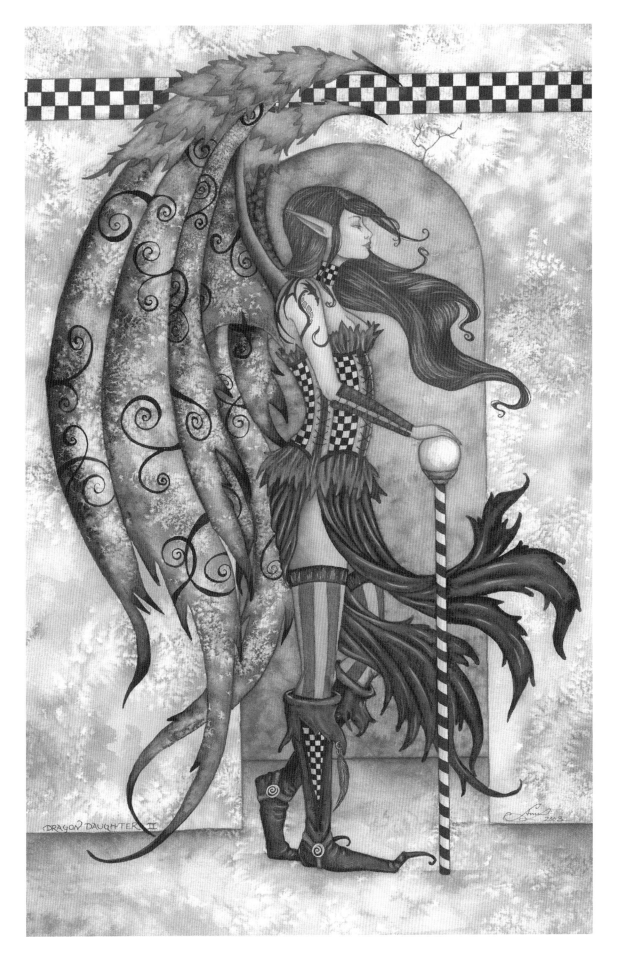

Dragon Daughter II

In this case, the dragon daughter is an actual descendant of dragons. She is unbelievably tall, with powerful legs and giant dragon wings that sweep the floor as she walks.

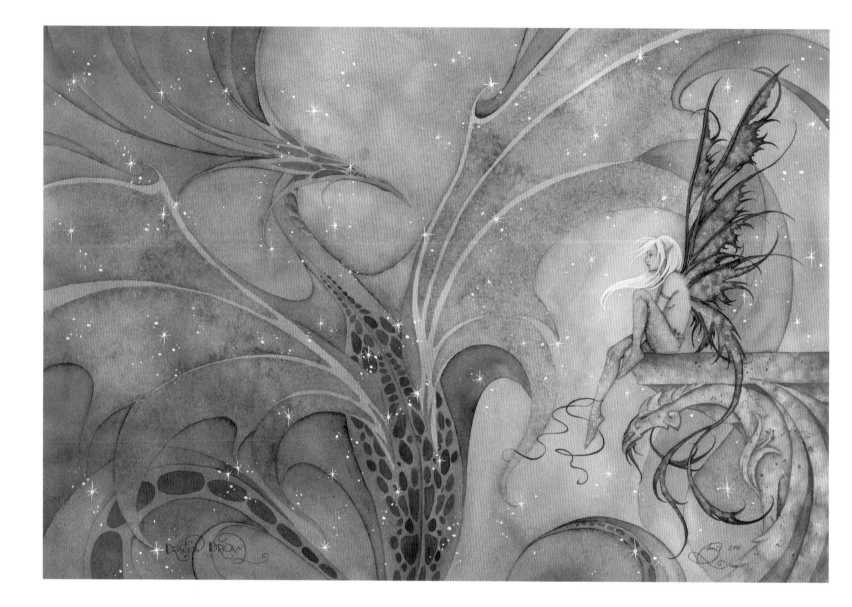

Dragon Dream

Dragon Dream is one of those paintings that I often look at and think "I'll never be able to re-create that piece." It's one of my favorites.

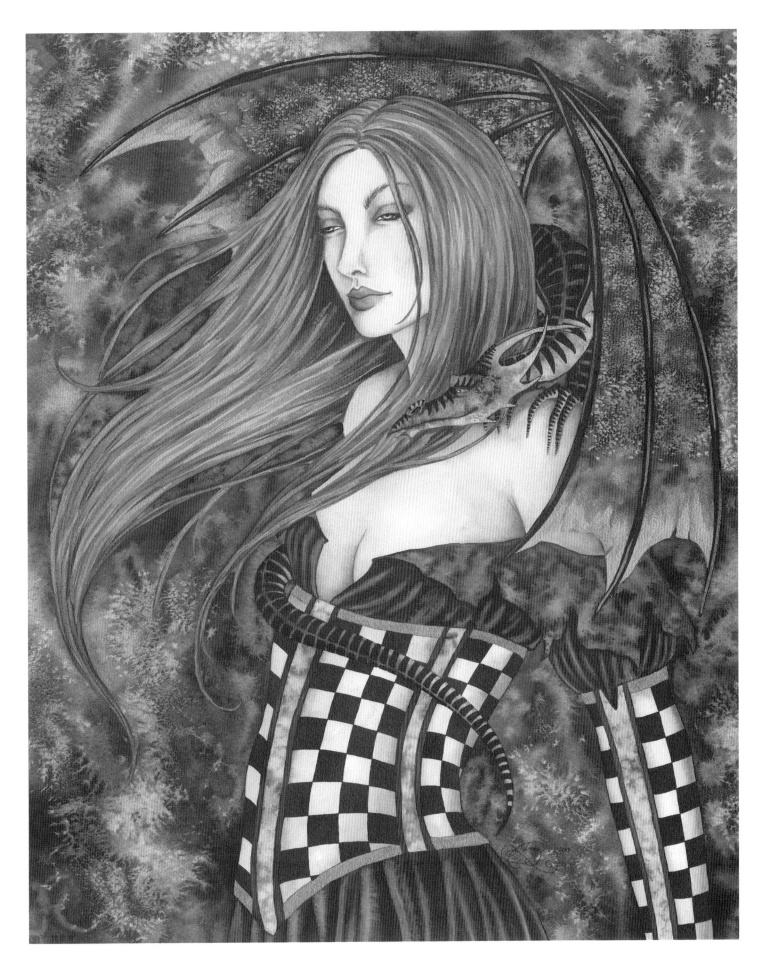

Dragon Keeper
The ultimate in exotic pets.

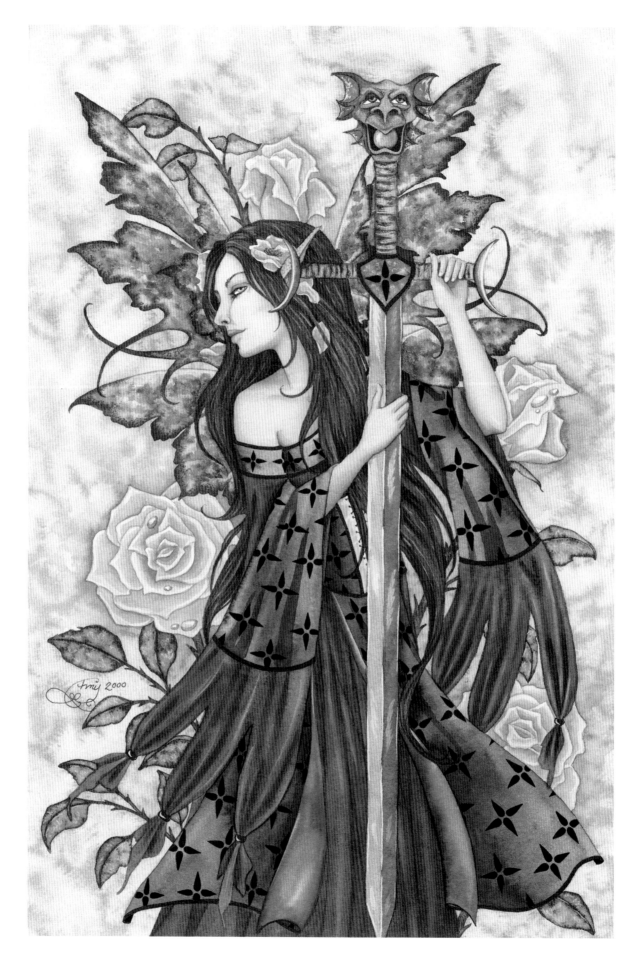

Dragon Sword

The Dragon Sword is an enchanted weapon. Occasionally the dragon's head will spit out its orb and make ludicrous predictions about the future. (i.e. "On the seventh day of March, an albino squirrel will have tea with a moose.")

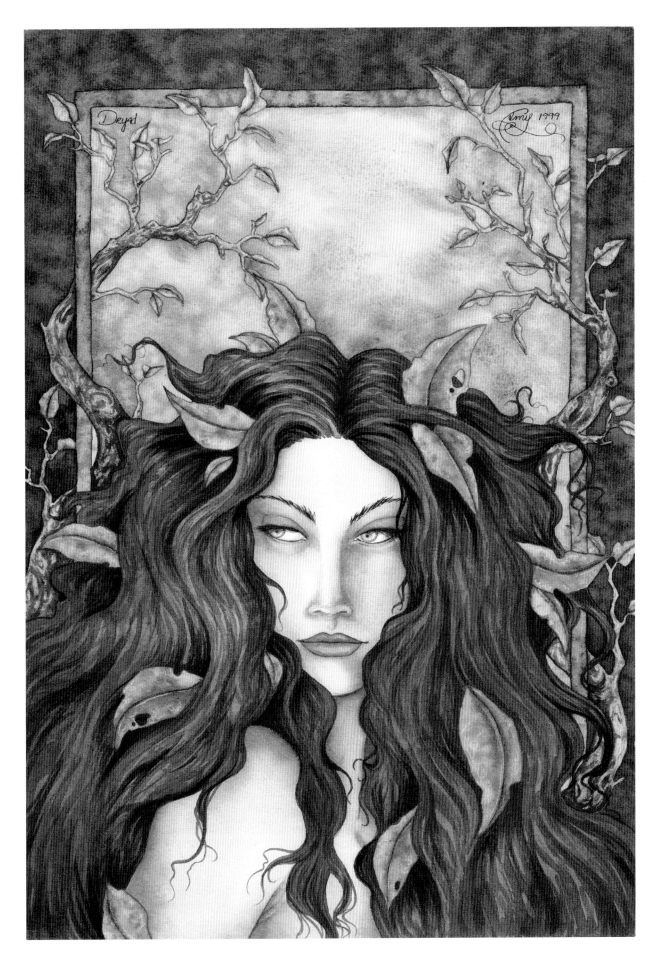

Dryad

Dryad was not inspired by anything in particular. However, to my surprise, when I had finished it, I realized it bore a striking resemblance to a character in a book I was reading at the time.

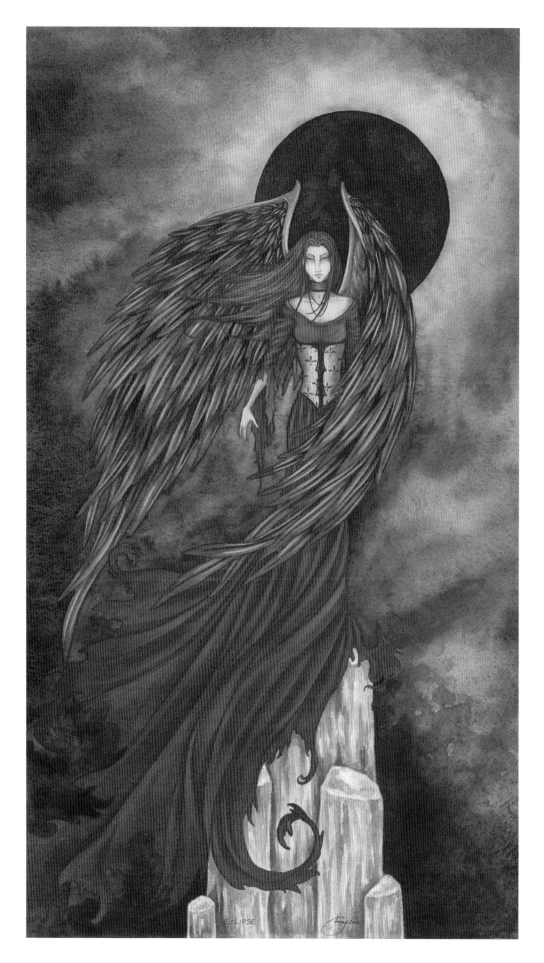

Eclipse
I had quite a time painting the dress in Eclipse. It seems to have a life of its own.

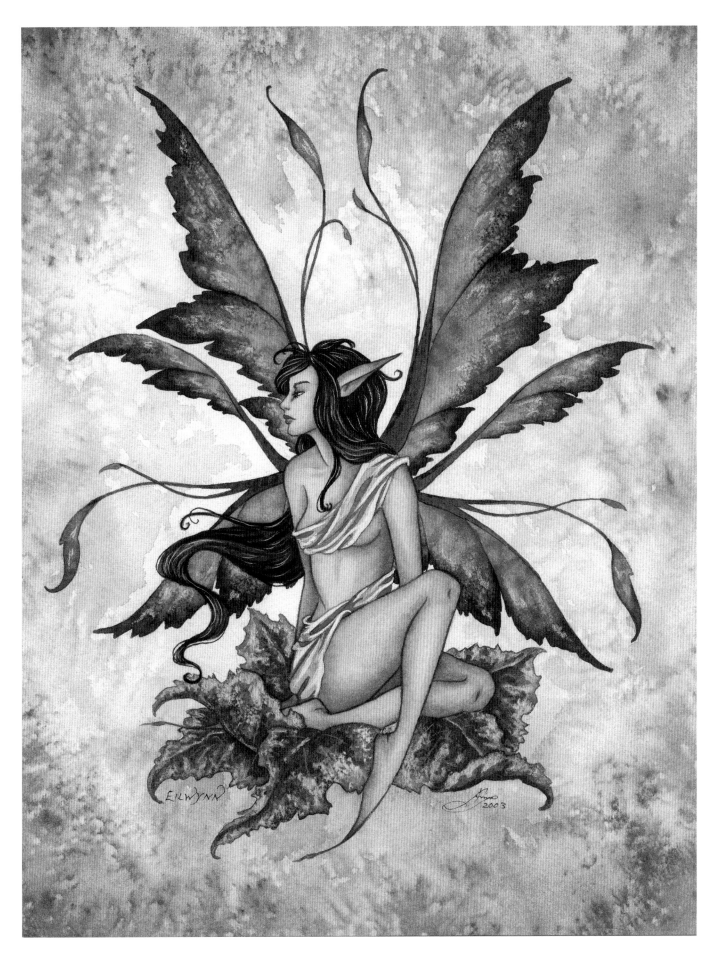

Eilwynn

Eilwynn is one of various single faery portraits that I like to do. Not only do they keep me in practice, they often become some of the more popular images.

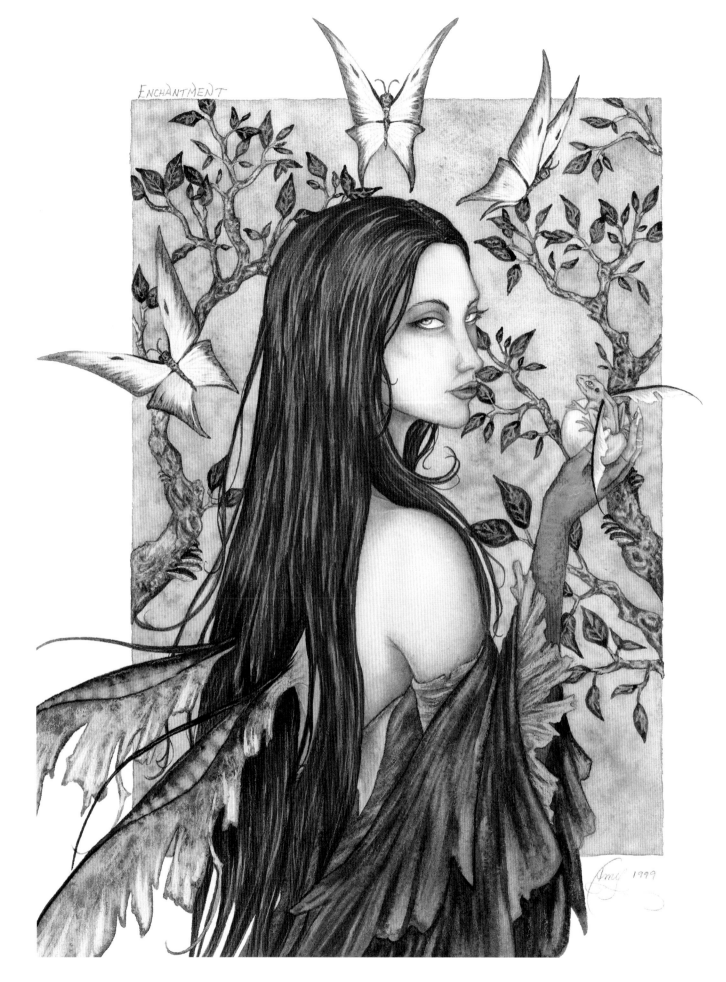

Enchantment

I went through a phase once where I kept putting winged frogs in my paintings.

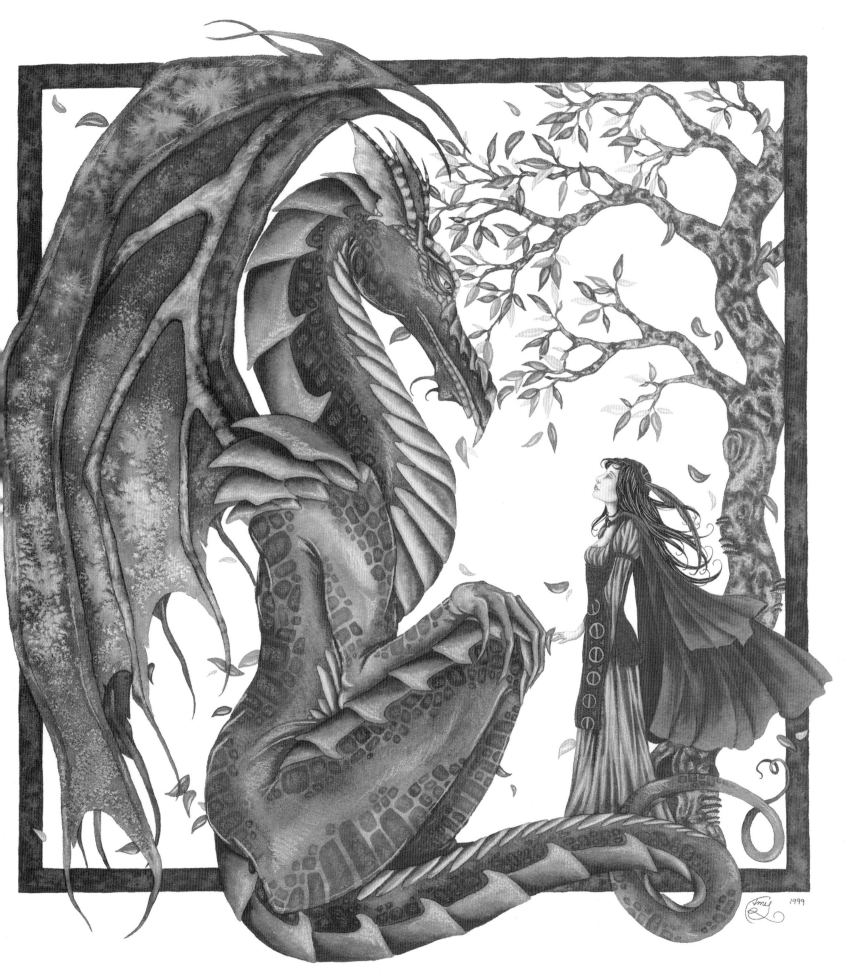

Encounter

Encounter—my favorite dragon. He has a lovable quality.

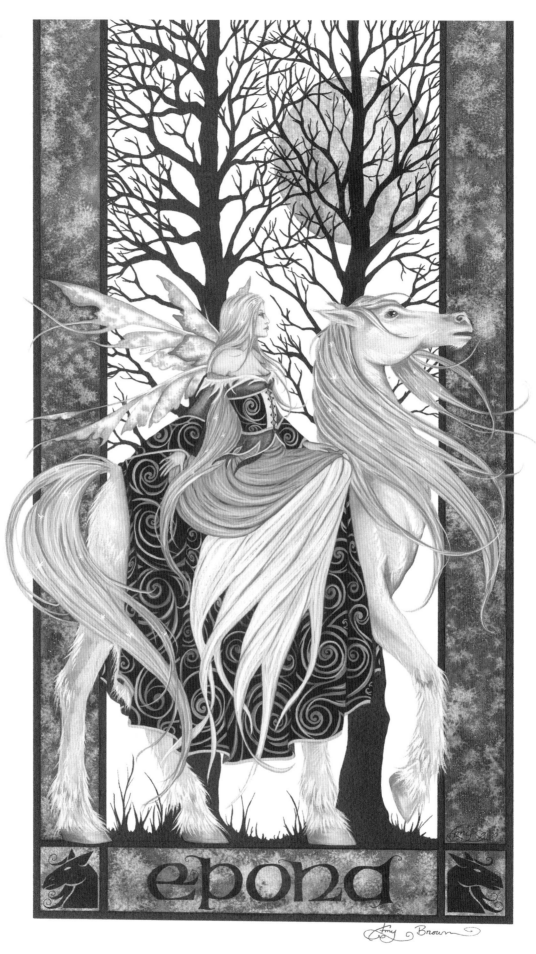

Epona

Epona is the goddess of horses, sometimes war, depending on what book you read. I wanted to play with the idea of a silhouette background...possibly out of laziness, because it's much easier to paint one color.

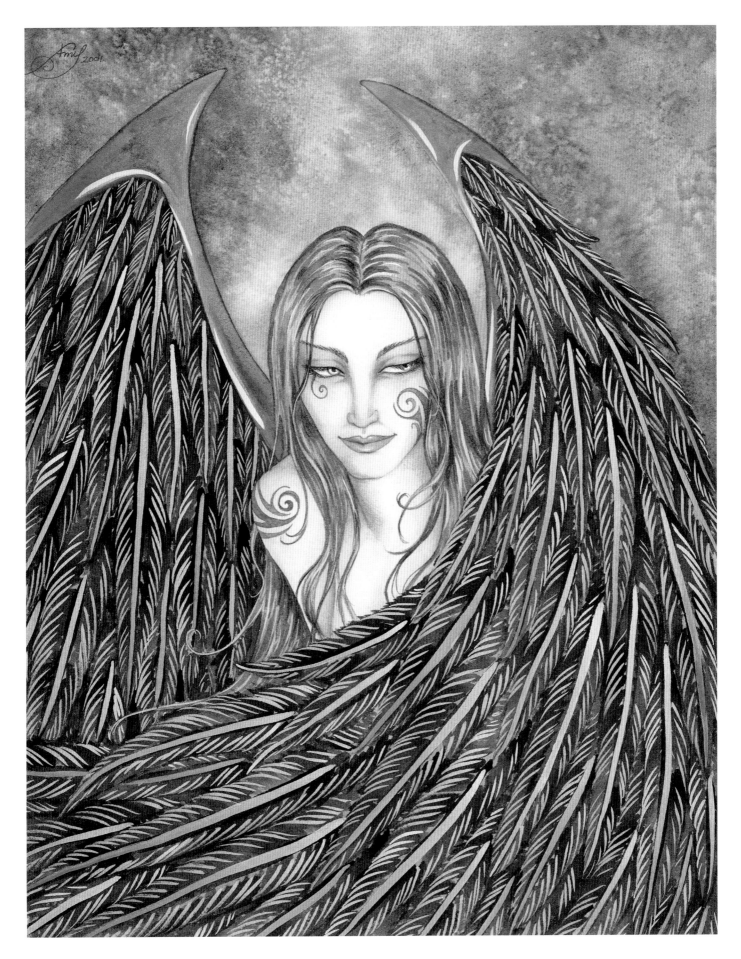

Evangeline

Evangeline is a darker, gothic angel.

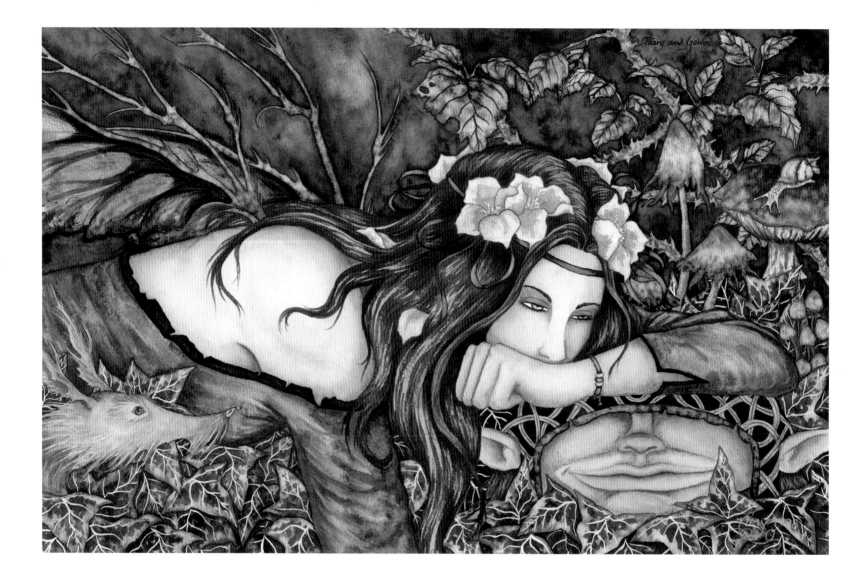

Faery and Goblin

Faery and Goblin...obviously heavily inspired by Brian Froud.

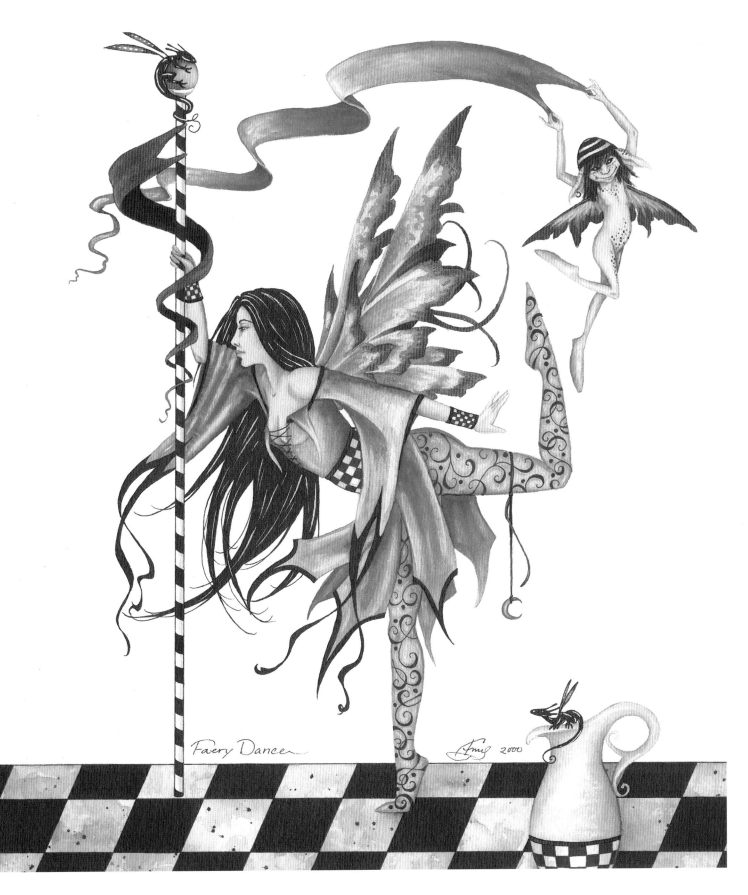

Faery Dancer

Faery Dancer was painted around the same time as Gargoyle I and II. I was stuck on checkerboard flooring.

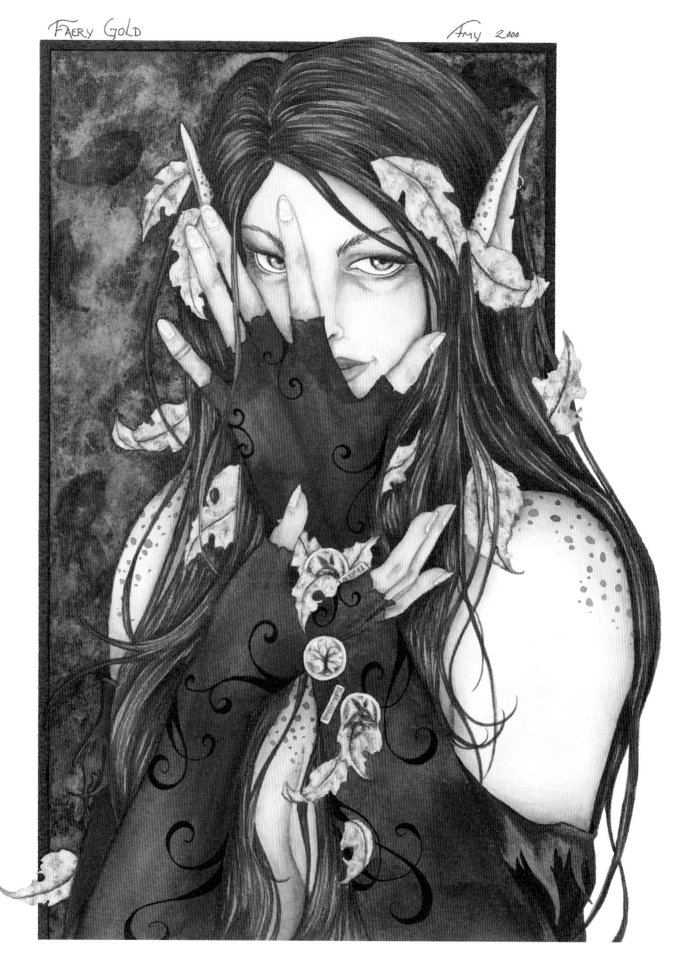

Faery Gold

The idea for the Faery Gold image surfaced one day when I was reading a story about faeries paying humans in gold which later, to the human's dismay, turned into leaves and stones.

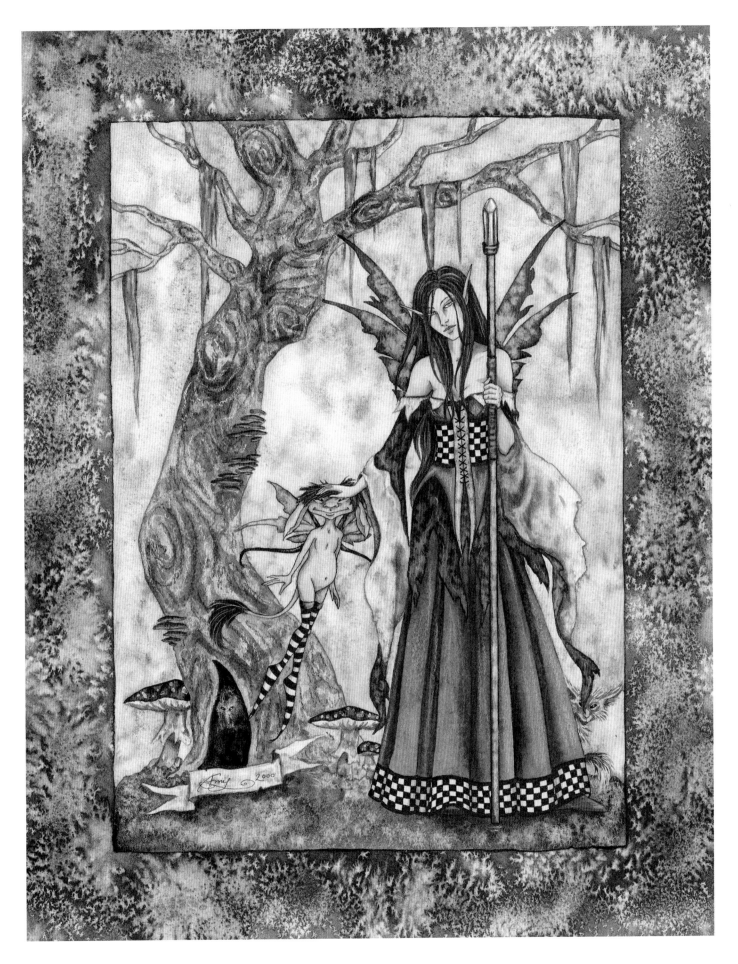

Faery With Staff

Faery with Staff evolved from a sketch of the smiling creature hovering near the faery.

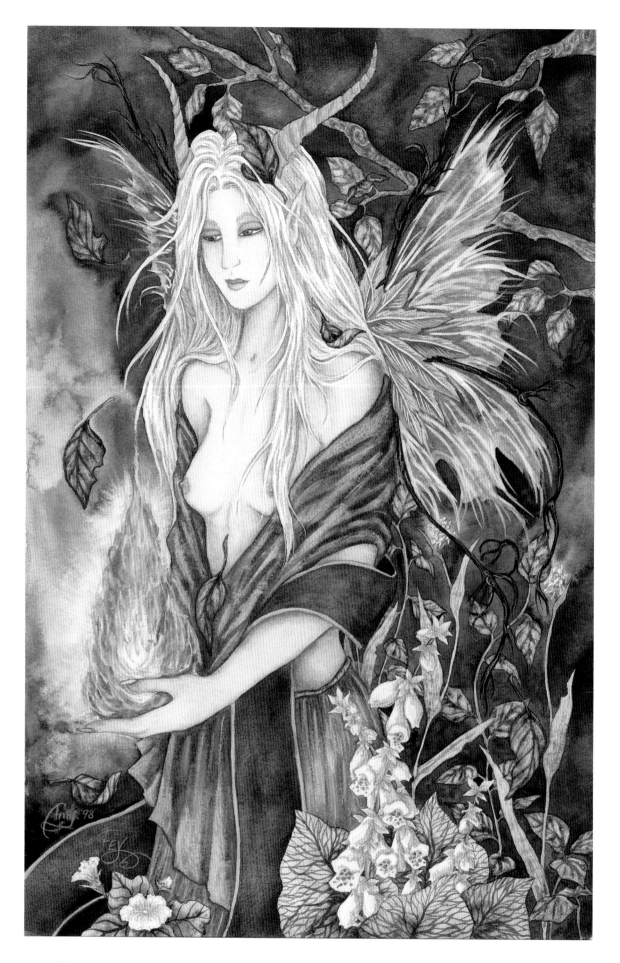

Fey

Fey is a faery Shaman. She holds a ball of magical flame in her hand.

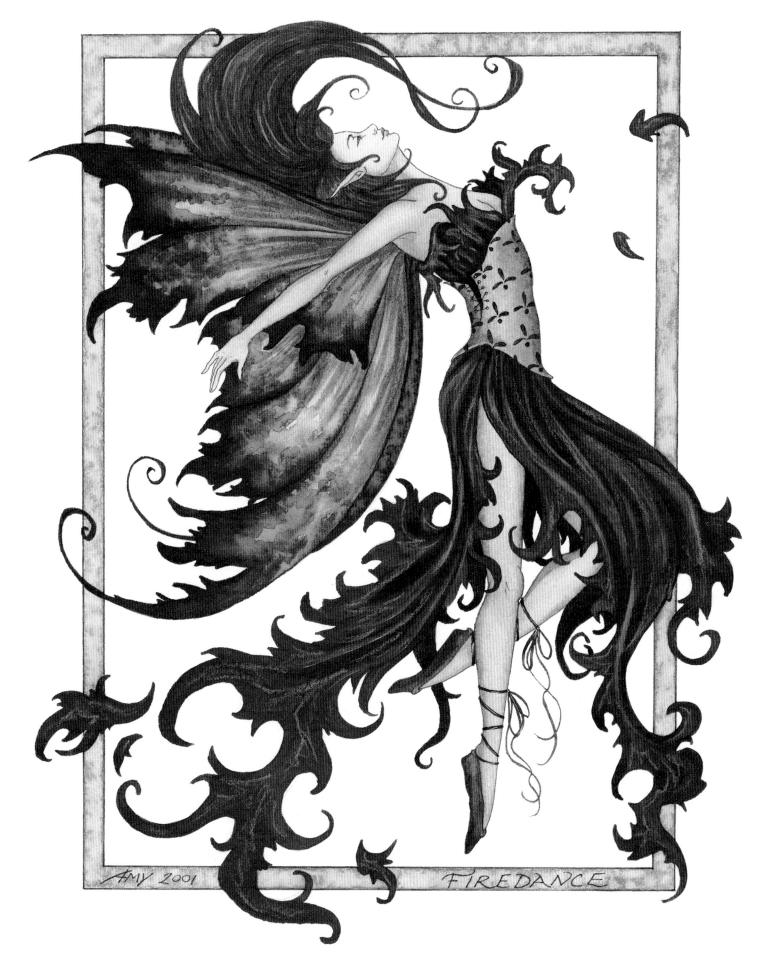

Fire Dance

My fire images are always some of the most popular. I revisit this theme often. I love to paint with vibrant oranges, golds and reds.

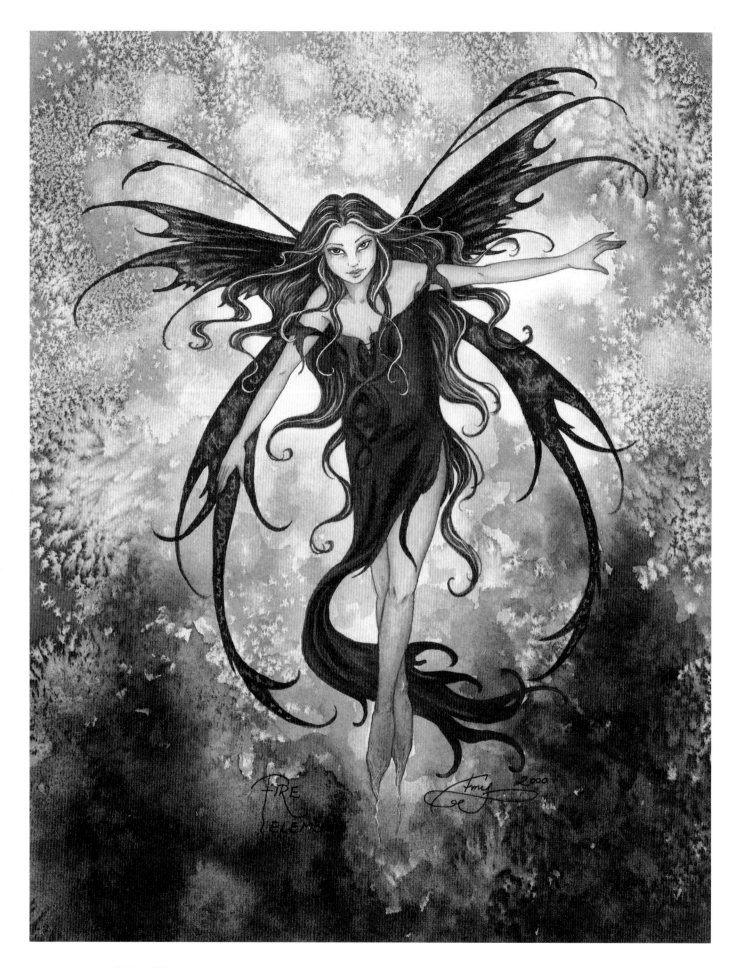

Fire Element

Fire Element is the first painting in my Four Elements series, followed by Water, Wind and Earth.

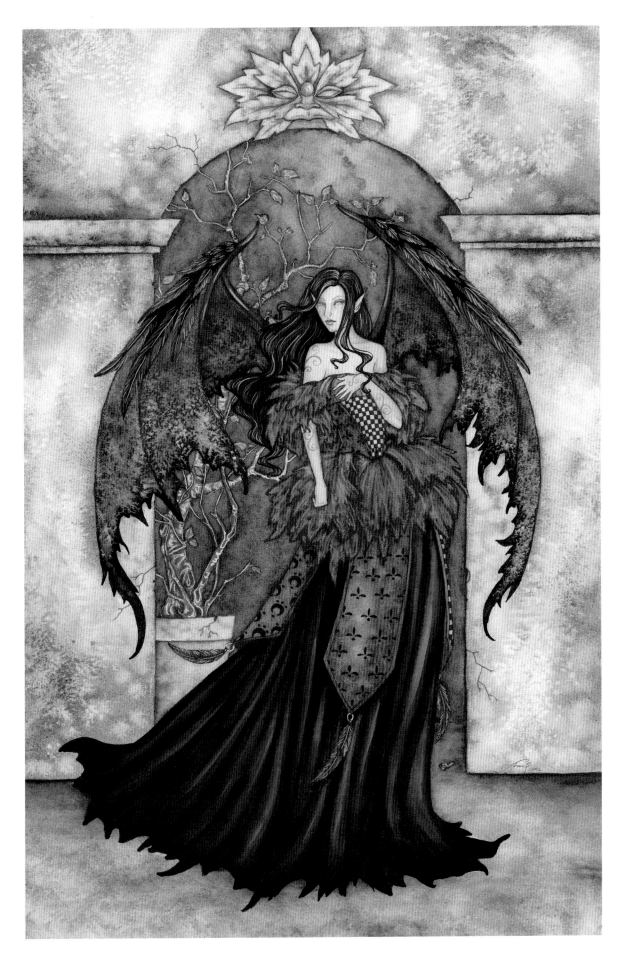

Follow Me

She quietly motions you to follow her through dark, lonely corridors. She seems helpless enough, but looks can be deceiving.

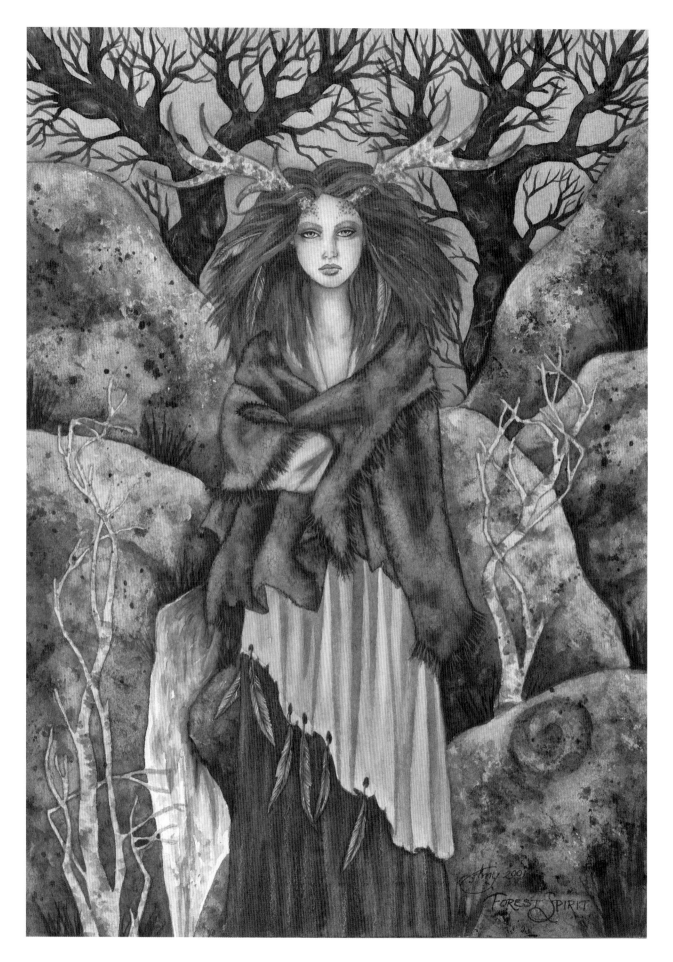

Forest Spirit

Forest Spirit was one of my early attempts at tackling full and complex backgrounds. Not being good at painting rocks, trees, etc., I had shied away from adding them to my paintings in the past.

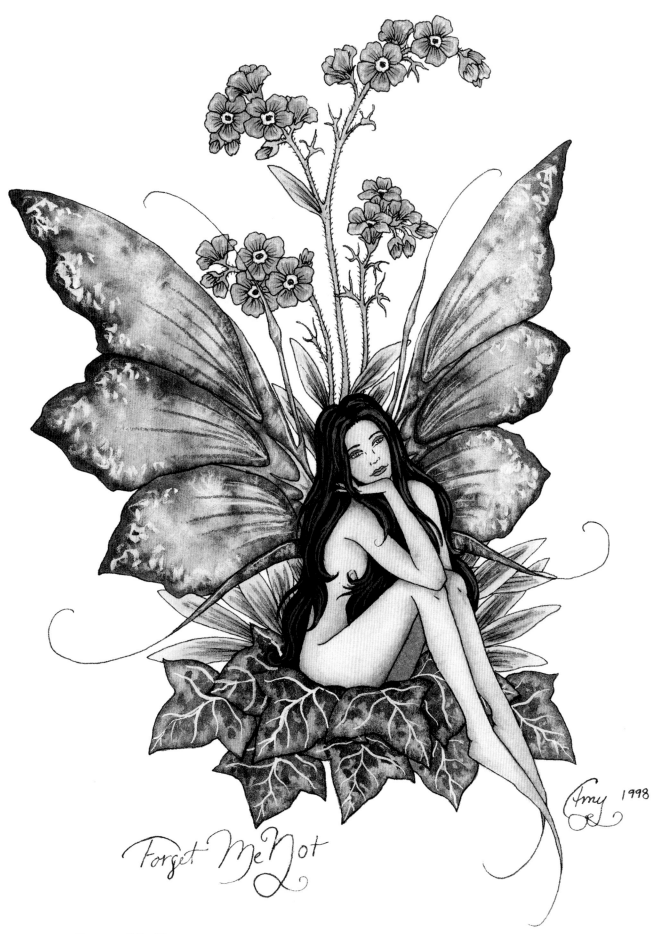

Forget Me Not

Forget Me Not

Forget Me Not...a romantic phrase, a lovely flower. She begged to be painted and I could not resist.

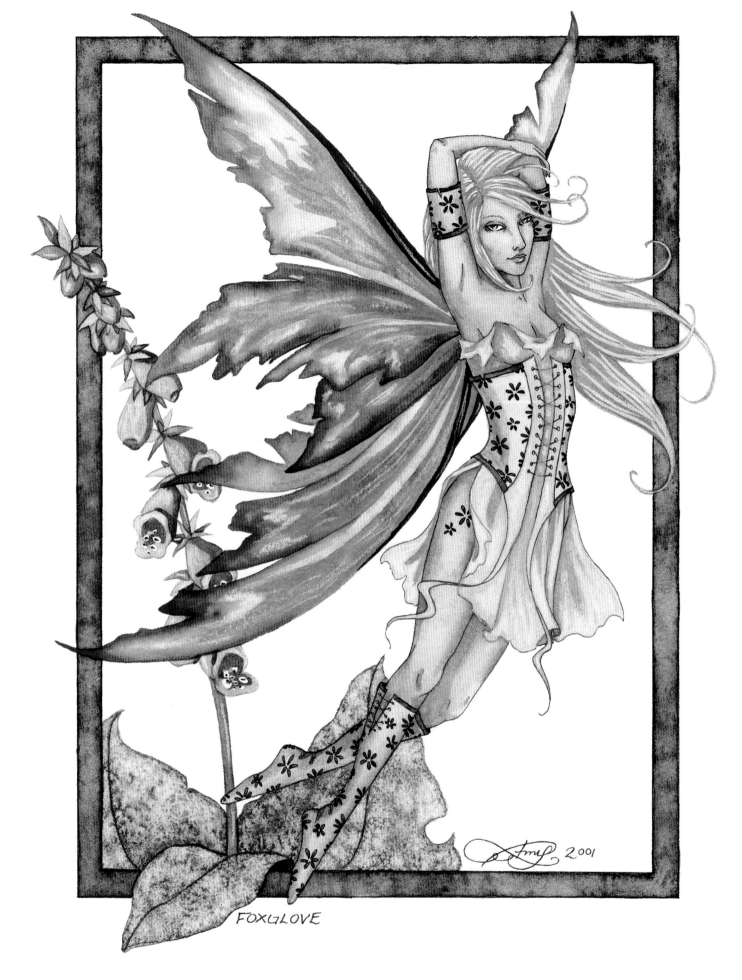

FOXGLOVE

Foxglove
Foxgloves are one of my favorite flowers. I like to fit them into paintings whenever possible.

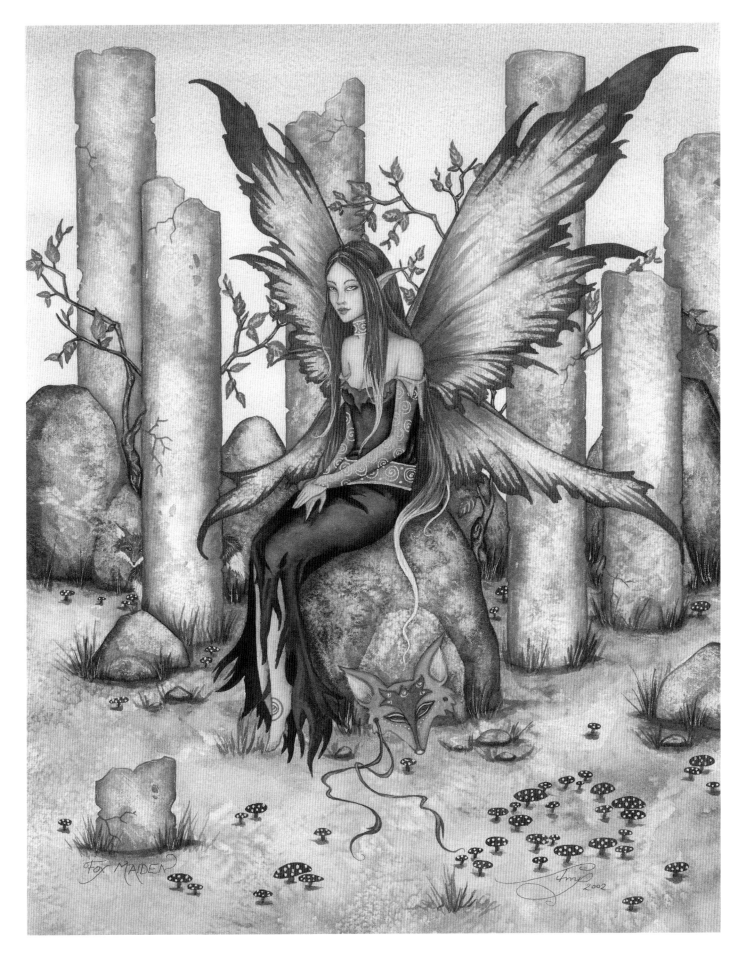

Fox Maiden

I believe fox maidens originated in Asian folklore (but I could be mistaken). They were not all together nice ladies—quite the opposite. I wanted to portray a fox maiden in faery form—pretty and sweet looking, but with a hint of something malevolent in her eyes.

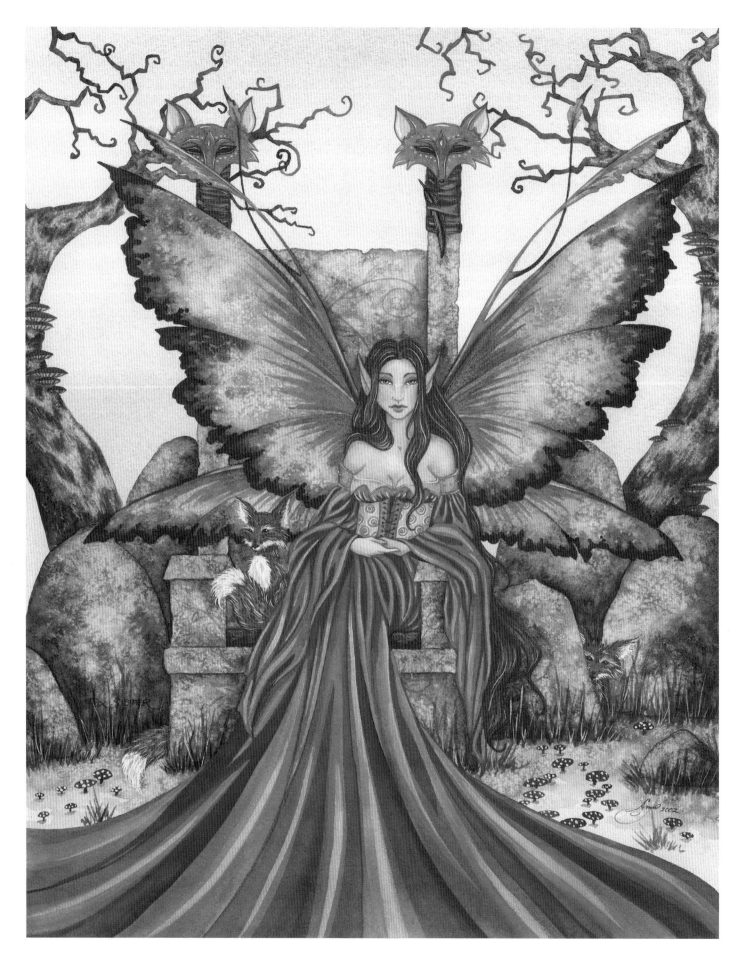

Fox Sister

Foxes...I just adore them. Any excuse to paint a fox.

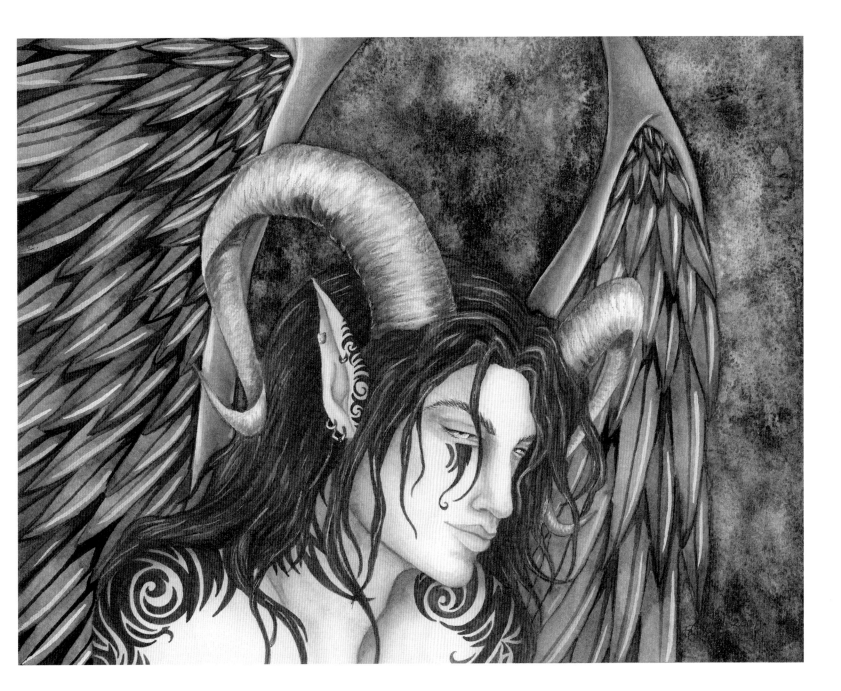

Gabriel

I have this idea that some day I'll have time to write stories to go with my paintings. Gabriel is one of several male characters I've painted for this purpose. They are half angel, half demon creatures, some are noble...some not. Gabriel is not to be trusted.

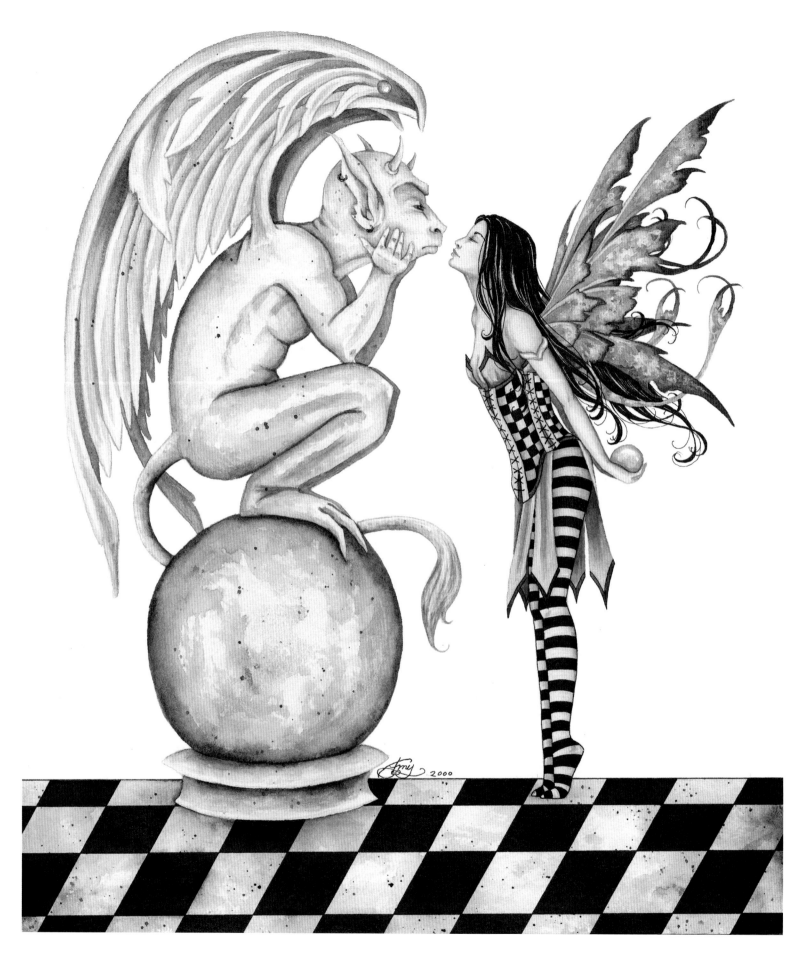

Gargoyle

I love gargoyles and have several throughout my house and yard. Gargoyle I is a tribute to them. It was brought to my attention that the gargoyle character is actually called a grotesque. The term "gargoyles" refers to waterspouts. My response to this is "Who wants to buy a picture titled 'Grotesque'?"

66

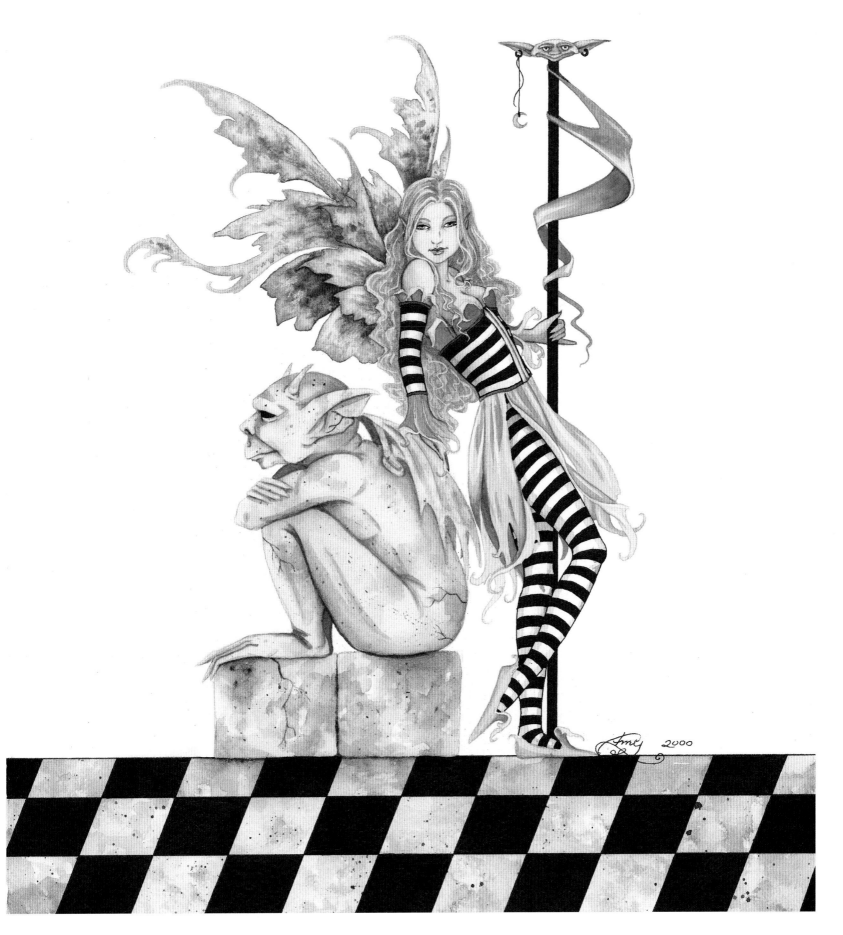

Gargoyle II

The first gargoyle piece was so fun, I decided to do another.

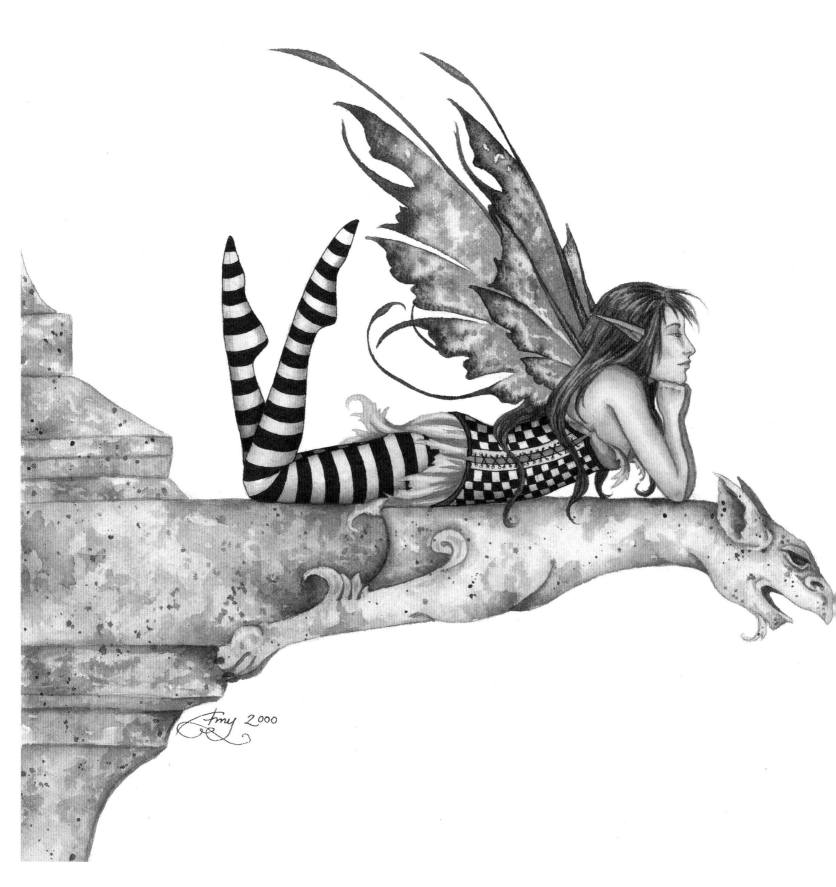

Gargoyle III
After Gargoyle I and II had both sold out, I received several requests for a third.

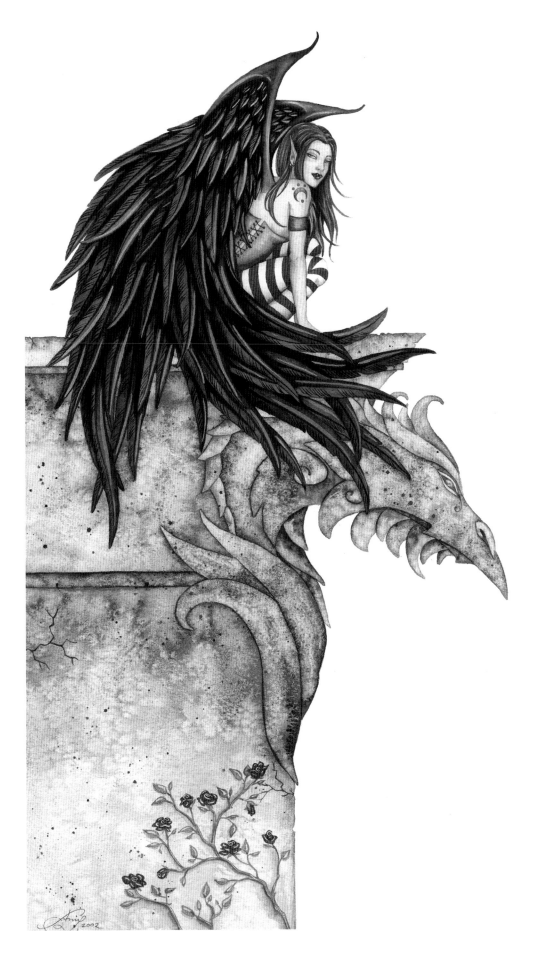

Gothic

I decided I wanted to toy with a mostly monochromatic painting. The result was Gothic. I added the touch of red to draw the viewer's eye to the piece.

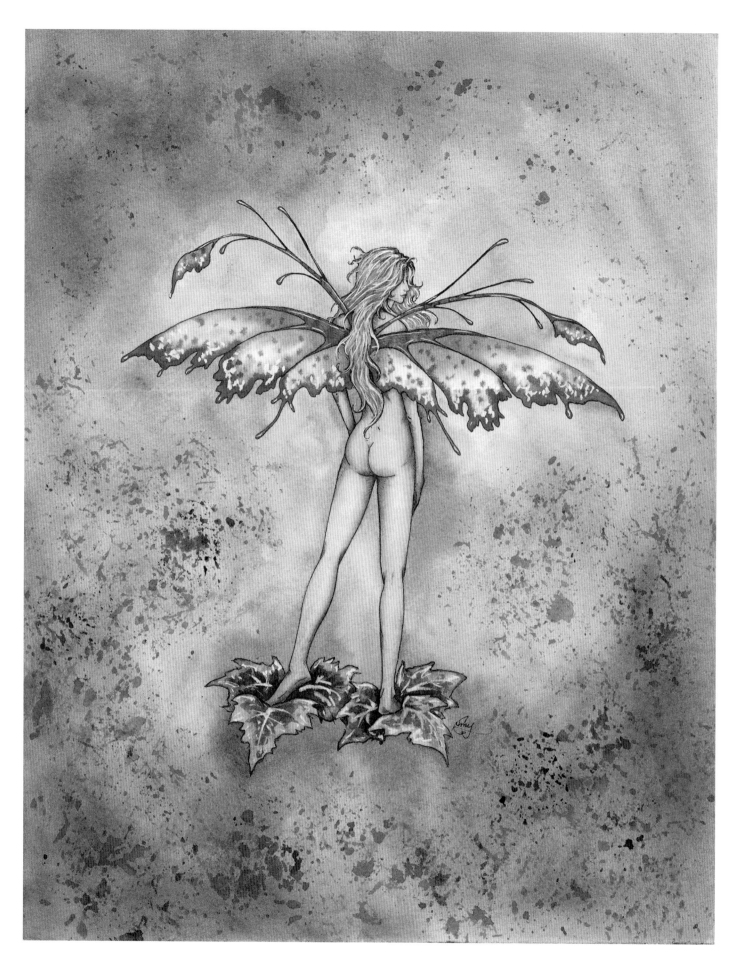

Green Faery

Green Faery...also known by my friends as the "Butt Faery."

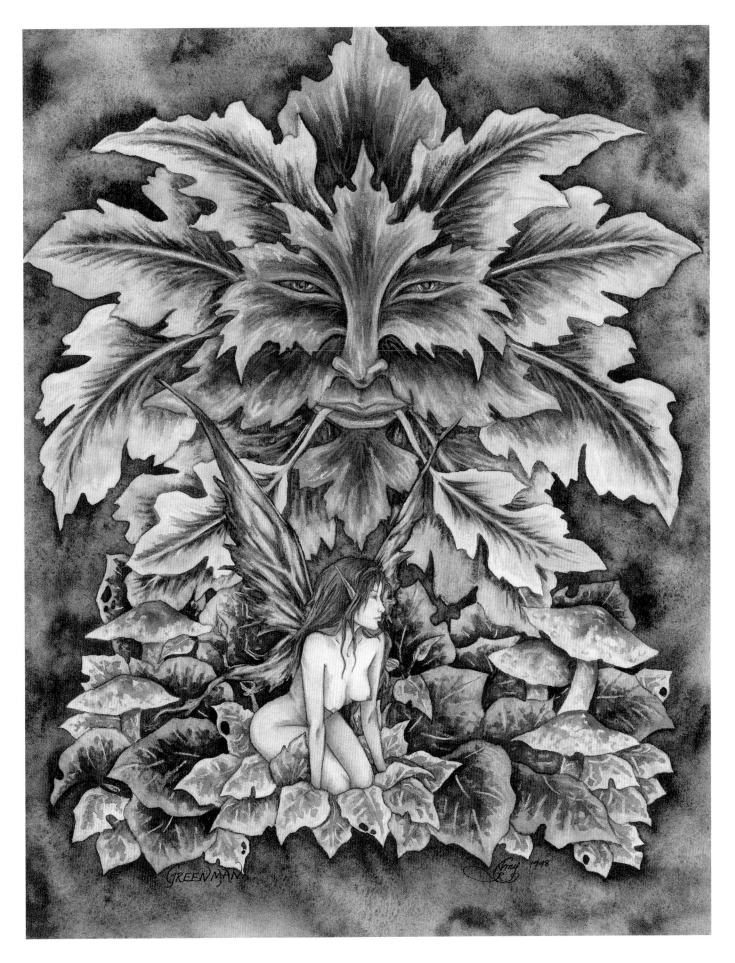

Green Man

I am very fond of the Greenman and have painted several versions of him in the past.

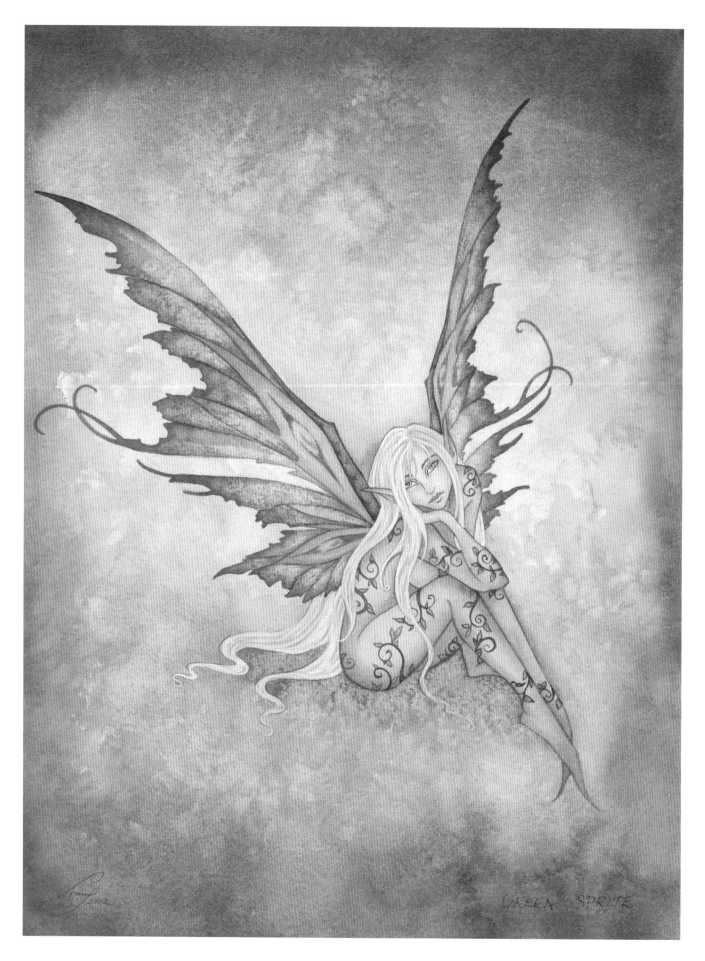

Green Sprite

I decided to paint Green Sprite simply because I realized I had not painted any green faeries in ages.

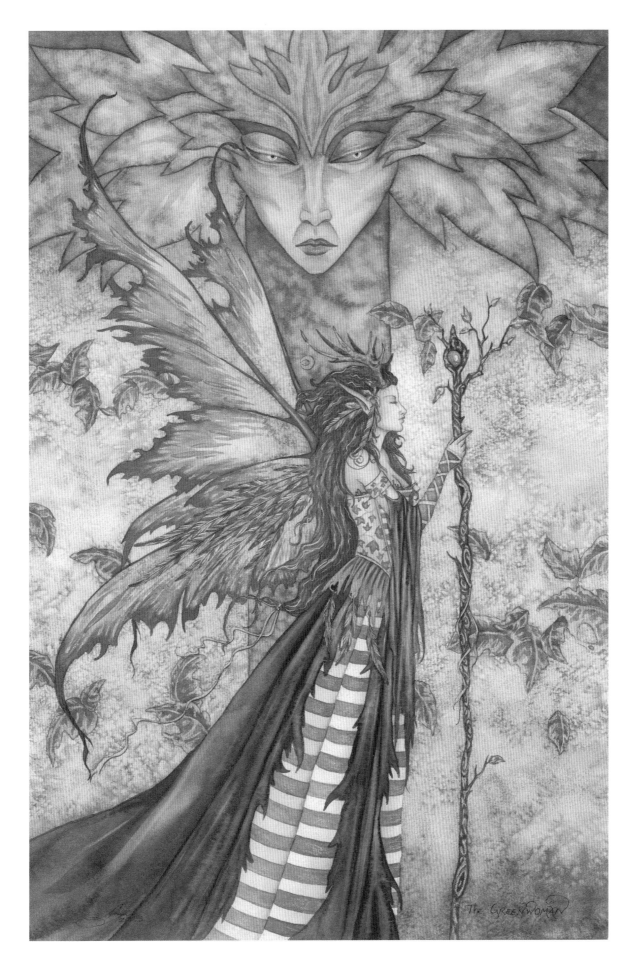

Green Woman

Green Woman is the feminine counterpart to the Greenman.

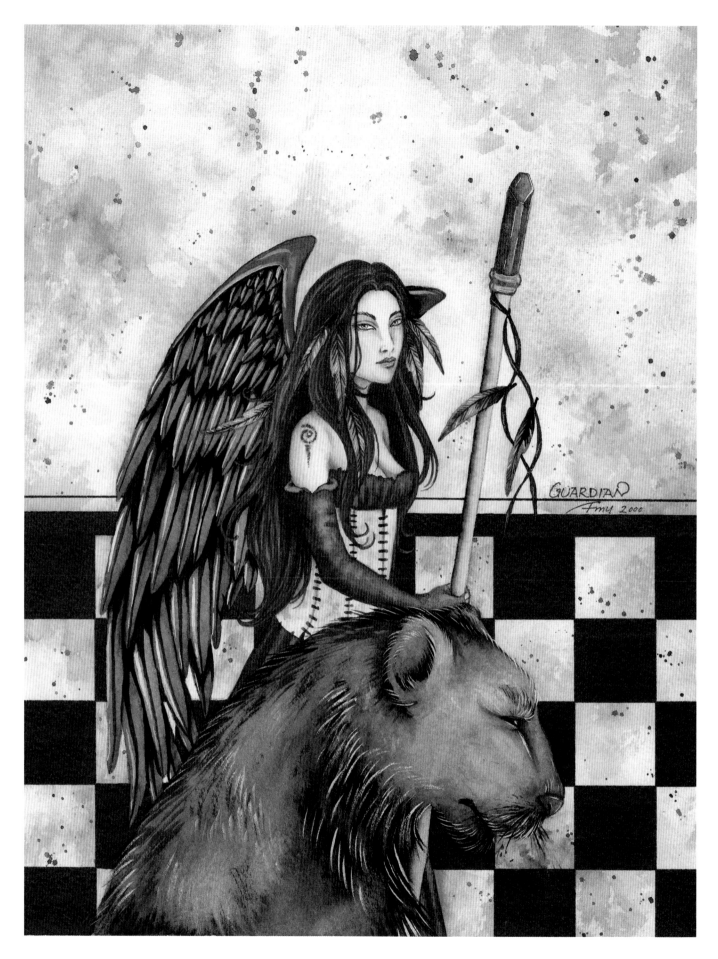

Guardian

Guardian was completed during my initial "dark-winged-angel" phase. I found myself putting these wings on nearly every painting I worked on for several months.

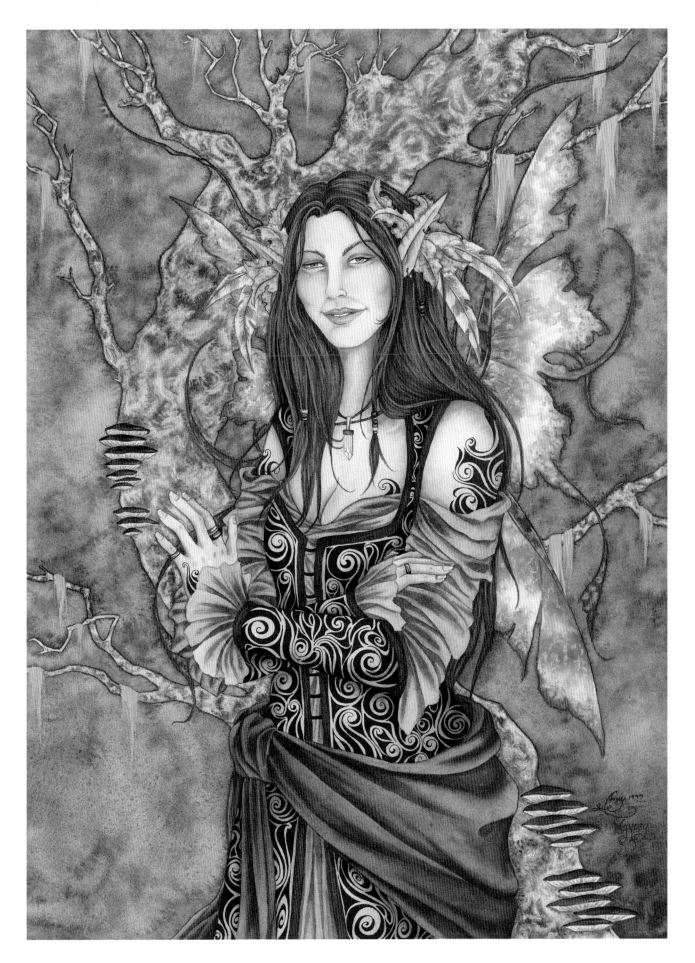

Gypsy
Gypsy was an experiment in facial expressions.

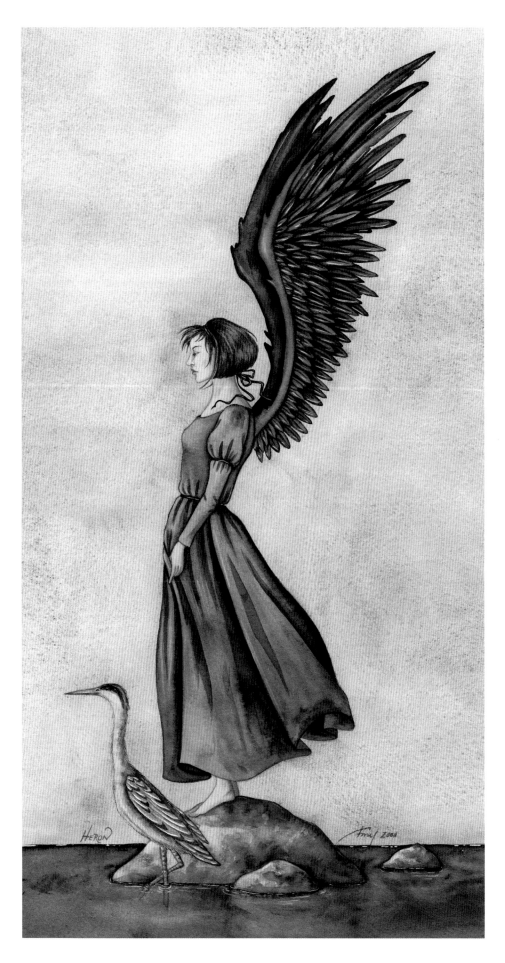

Heron

Heron was an attempt to branch off to a small degree from the faery theme. It has a slightly more contemporary feel, but is still fanciful.

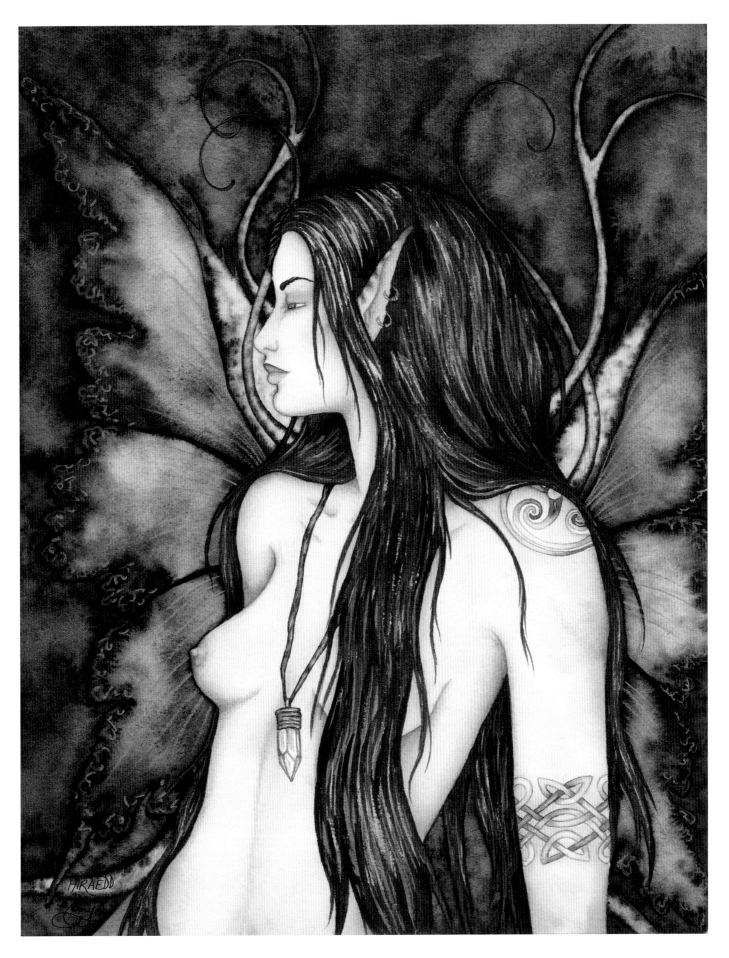

Hiraedd

I read a book once in which the author repeatedly used a Celtic word (hireadd), which she said meant "something that is longed for but cannot be attained." I think that says it all....

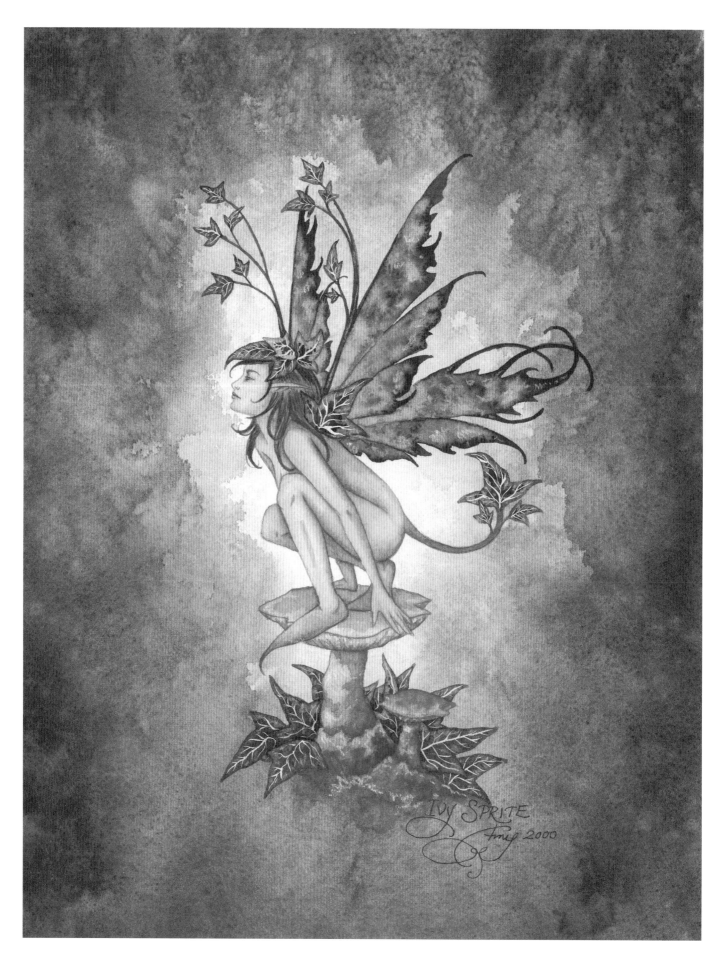

Ivy Sprite

In Ivy Sprite, I wanted to paint a creature that seemed to blend in with nature.

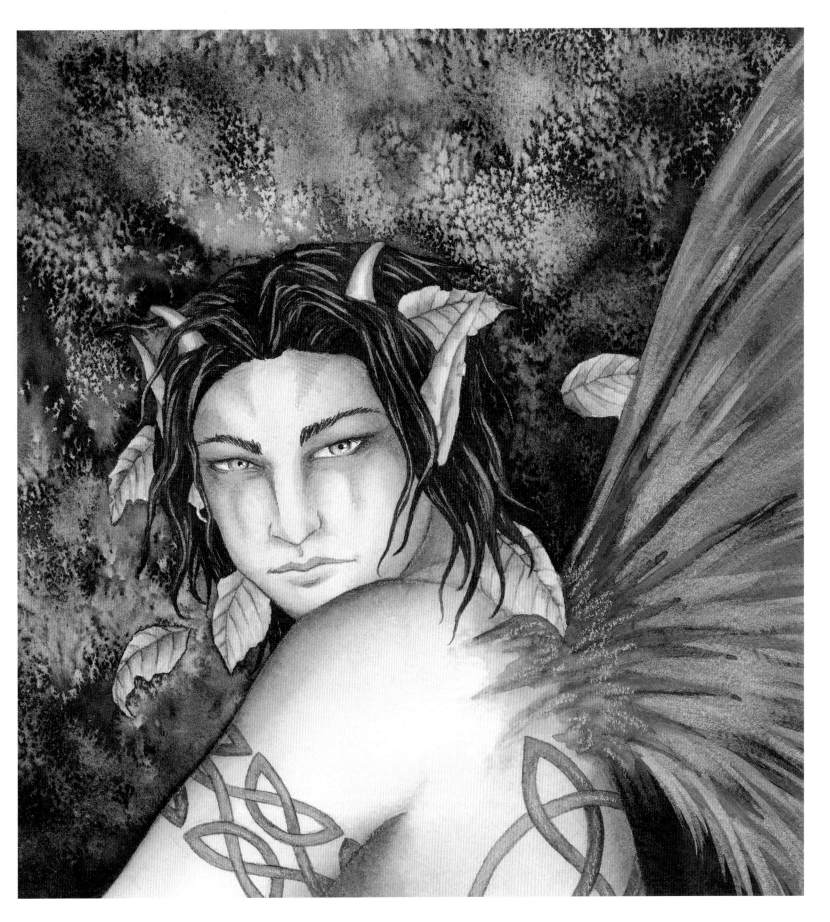

Jack

Jack is the forest boy, Jack of the Green, wild and free. I imagine he has broken many hearts and will continue to do so.

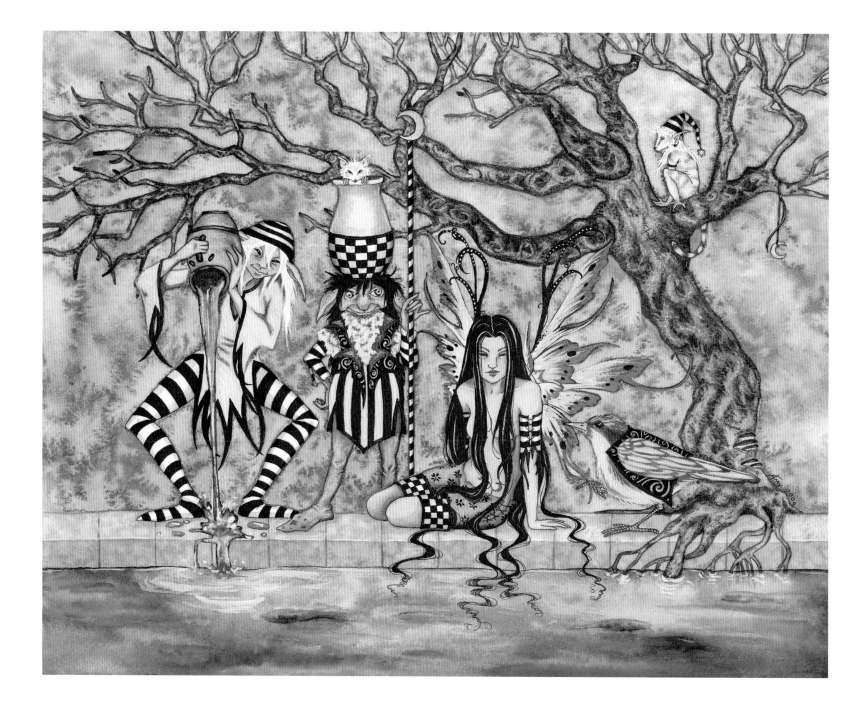

Koi Watchers

This group is tending the koi pond—not working very hard by the looks of it. The bird is trying to boss everyone around, but no one is listening to him, as usual.

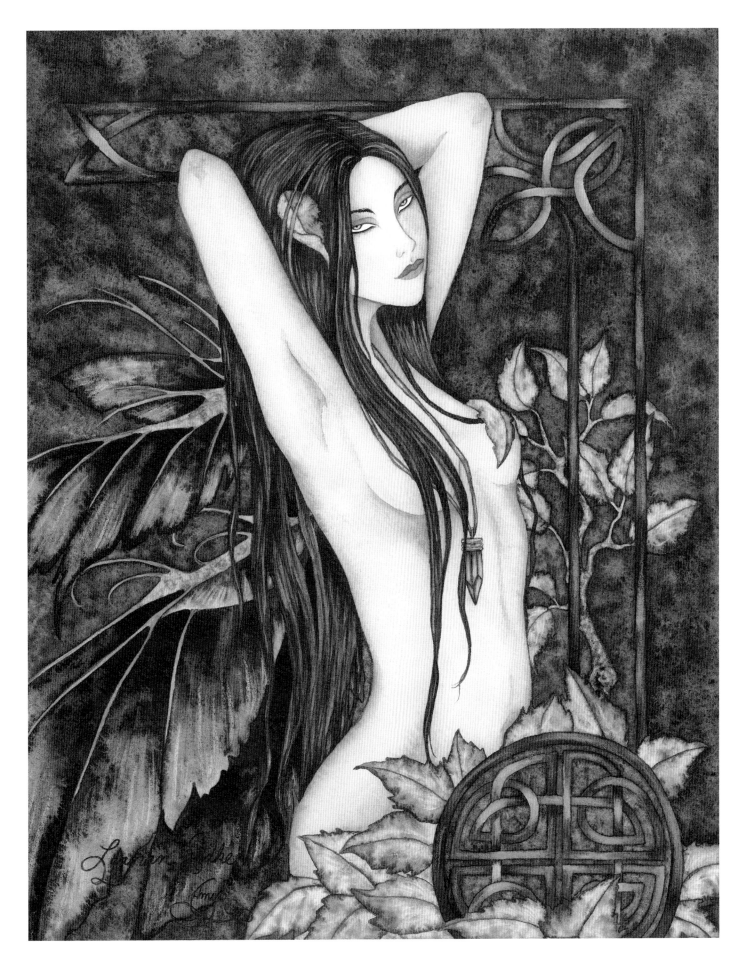

Leannan Sidhe

The Leanan Sidhe is a dangerously seductive creature. She sucks the spirits of artists, poets and musicians.

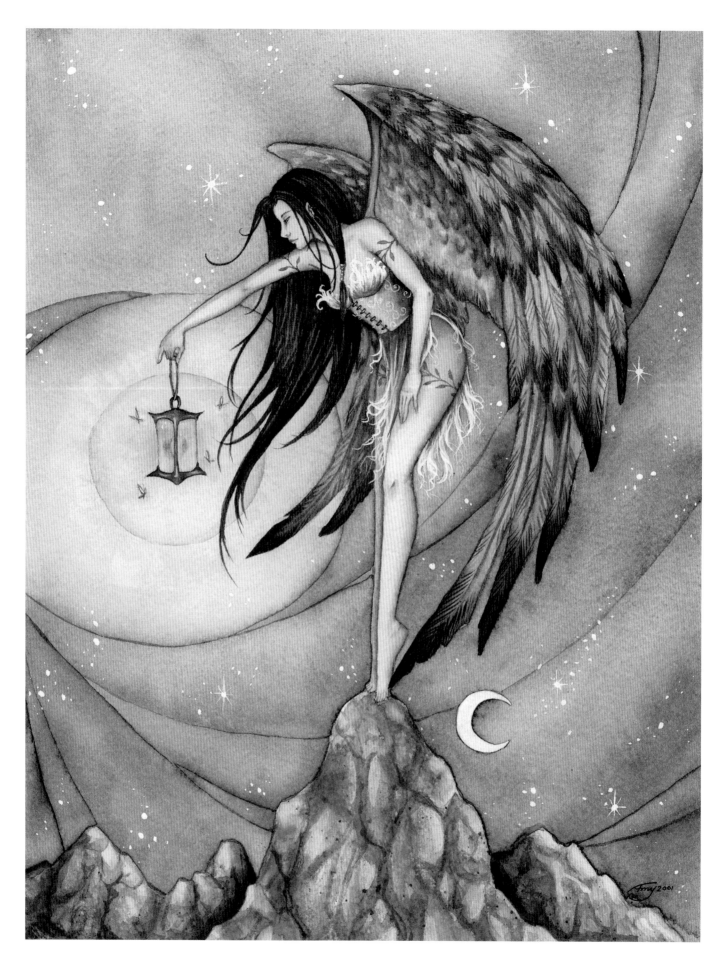

Lighting the Way

This angel guides us to our destinies.

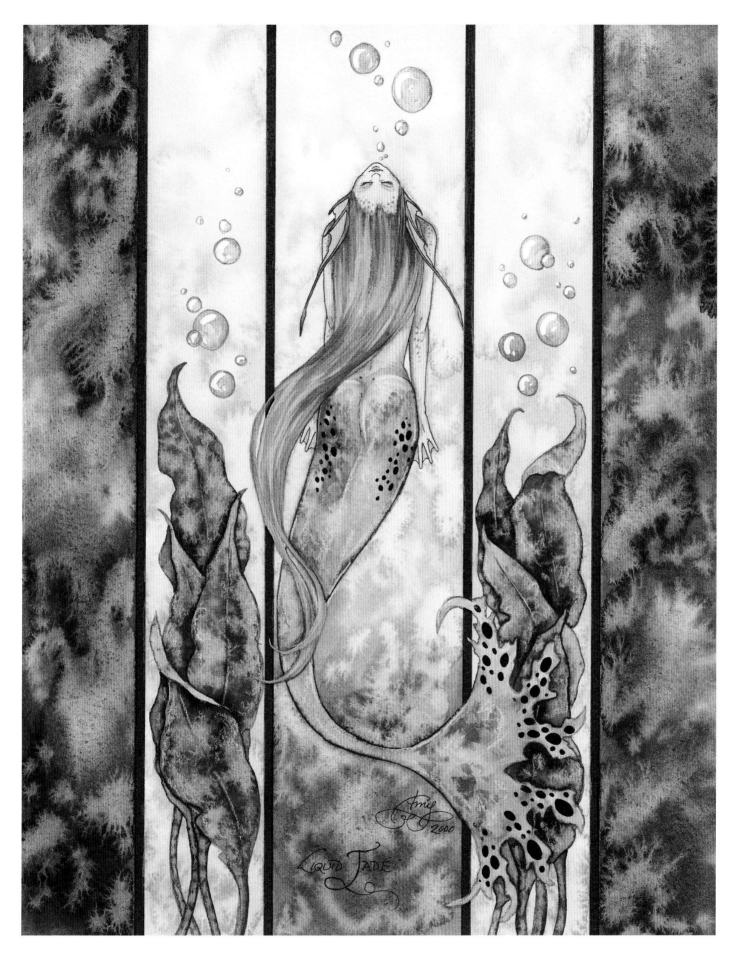

Liquid Jade
Another painting from the gem stone mermaid series.

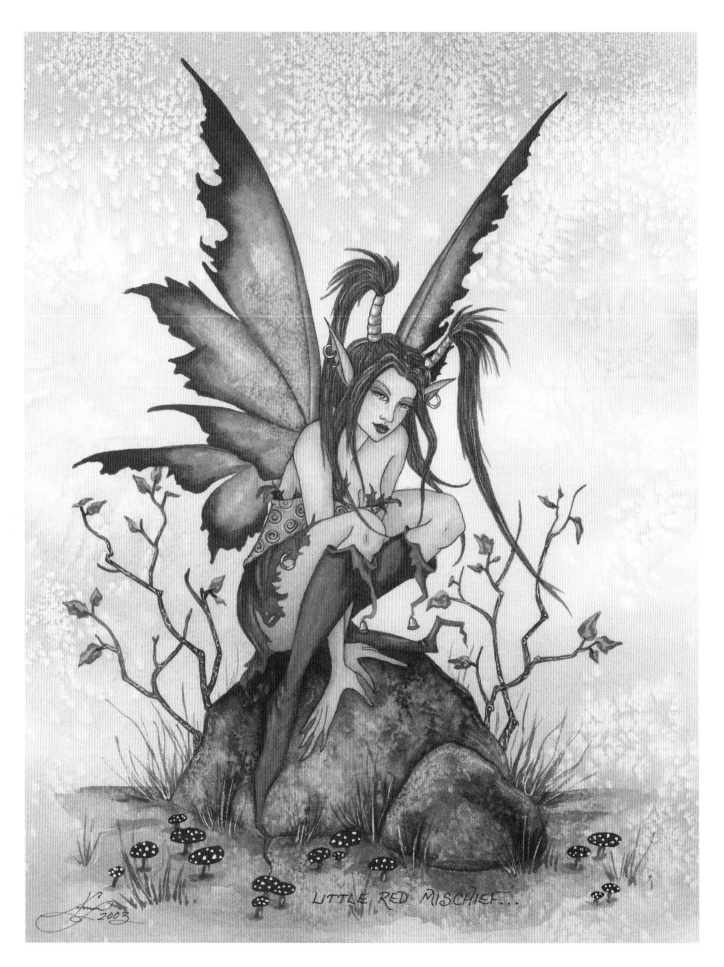

Little Red Mischief

It is said that red-haired people have faery blood. Faeries are notoriously mischievous. I'd say by the color of this little creature's hair, one would be wise to stay far away from her.

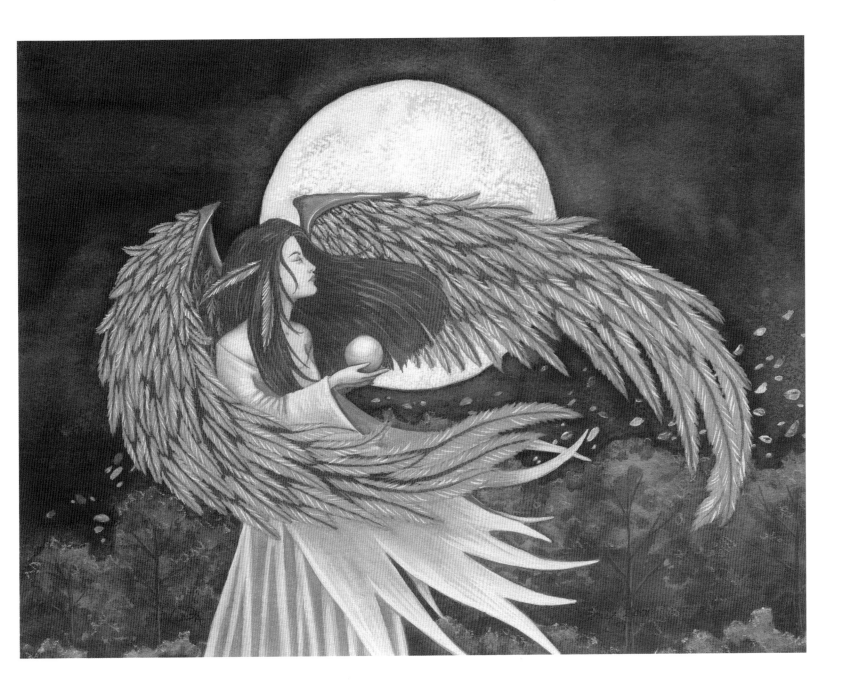

Luna

So many of my angels have been painted with dark wings, I decided to do one with brown wings. She is surrounded by warm, autumn colors. The full moon adds a touch of mystery.

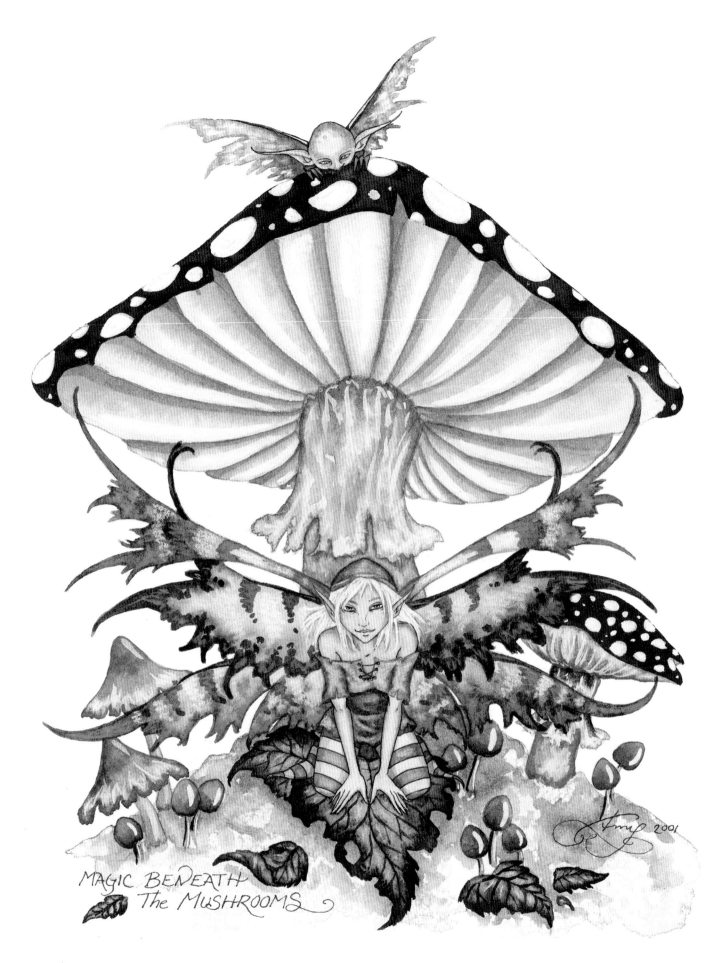

Magic Beneath the Mushrooms

Can you imagine what could be hiding under all those mushrooms growing in the woods...or in your back yard?

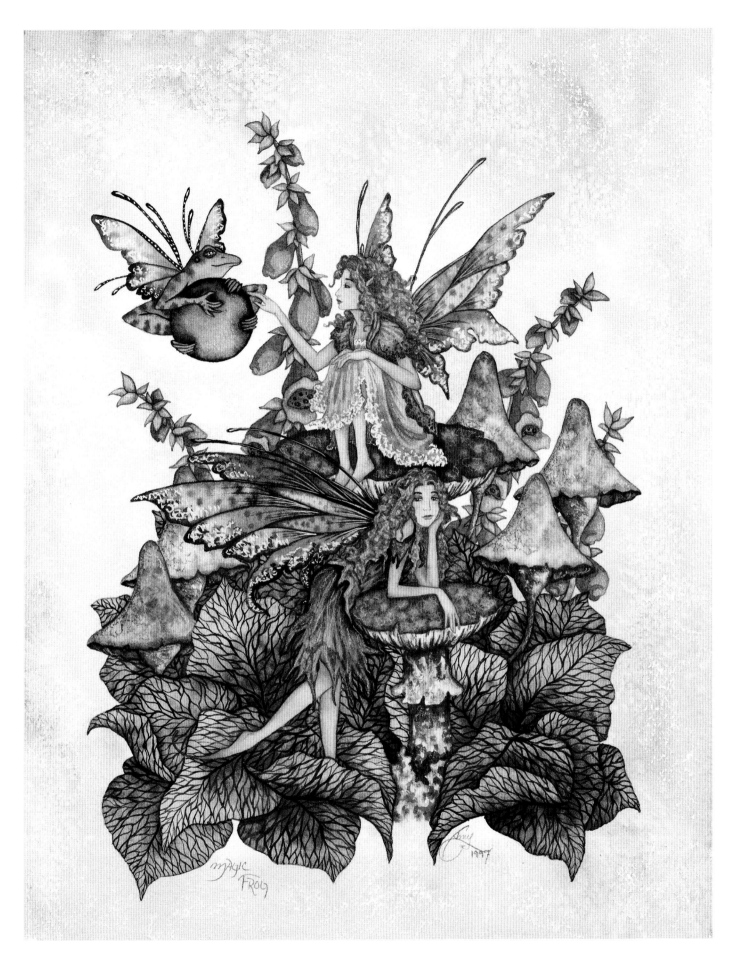

Magic Frog

One wonders what magic powers the frog possesses.

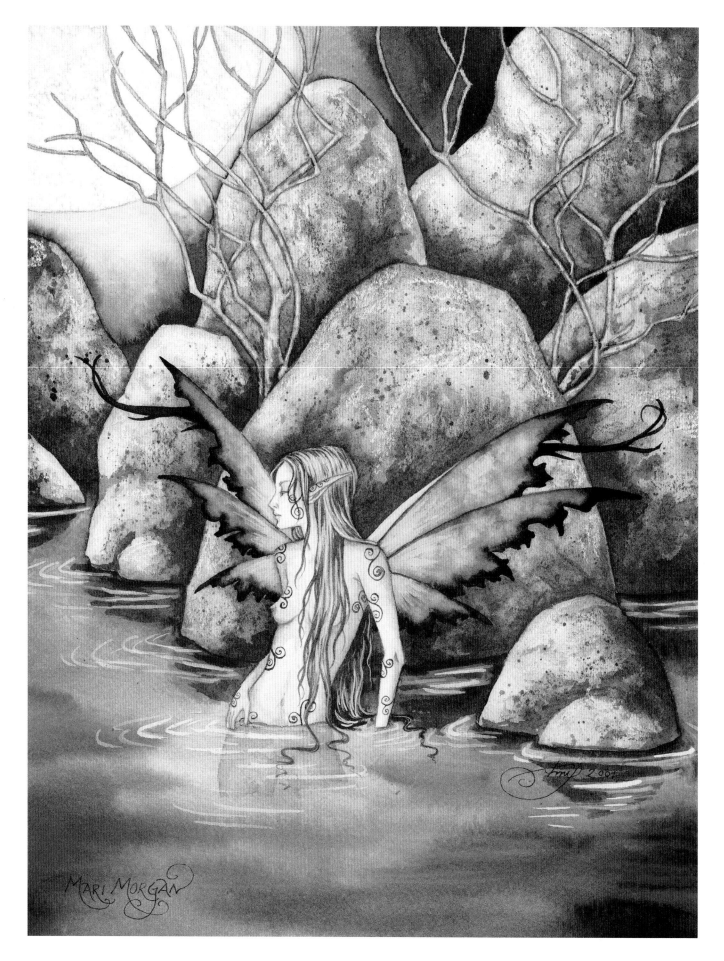

Mari Morgan

Mari Morgans are water spirits.

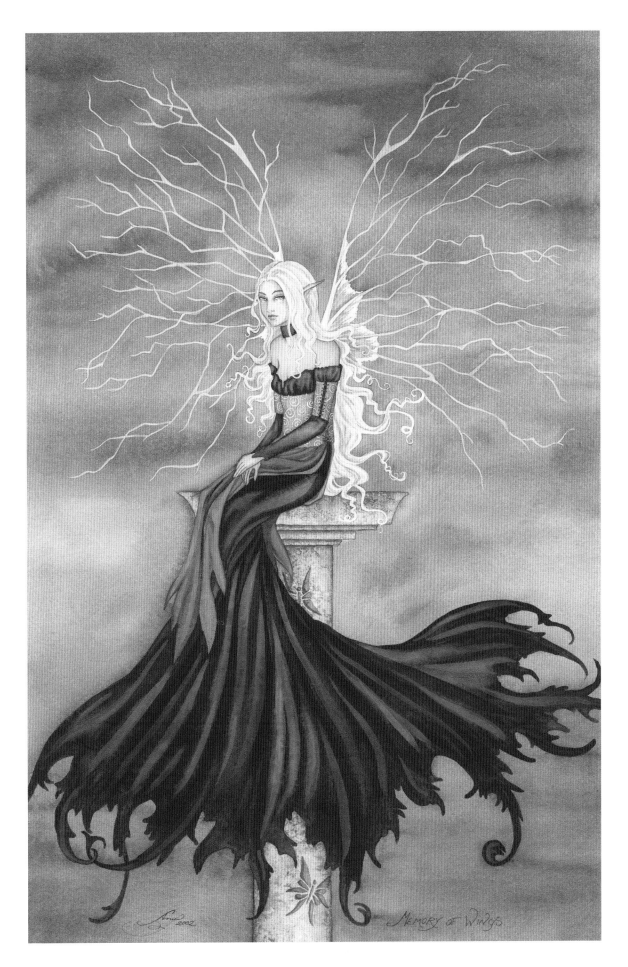

Memory of Wings

Memory of Wings is not necessarily meant to be a sad image; though that's the way it turned out.
The faery sits and remembers a time when she had wings. I am hoping her situation is not a result of
humanity's lack of belief.

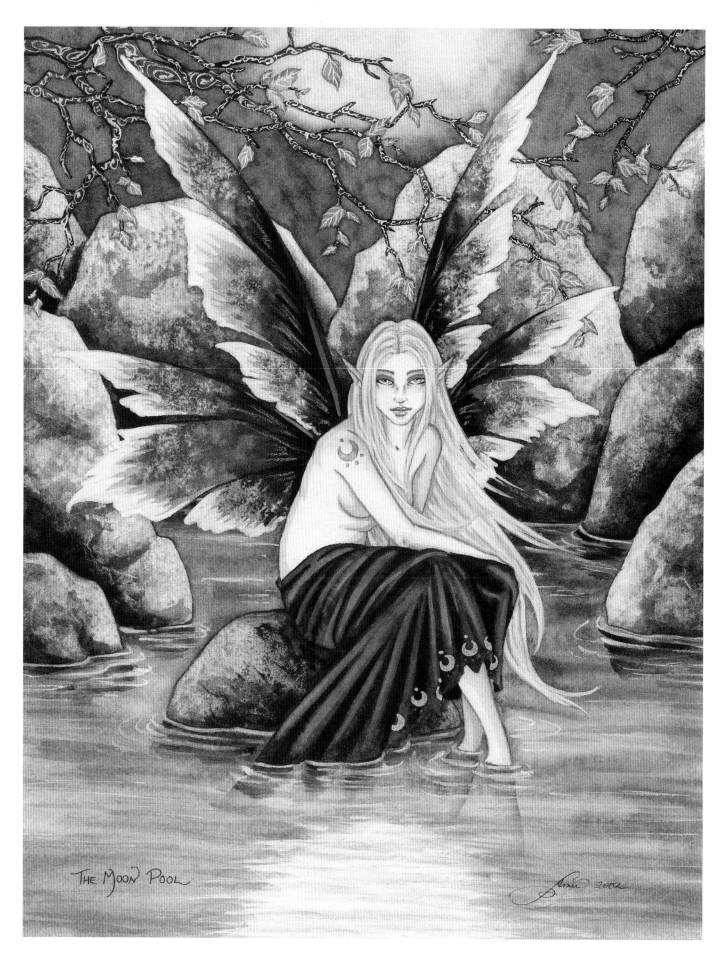

The Moon Pool

The Moon Pool

Midnight...a full, shining moon above, light dancing softly on the water.

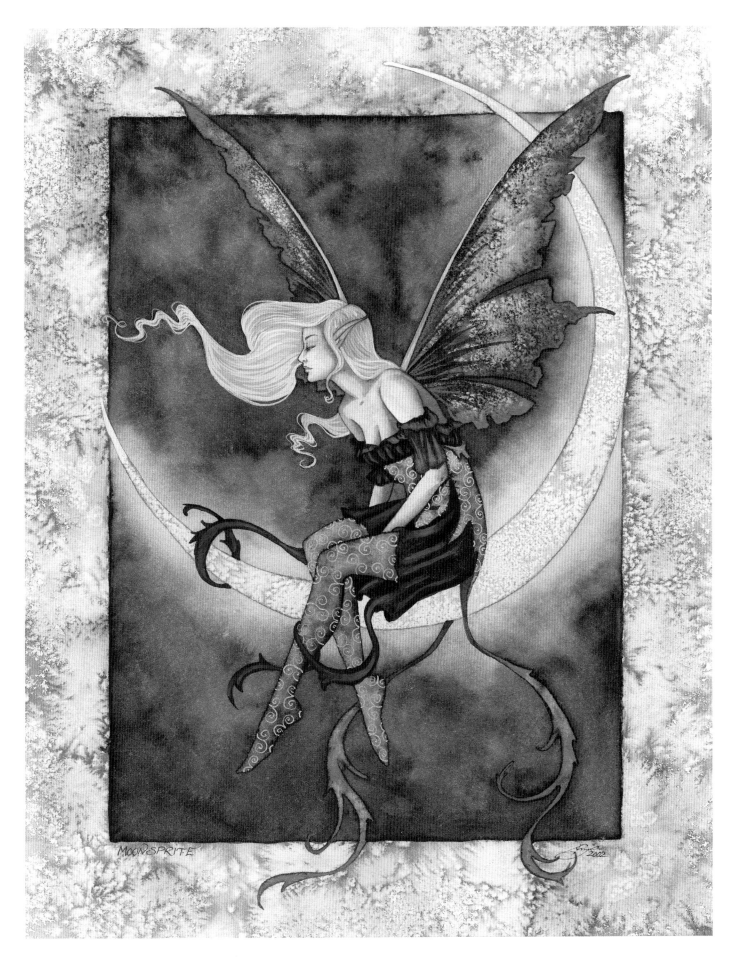

Moonsprite

The pose in Moonsprite is a variation on the pose from Wings Like Sunsets. I often use similar poses in several different paintings, as there are so many possibilities to explore.

91

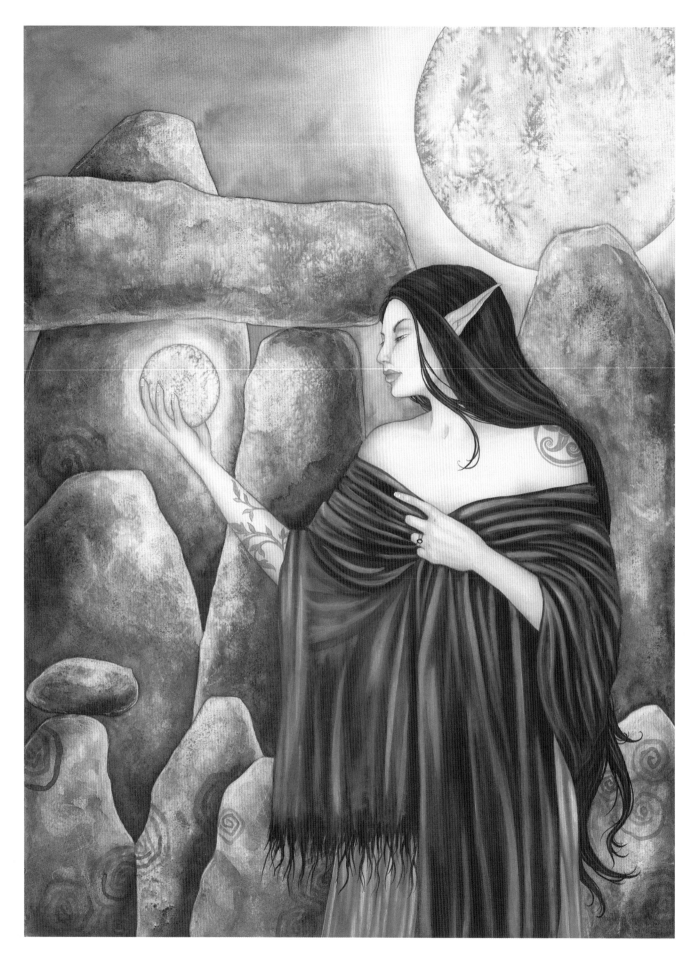

Moonstone

Moonstone portrays an Elvin priestess performing magic under a full moon.

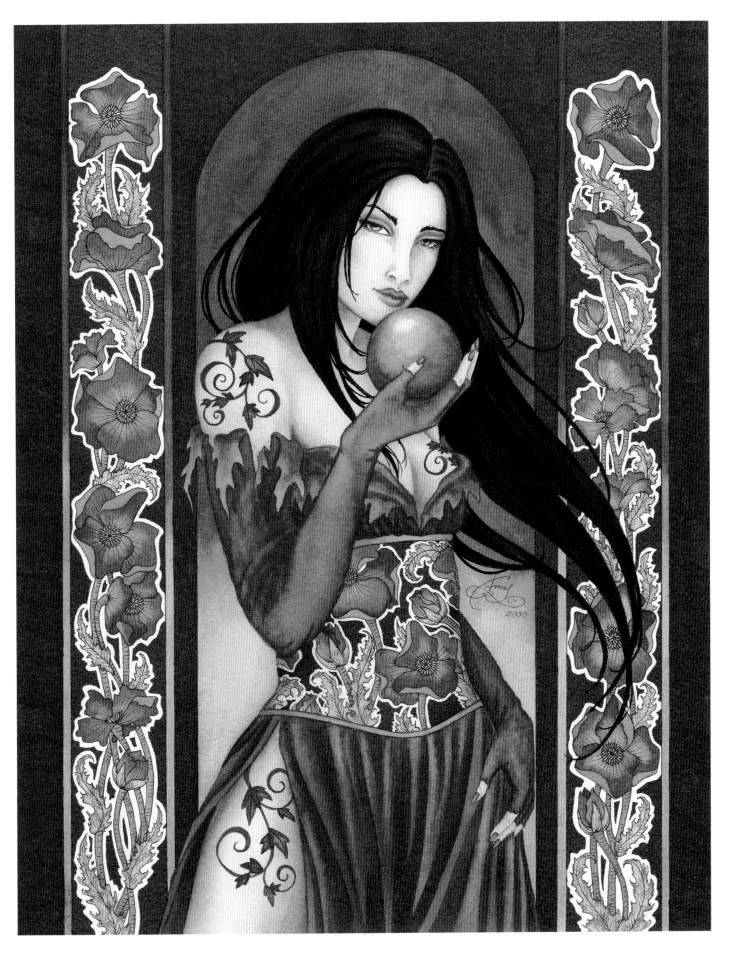

Morgana

Morgana is a character I paint over and over again. She is the dark enchantress, half sister to King Arthur, and some believe of faery descent. She is seductive, mischievous and powerful.

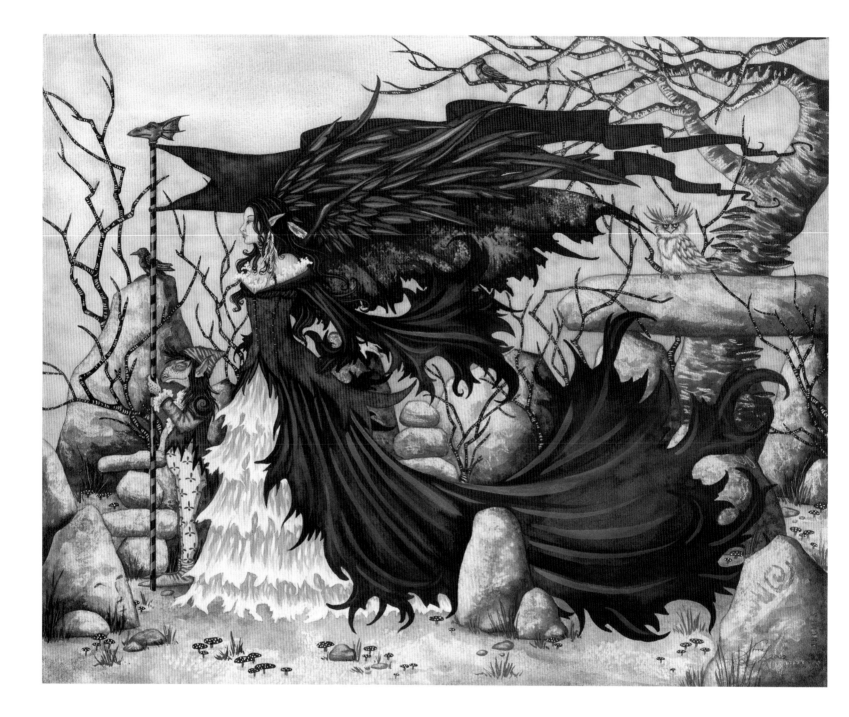

Morgan Le Fey

Also known as "Memories of Avalon." While scribbling on a piece of paper one day, I came up with the dress for this piece. Immediately I decided I had to fit it into a painting somehow. This was the result.

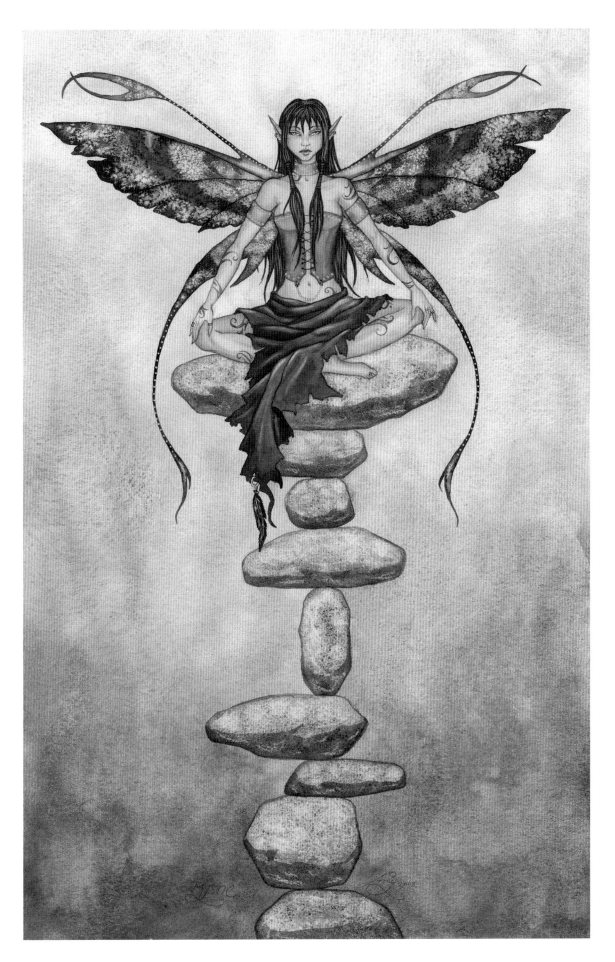

Mystic

Mystic was inspired by a bronze statue I saw one day.

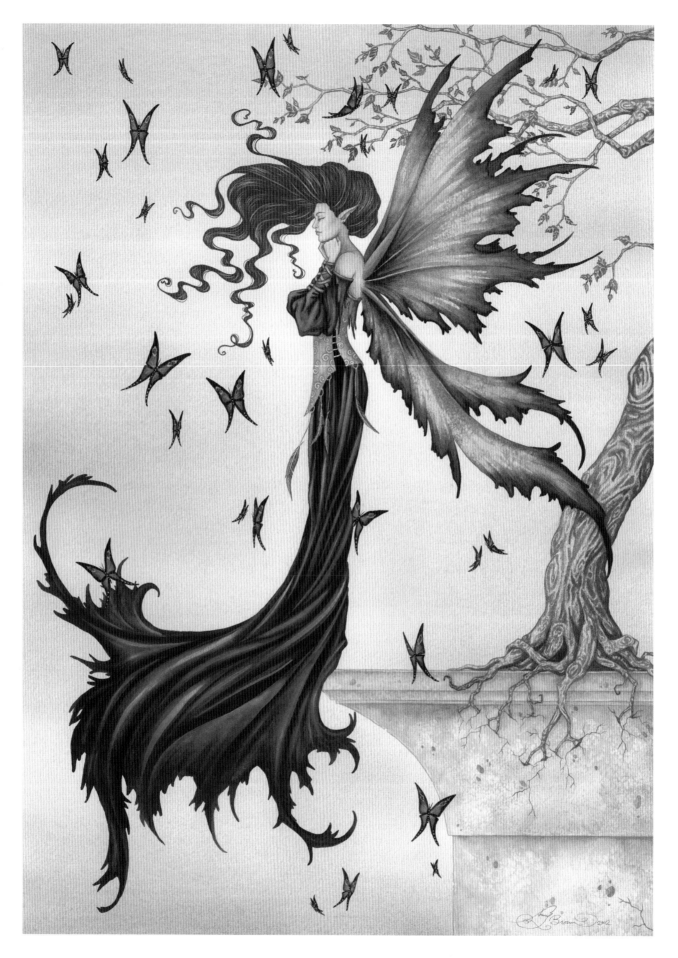

Mystique

"Mystique" is the companion piece to "Summons." Both images are much larger than I normally am comfortable painting. I was very pleased with the way they turned out and later painted "Rook" and "Euphoria," which have the same feel, but are smaller pieces.

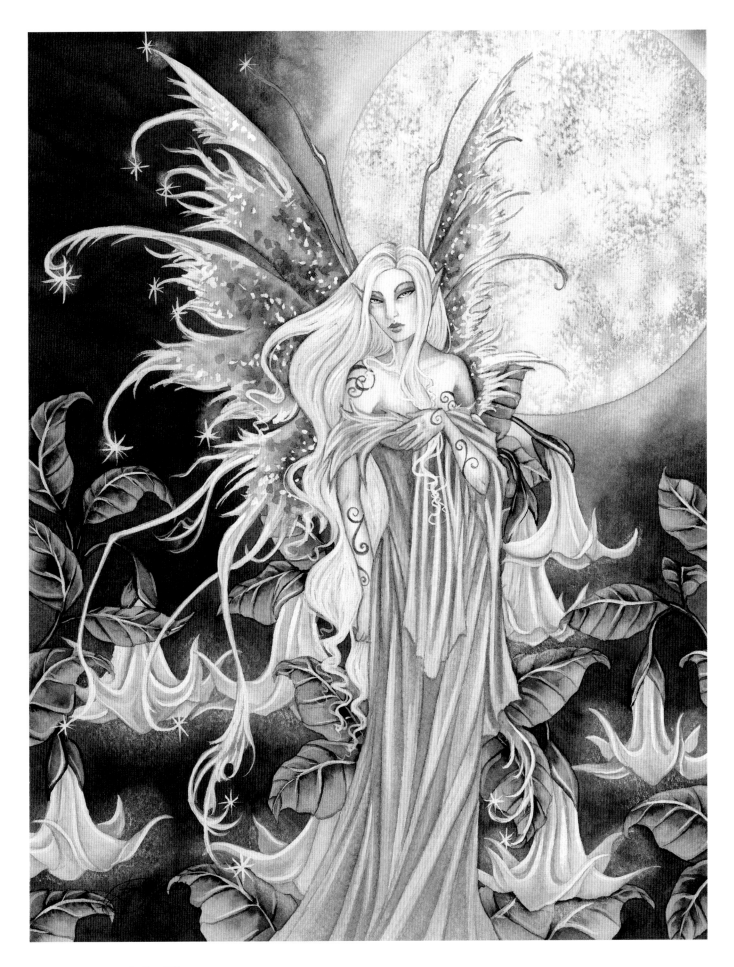

Night Blossom

A note card I bought several years ago inspired the flowers in Night Blossom. It depicted a dragon slumbering, surrounded by large, glowing blossoms.

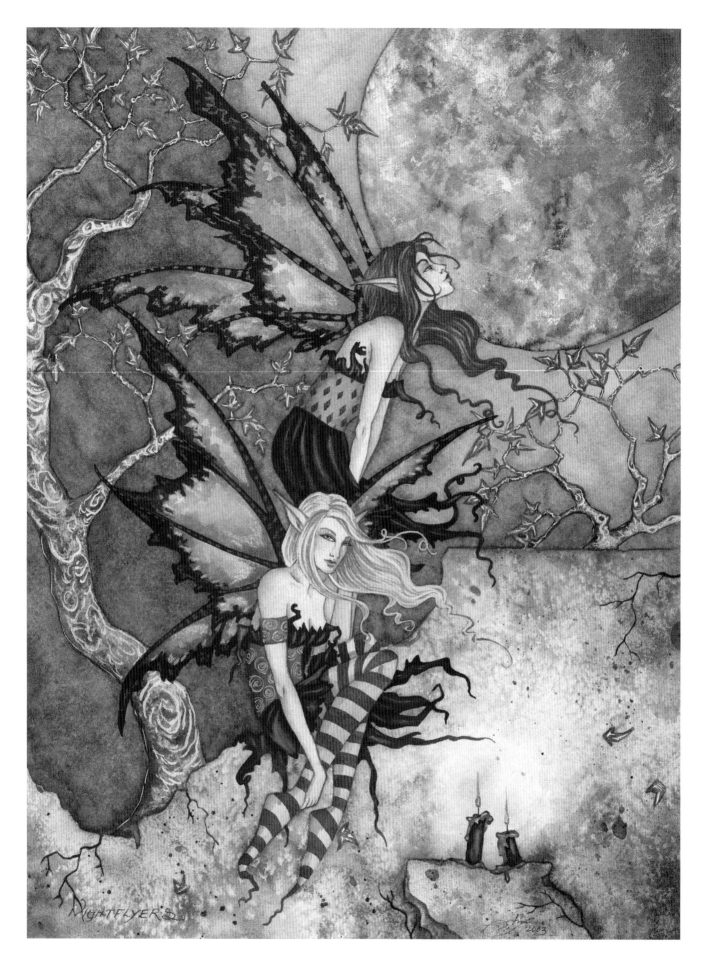

Night Flyers

I began this piece with the intention of titling it "Lightning Bearers." The painting was supposed to look different than how it eventually turned out. This goes to show how often the completed image can be different from the image I originally intended to create.

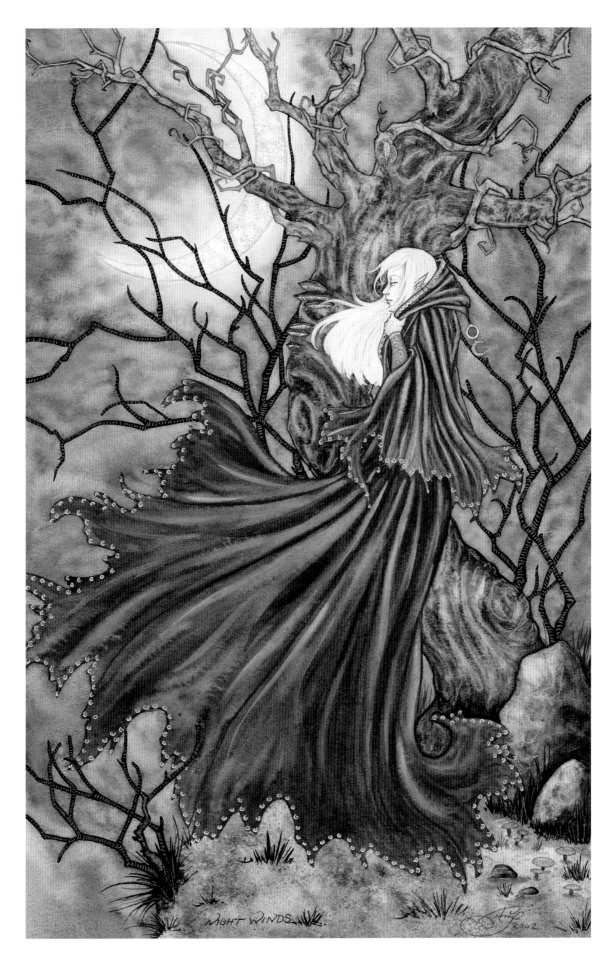

Night Winds

Night Winds is another installment in the Elf series. This character stands at the edge of a cliff as the wind rushes past.

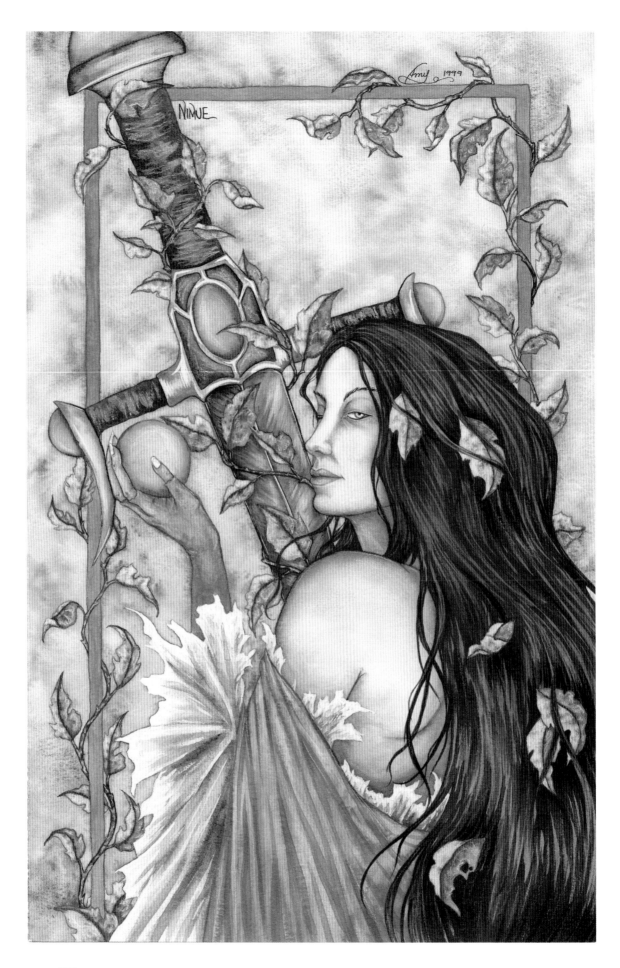

Nimue

Nimue is from Arthurian legend and is accompanied here by the sword, Excalibur.

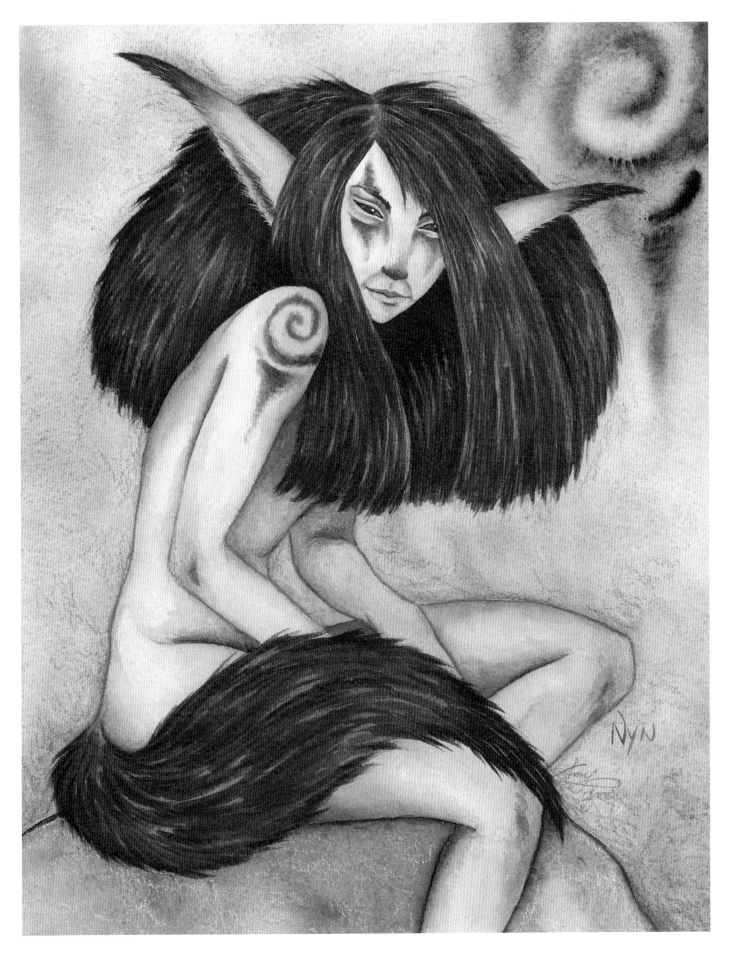

Nyn

I spent a week once trying to create interesting faery creatures. Nyn was one of the results.
She is a cousin of foxes.

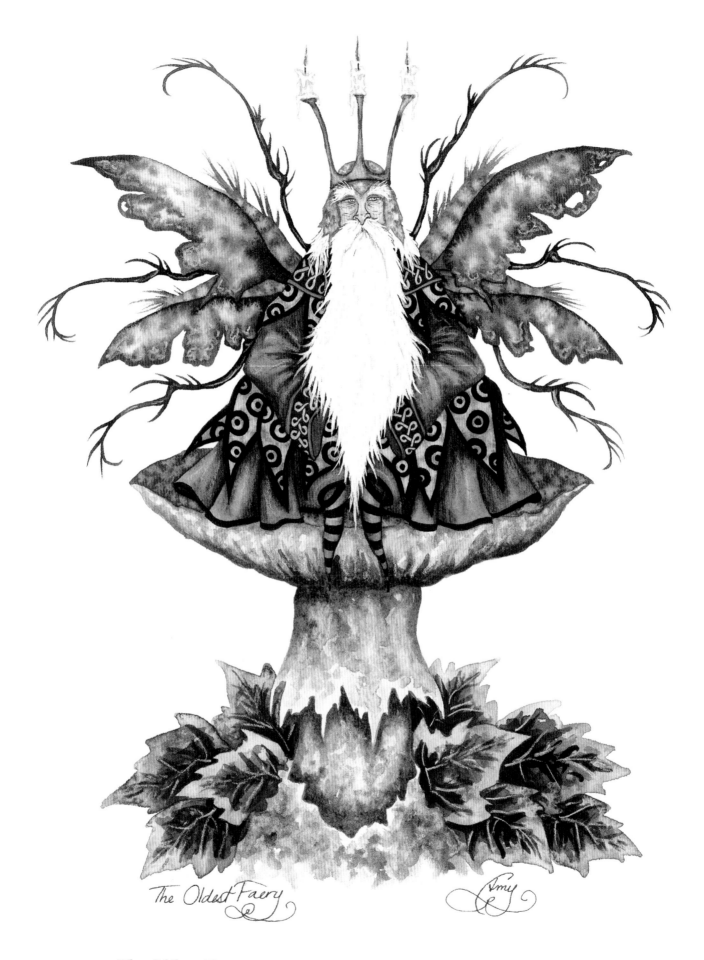

The Oldest Faery

Don't ask him how old he is...he'll never tell. All you need to know is that he's the OLDEST faery of them all.

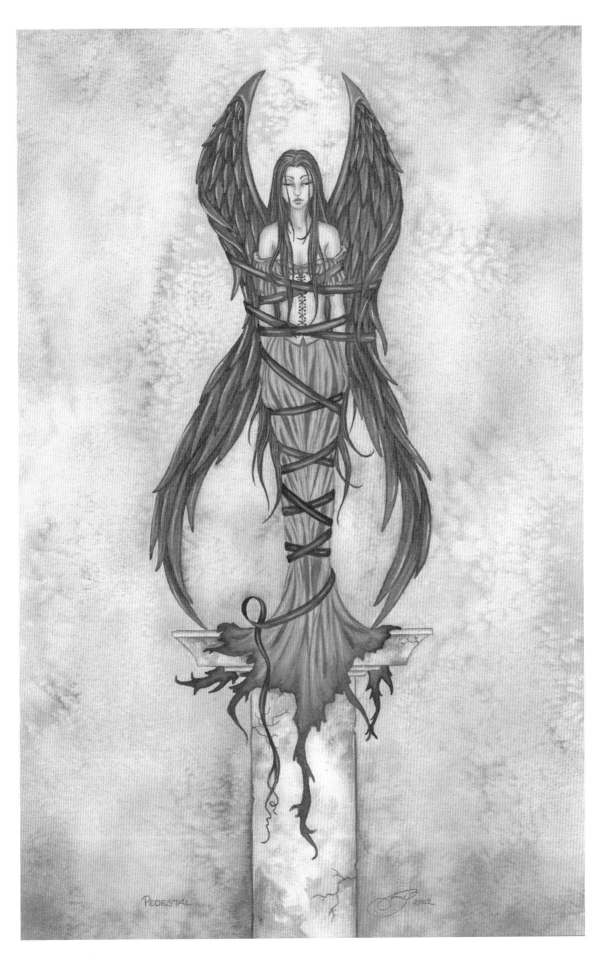

Pedestal

Before you feel sorry for the bound faery on the pedestal, notice that her binding has not been secured properly. She might free herself at any moment.

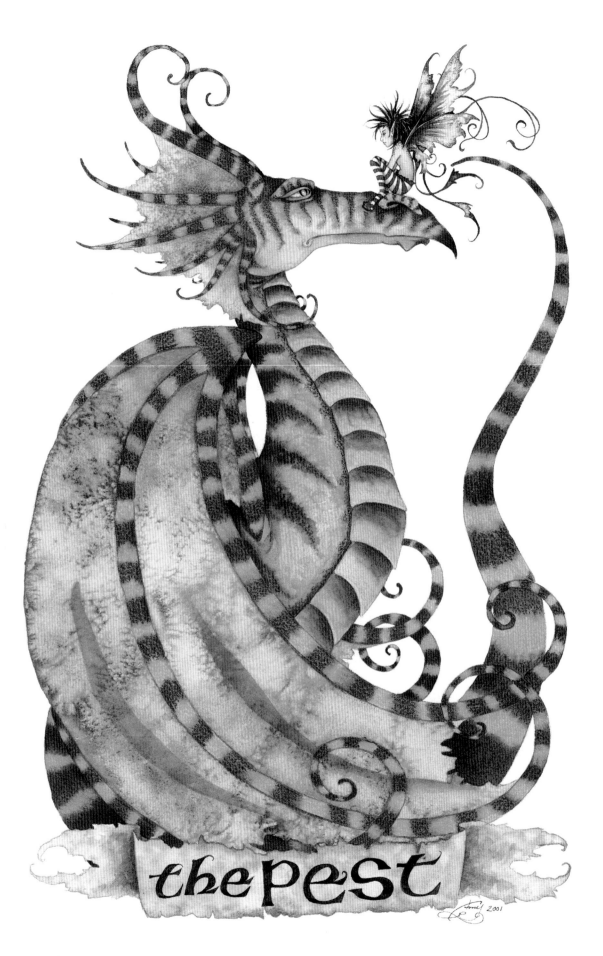

The Pest
The Pest was created during another one of my humorous moods.

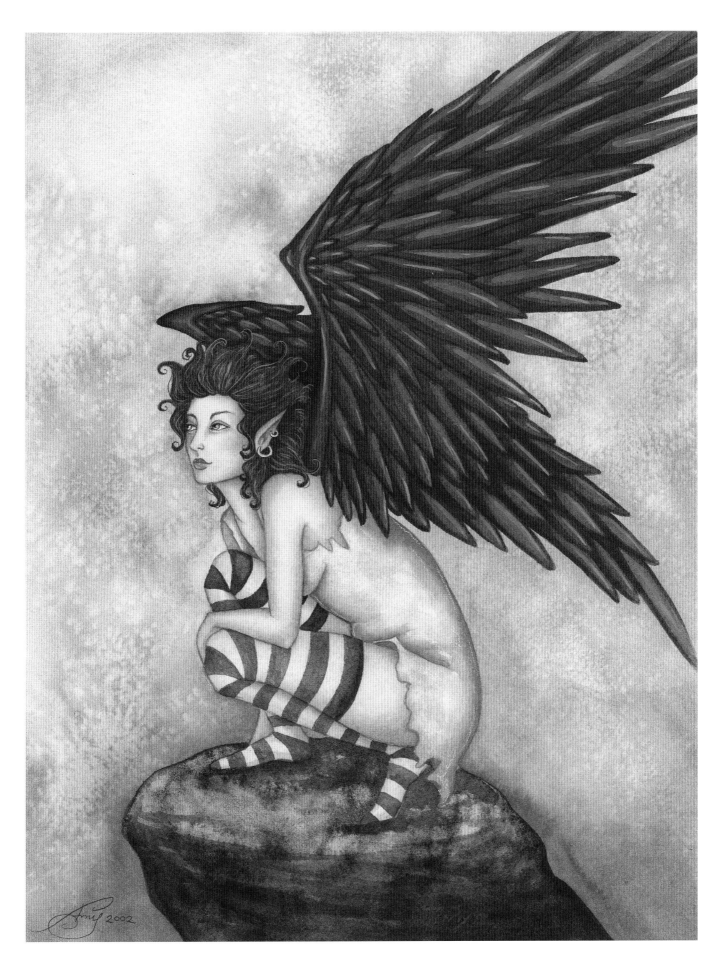

Phoenix II

Phoenix II was inspired, in part, by Charles de Lint's writing. In his book, Some Place To Be Flying, he writes of Crow Girls. The imagery of women with great, feathered wings has stuck with me ever since. Phoenix is strong and free spirited.

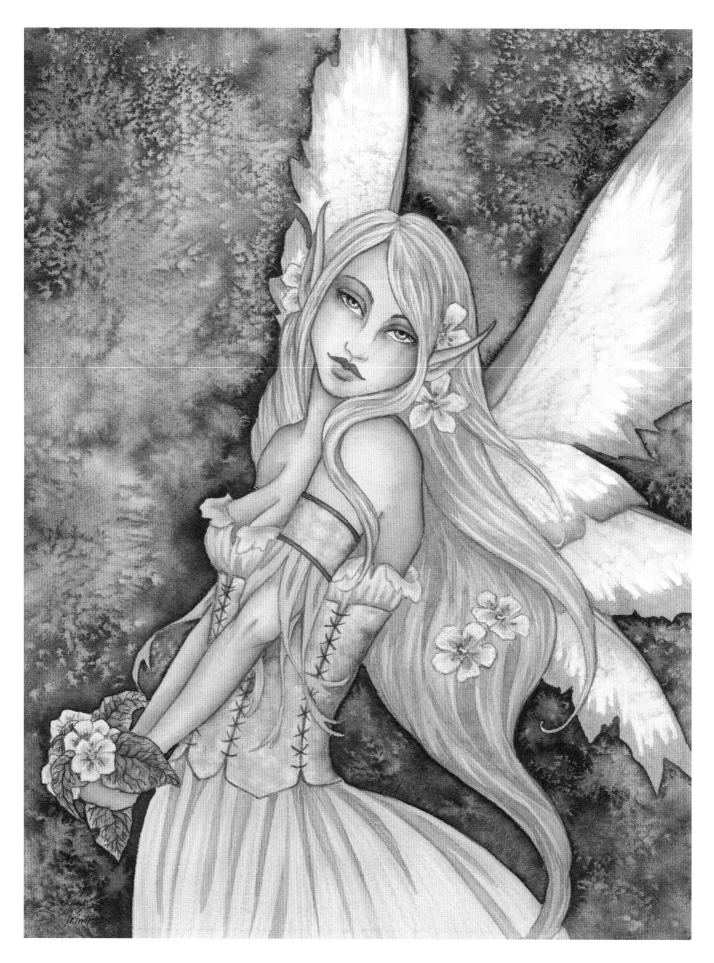

Primrose

Primrose is a sweet faery. Her large, liquid eyes enchant all who see her.

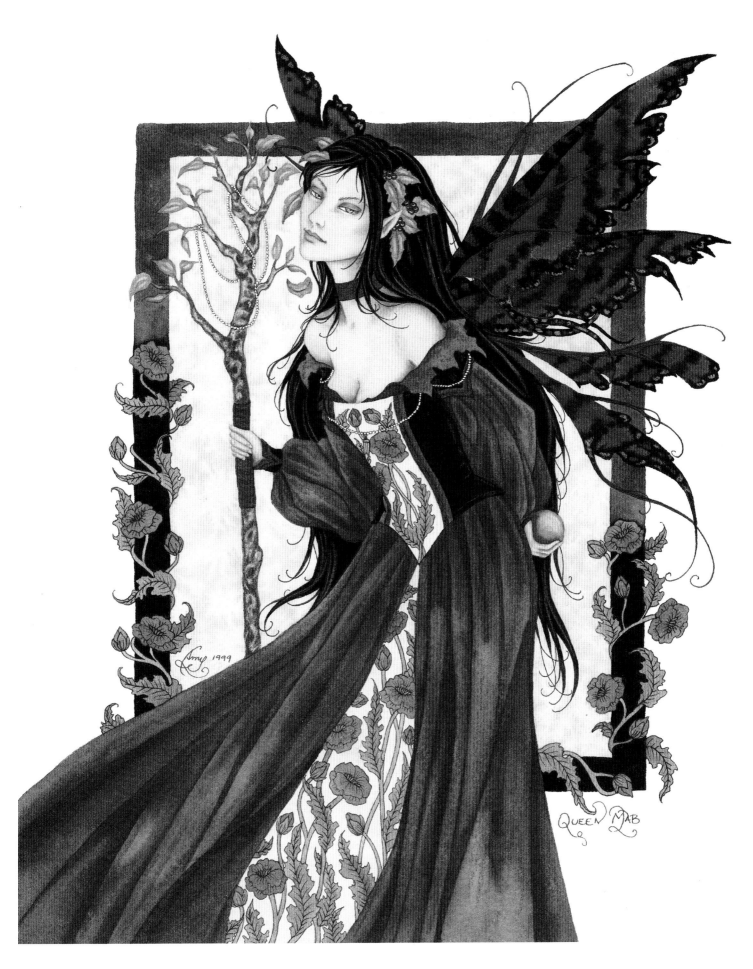

Queen Mab

Queen Mab is a character I have to paint frequently. She is quite vain and demands to be painted over and over again.

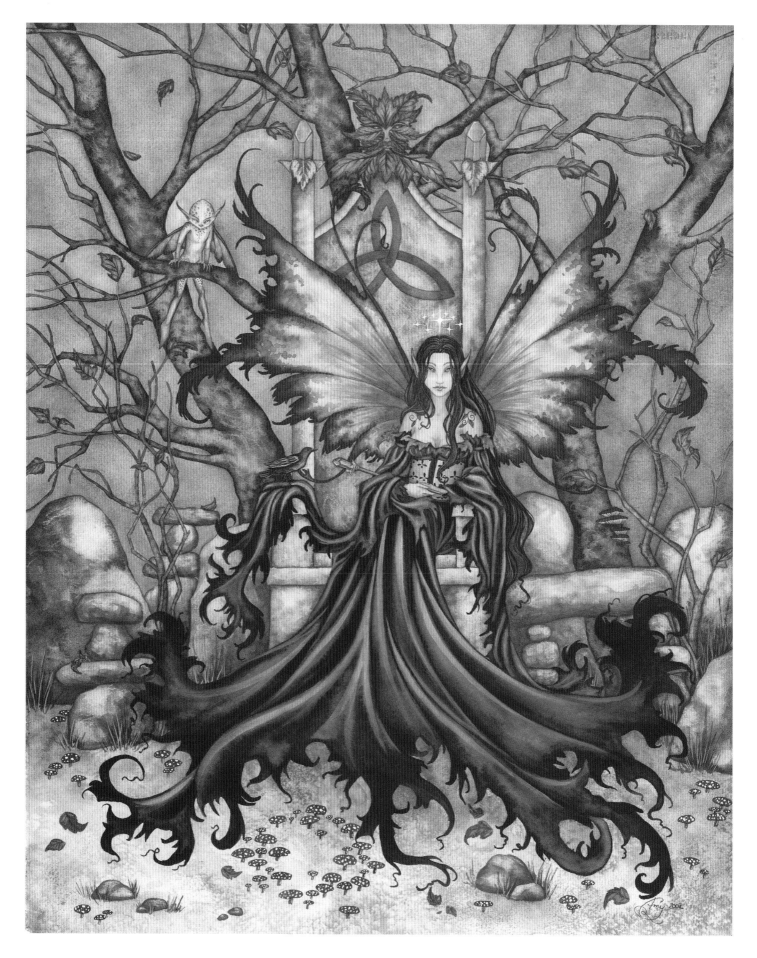

Queen Mab

Once again, Mab has demanded an appearance.

108

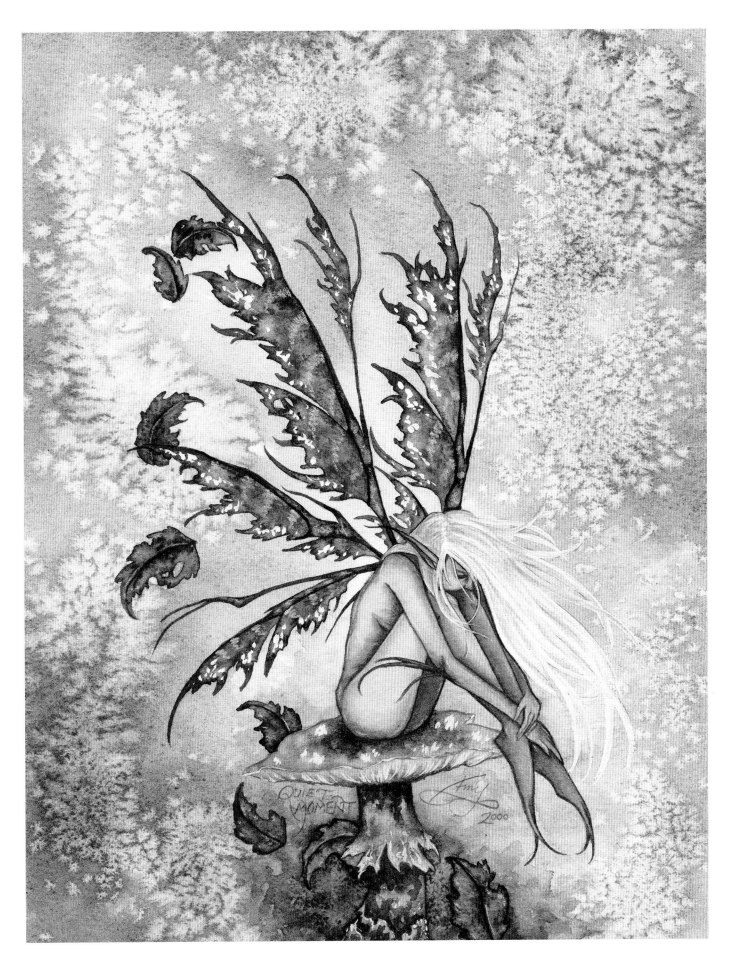

Quiet Moment

Another solitary faery.

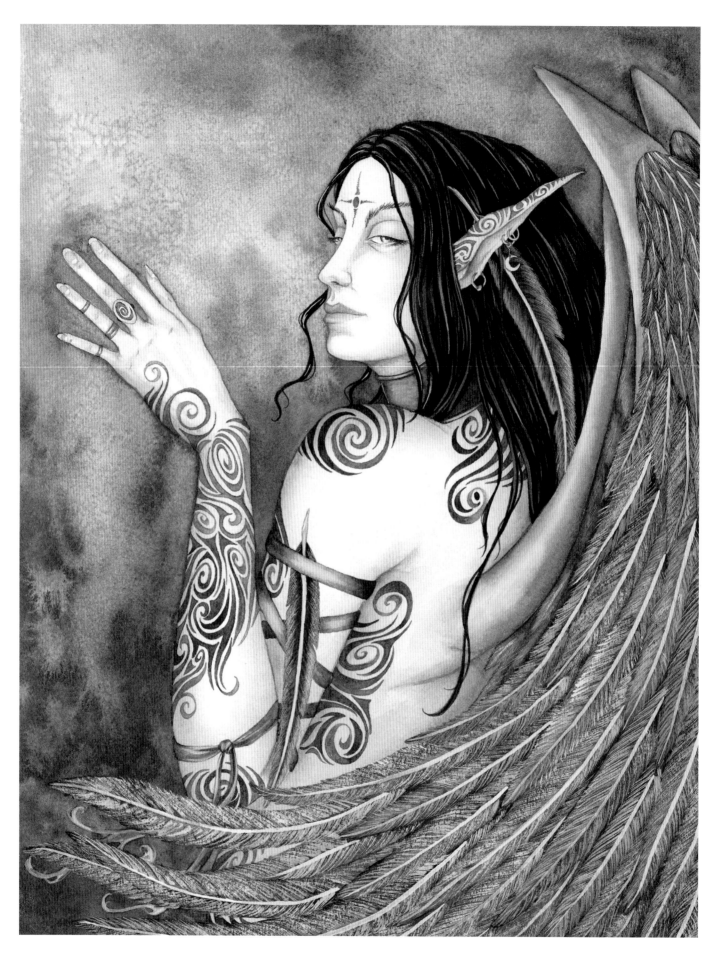

Raven

Raven is another dark angel. She is a companion piece to Evangeline.

110

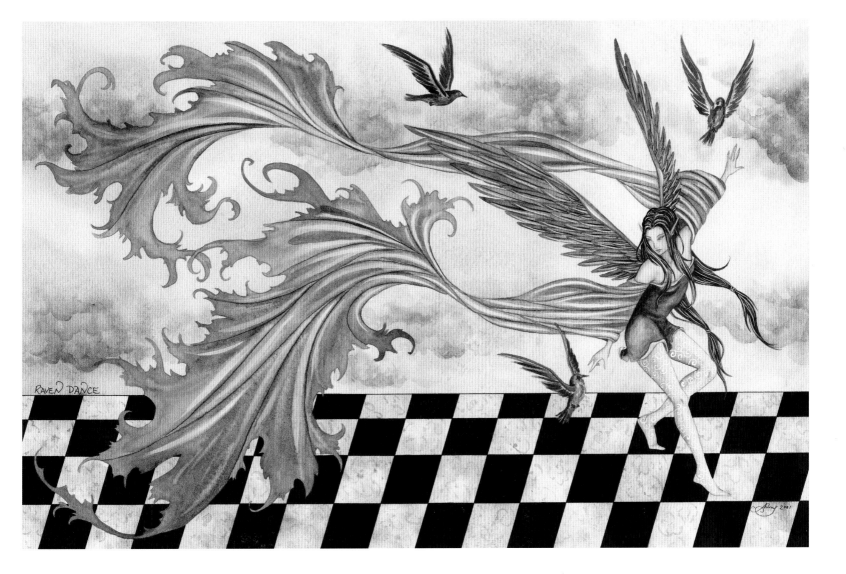

Raven Dance

Raven Dance originated from a scribble I did on my drawing table. The doodle stuck with me and I decided to bring it to life.

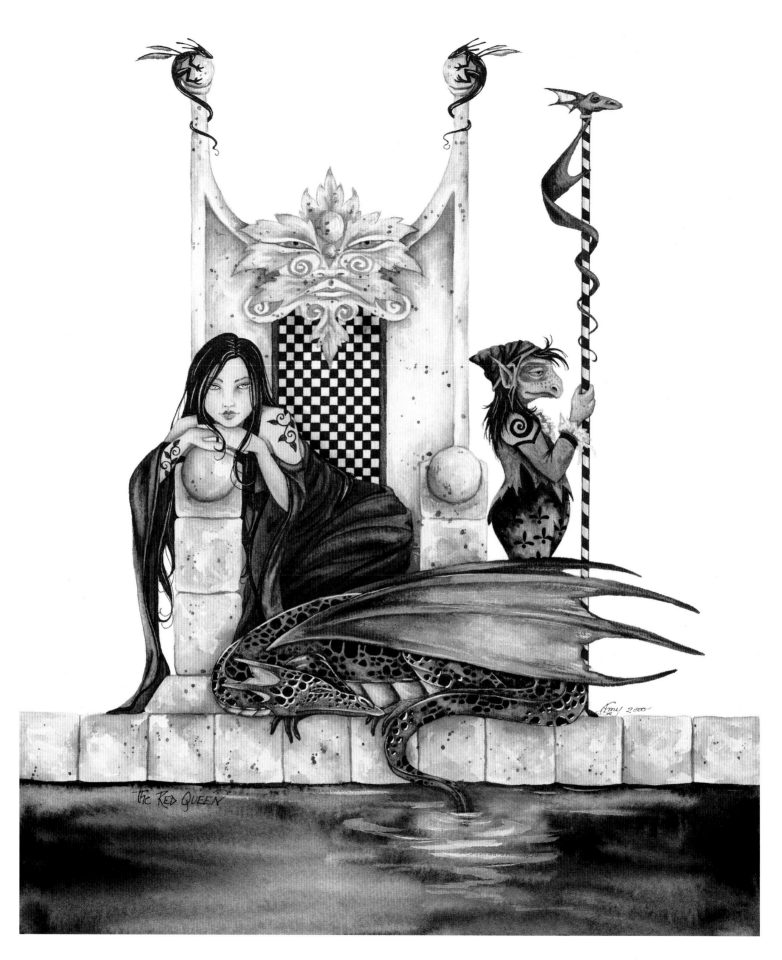

The Red Queen
The Red Queen is terribly bored and is dreaming of adventure in far-off places.

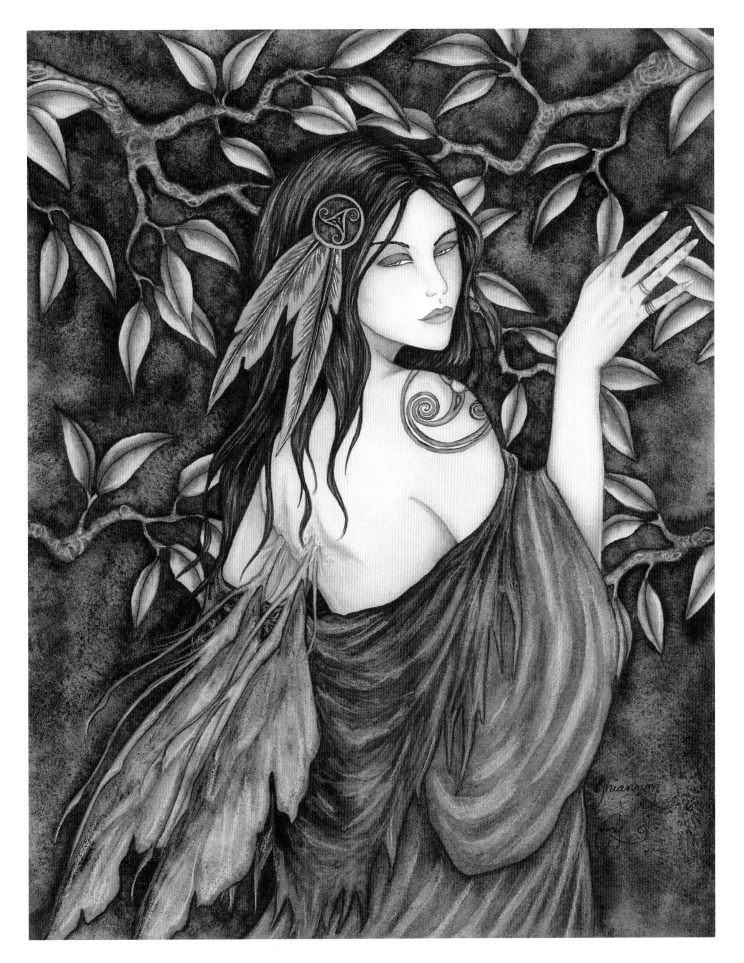

Rhiannon

Rhiannon is another character I paint often. I am drawn to faery queens.

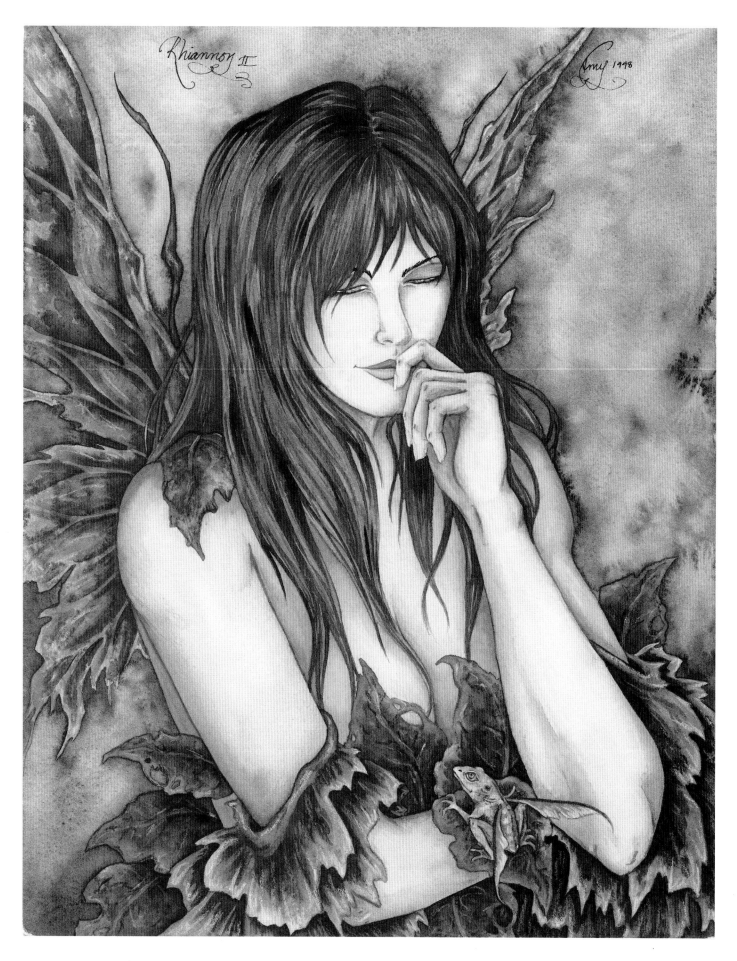

Rhiannon II

Rhiannon II developed from a photo my husband took of me several years back. I felt the angle of the face would be challenging for me at the time.

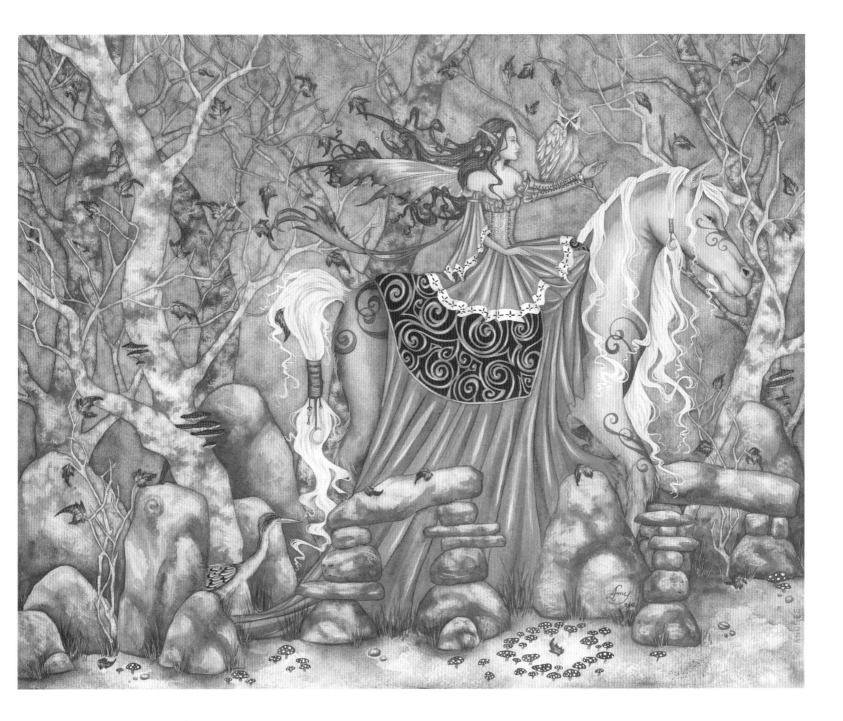

Rhiannon 2001

Also known as "Enchanted Journey." This is Rhiannon, the faery queen riding on her gray horse.

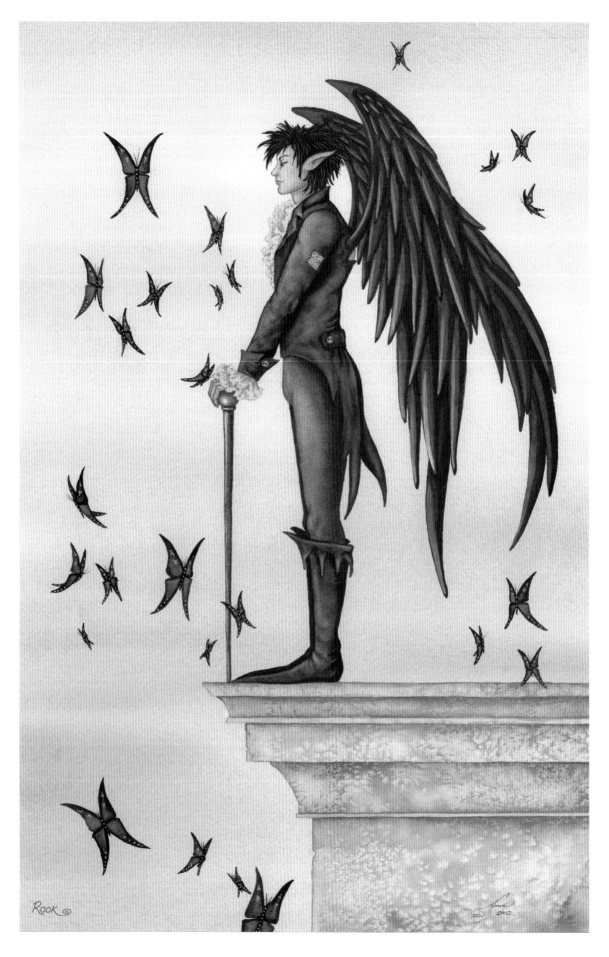

Rook

Rook is another character I have in my head. He started as a sketch I did one night while watching television. I was immediately fond of him and decided he needed to be introduced.

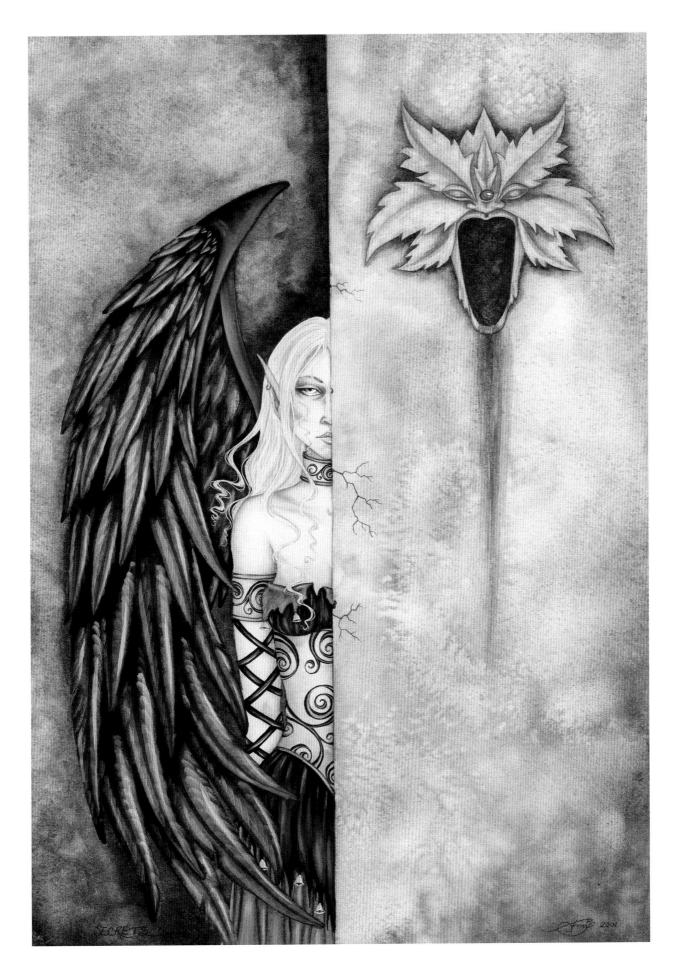

Secrets

Dark Secrets. What else is behind the wall? The faery woman knows, but it does not look like she's telling.

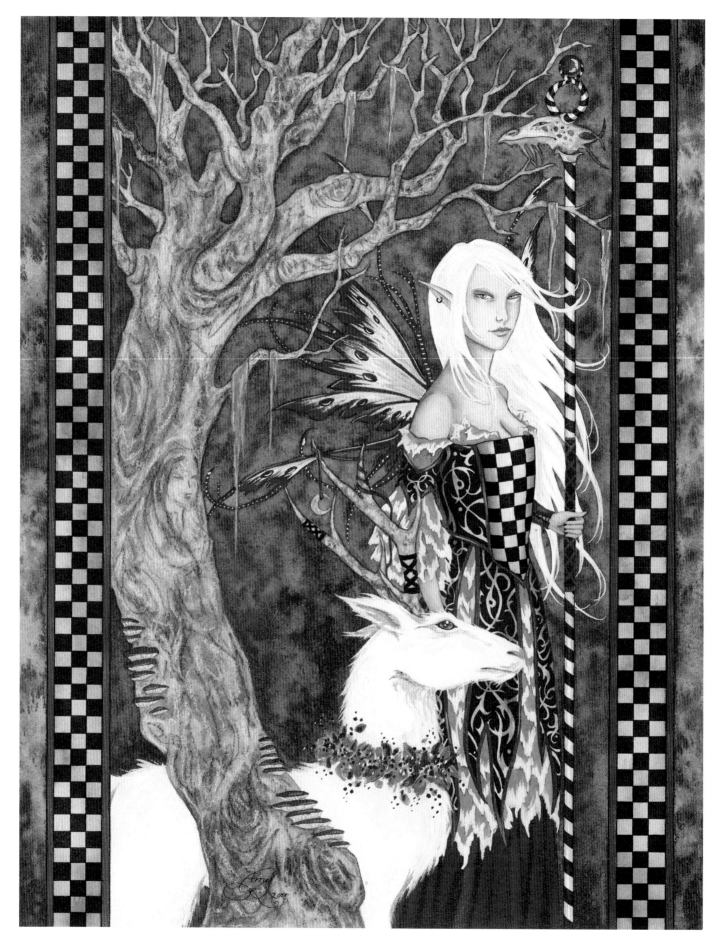

Seer

In Seer, I was trying to convey that the faery woman is extremely tall. That is why the deer beside her seems short. I envisioned the faery stalking through the forest, her head brushing against tree limbs.

118

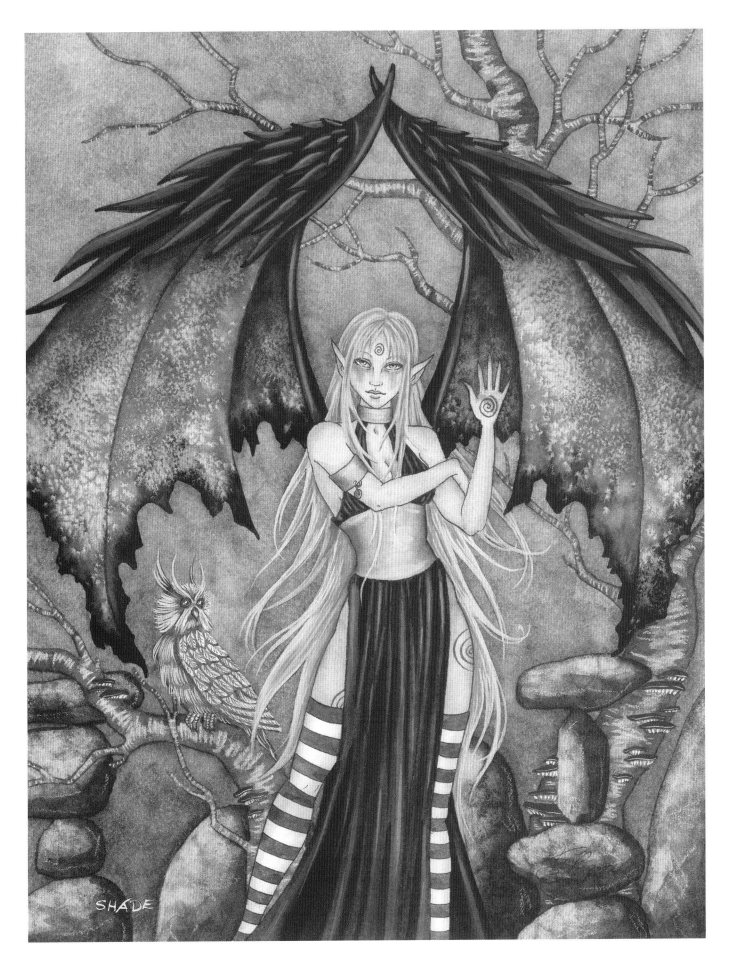

Shade

In Shade, I once again revisited the gothic theme. I wanted to play with the new wing style idea I had come up with and thought a gothic faery would work well. I also felt the need to include an owl, as I had not painted any for some time.

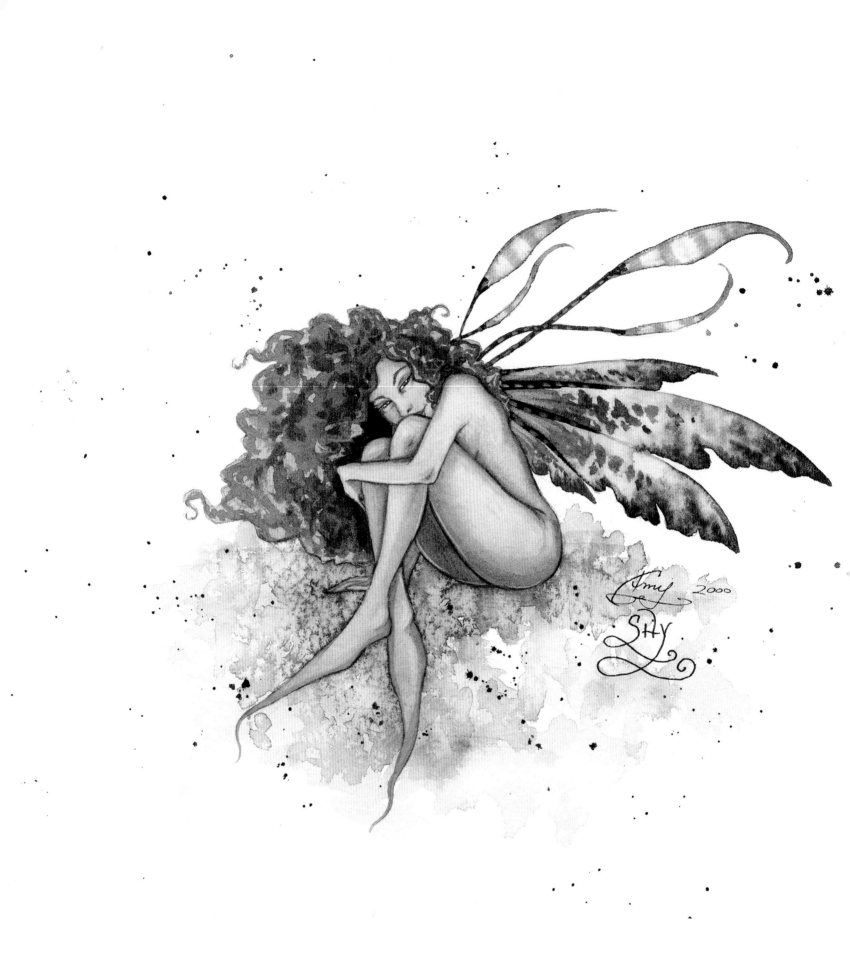

Shy
Sometimes I see a pose I like and just have to try painting it. Shy was one of those poses.

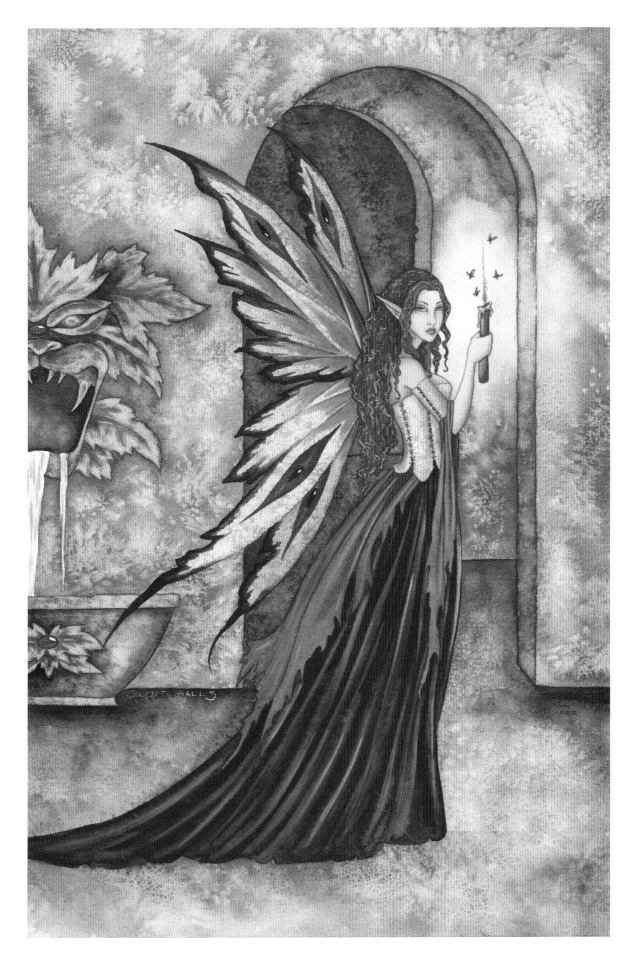

Silent Halls

A companion piece to Follow Me. Once again, a lovely creature attempts to lead an unsuspecting and weary traveler away down dark, silent halls.

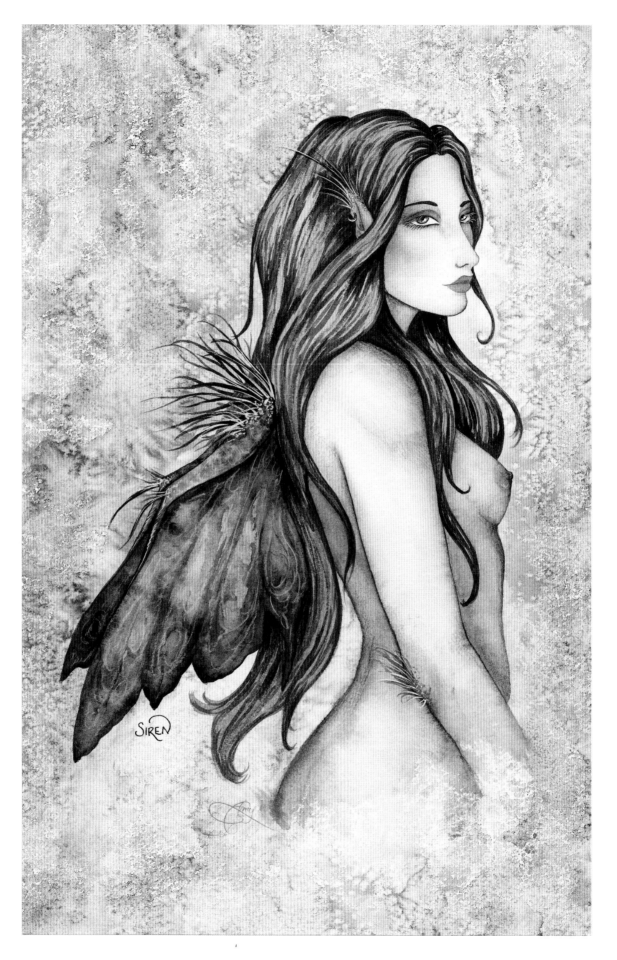

Siren

Siren is one of my older paintings. By comparing her to later images, you can see how much I've improved at figure drawing and painting.

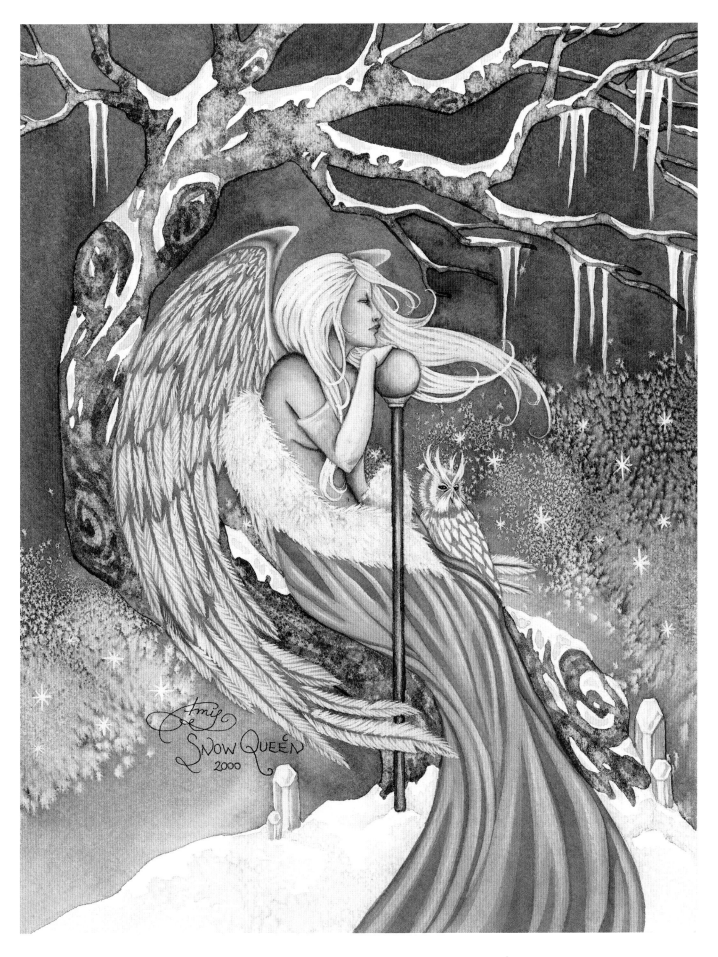

Snow Queen

I often use salt in my backgrounds to create interesting textures. Usually the salt is sprinkled liberally throughout the piece. In Snow Queen, I wanted to see what the result would be if I controlled the placement of the salt and used it sparingly. I wanted to suggest a snow flurry in the background.

123

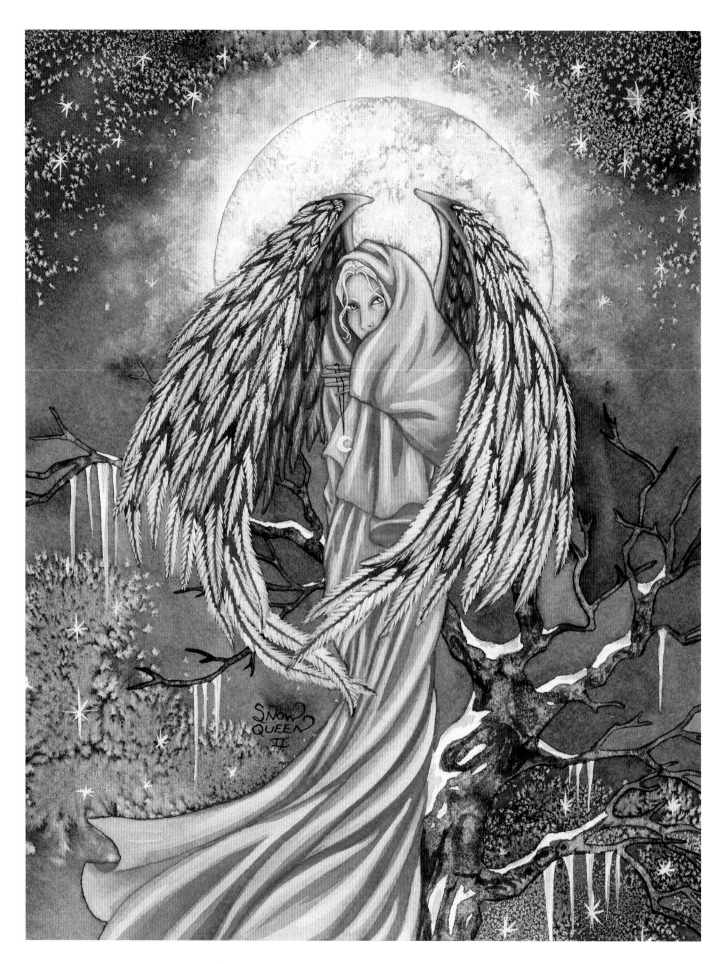

Snow Queen II
Snow Queen II was another experiment with controlled salt placement.

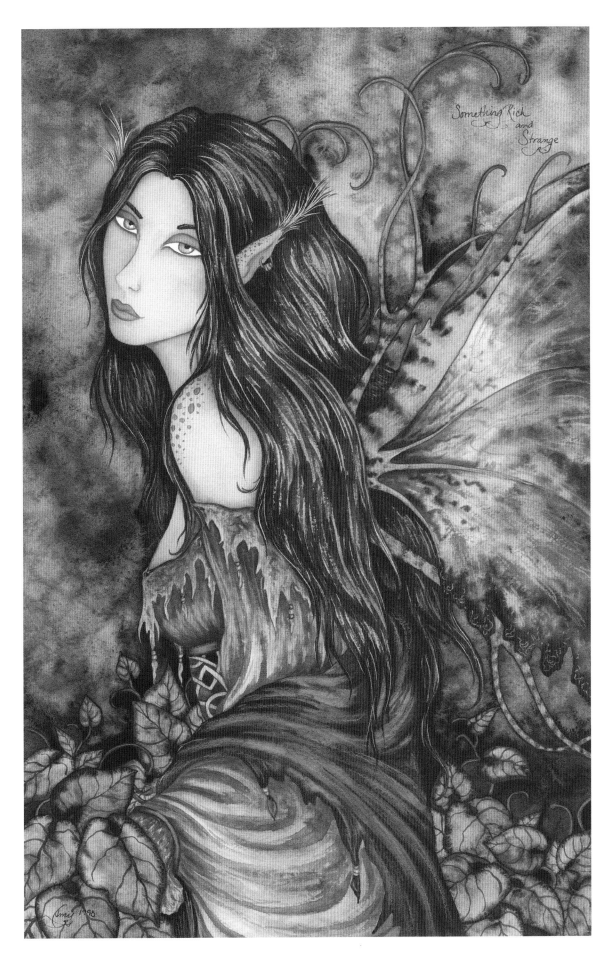

Something Rich and Strange

After reading the book Something Rich and Strange by Patricia McKillip, I was very inspired and thought that it was the most wonderful title. I sat down and created my interpretation.

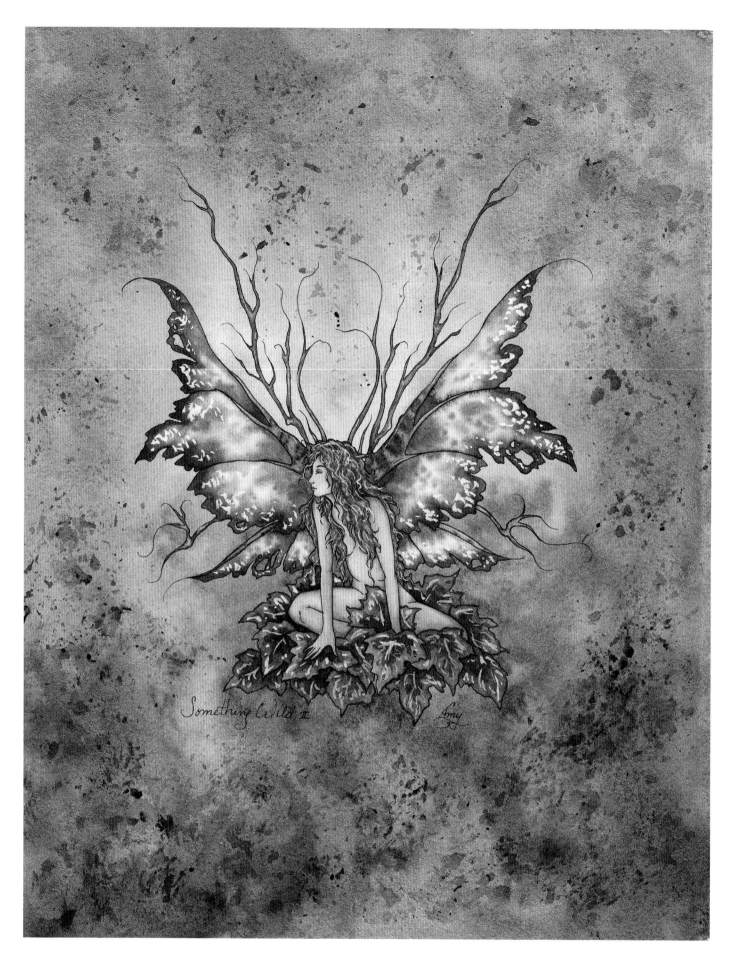

Something Wild II

Something Wild II is a good example of the textured backgrounds I like to do. They are relatively easy, but give the illusion of being much more difficult. The hardest part is waiting for the paint to dry completely before adding the next layer of color.

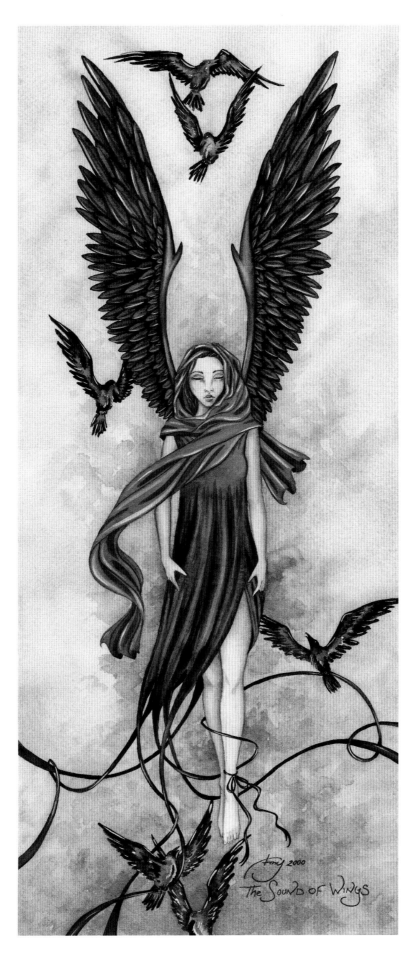

Sound of Wings

The Sound of Wings was done during a raven phase I was having. Almost every painting I did for several months had ravens in it.

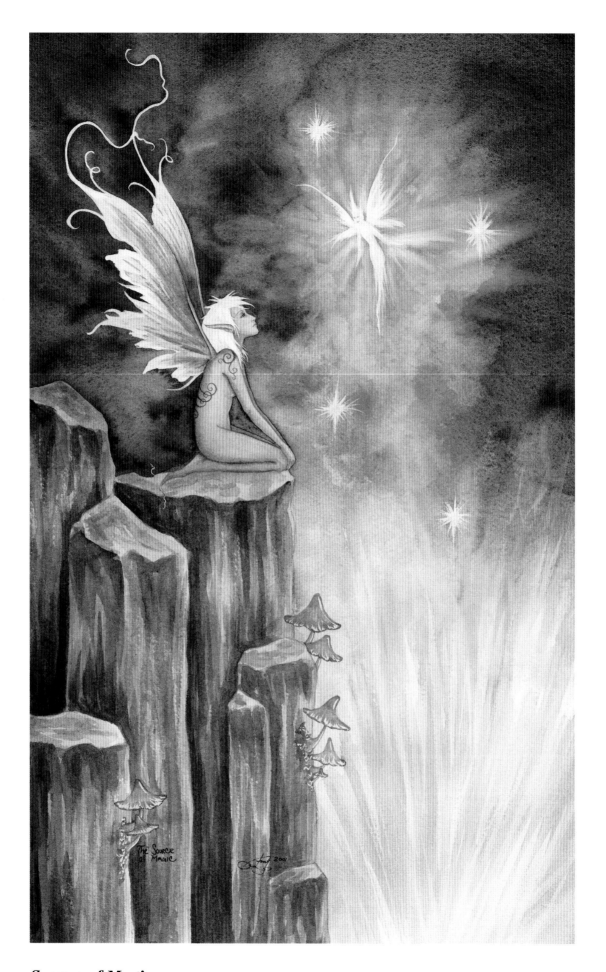

Source of Magic

This piece was drawn and painted in half a day. I wanted to see if it was possible for me finish a complete painting in one sitting.

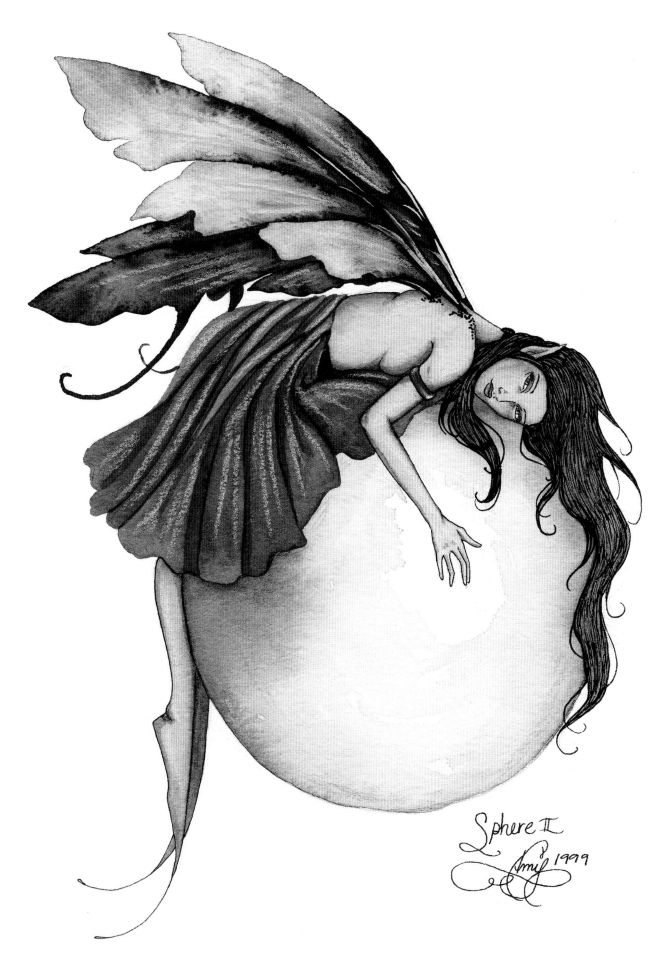

Sphere II

Sphere II was originally meant to be a quick painting that I was going to sell on my website. A friend saw it before I had a chance to put it up for sale and thought it was adorable. I decided to make prints and see what happened. To my surprise, it became one of the better selling images, despite the simplicity of the piece.

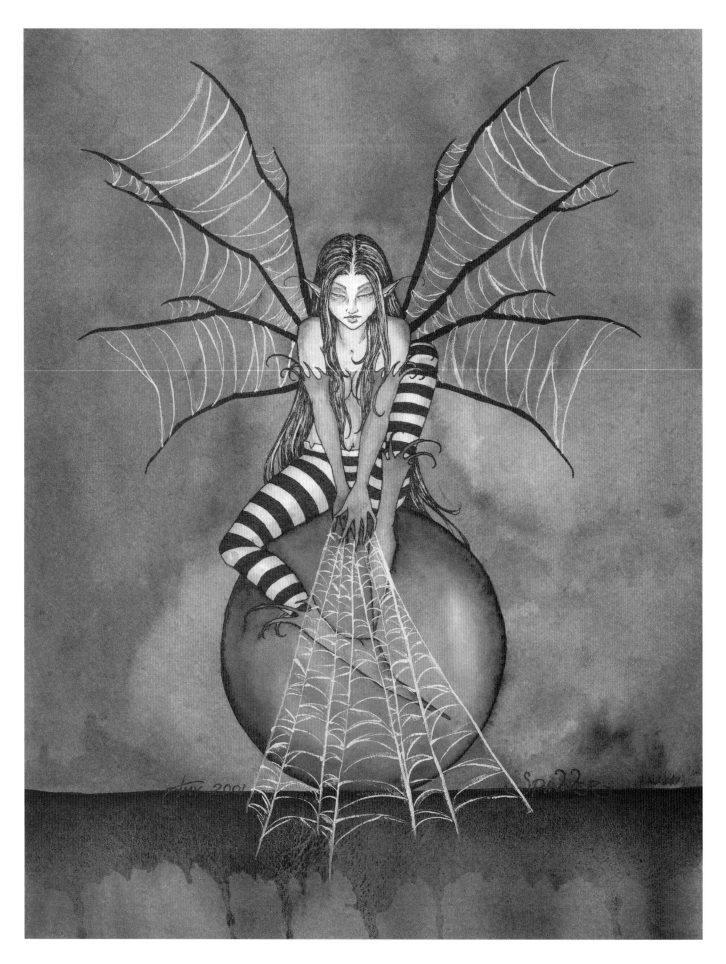

Spinner

Spinner and Web Dancer were an attempt at arachnophobia therapy. I can't stand spiders and thought that maybe they would seem less scary if I painted their faery counterparts...didn't work.

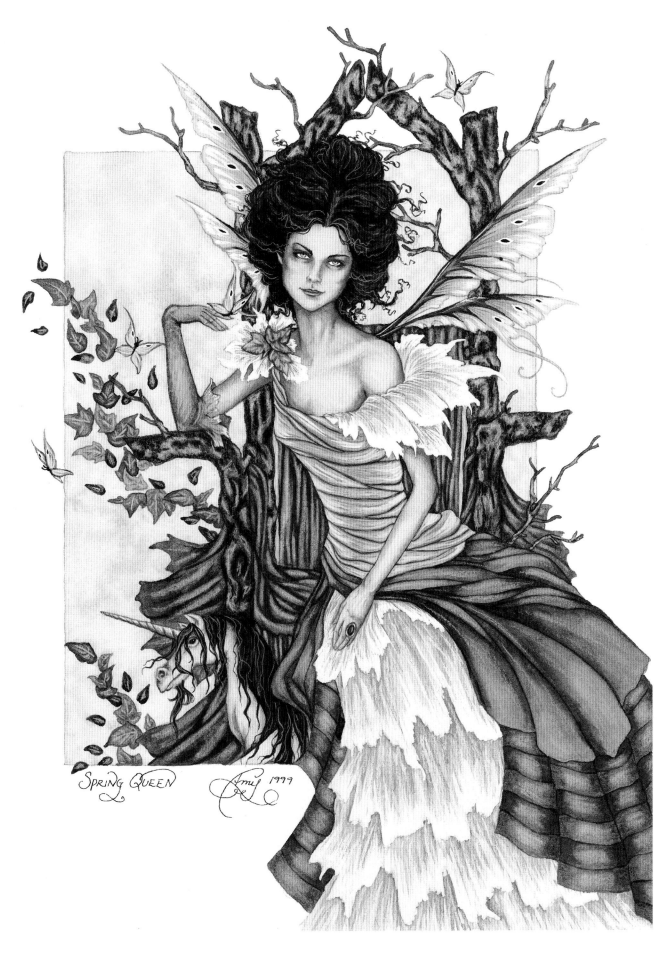

Spring Queen

1999

Spring Queen

Several years ago I came across an article in a magazine about an upcoming movie staring Nicole Kidman. Ms. Kidman was photographed in several gorgeous and elaborate costumes. Spring Queen is inspired by one of those photos.

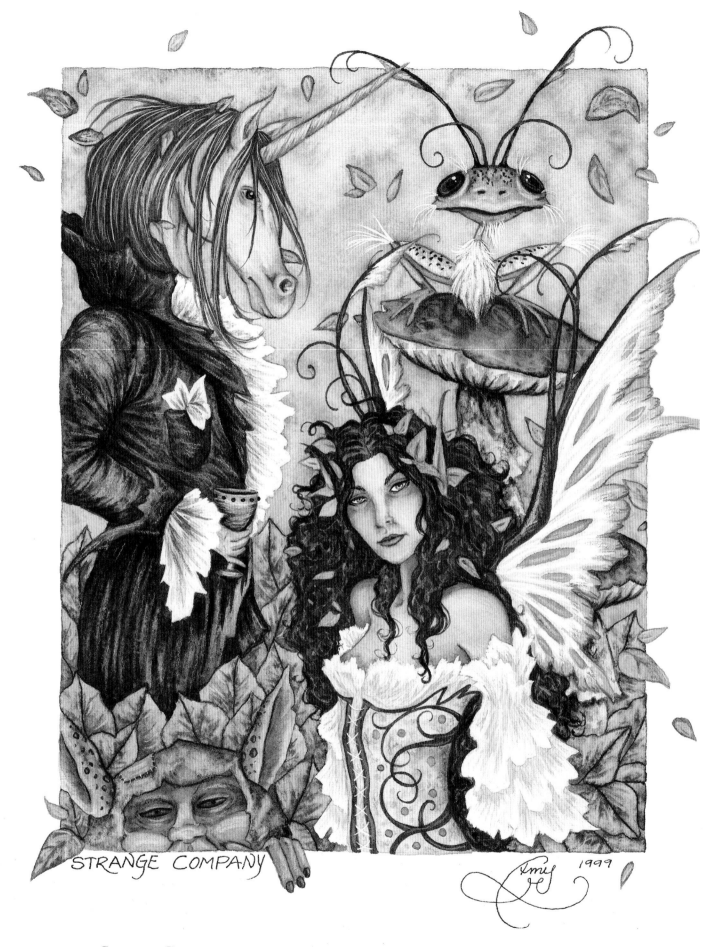

STRANGE COMPANY

1999

Strange Company

Imagine opening your door one day to these characters....

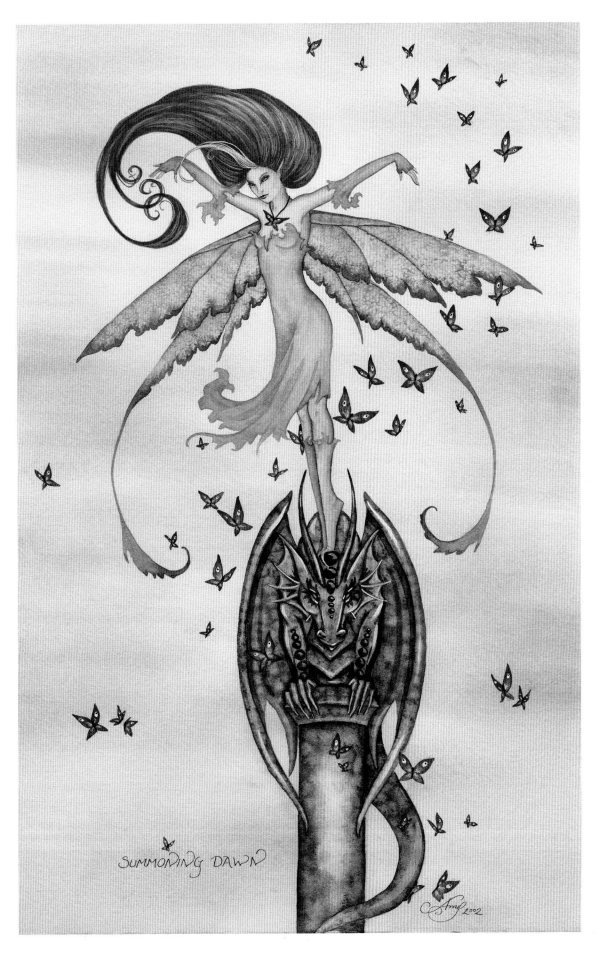

SUMMONING DAWN

Summoning Dawn

For those who always wondered who tempted the sun to rise.

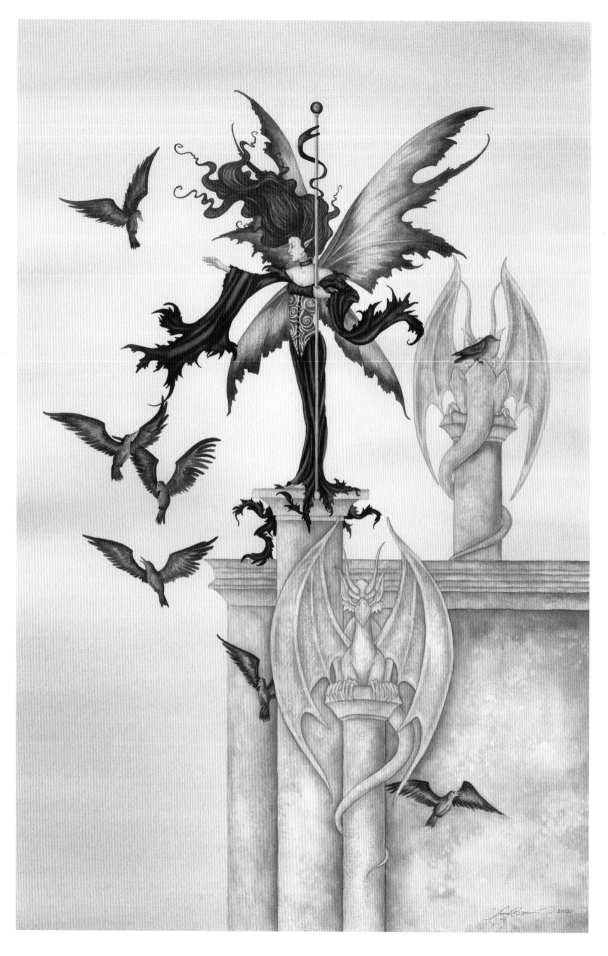

Summons

The faery woman is summoning the crows...though she does not tell us why.
We will have to wait and see....

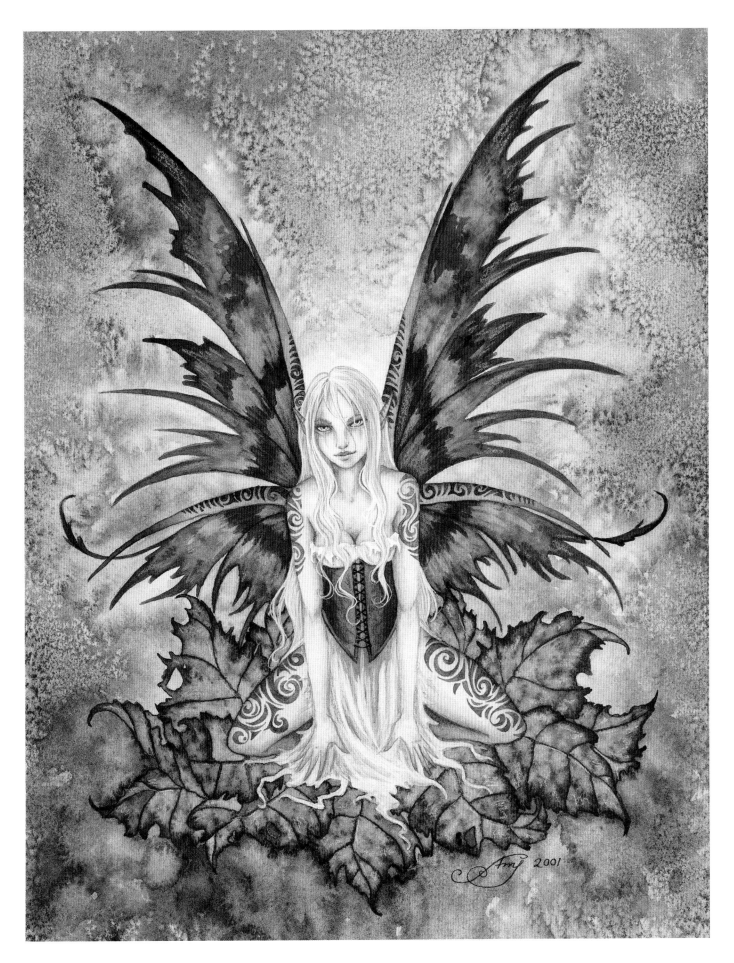

Tattooed

Just another excuse to paint more tattoos. I wanted to play with the idea of some tattooing on the wings as well.

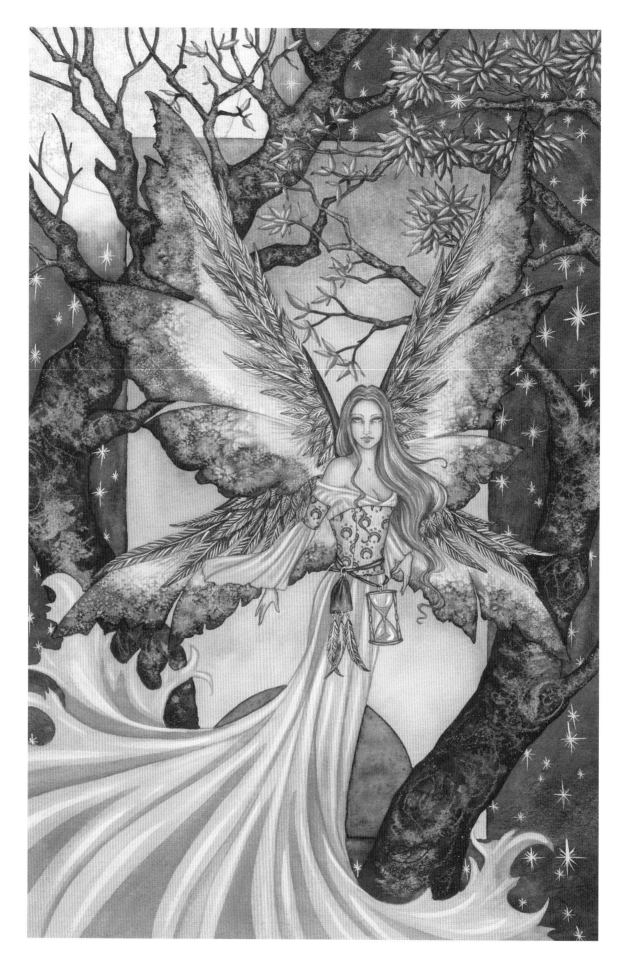

Tempus Fugit

Time Flies. Note the hourglass tied to her waist and the bag of sand "extra time" she also carries. Behind her, day becomes night, the seasons change.

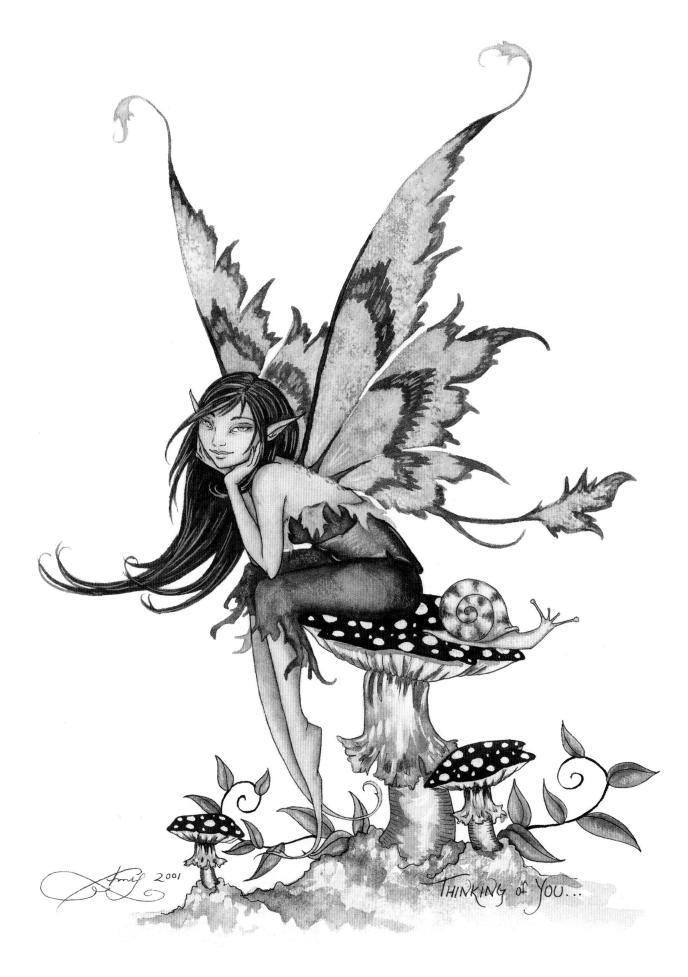

THINKING of YOU...

Thinking of You

Another sentimental faery.

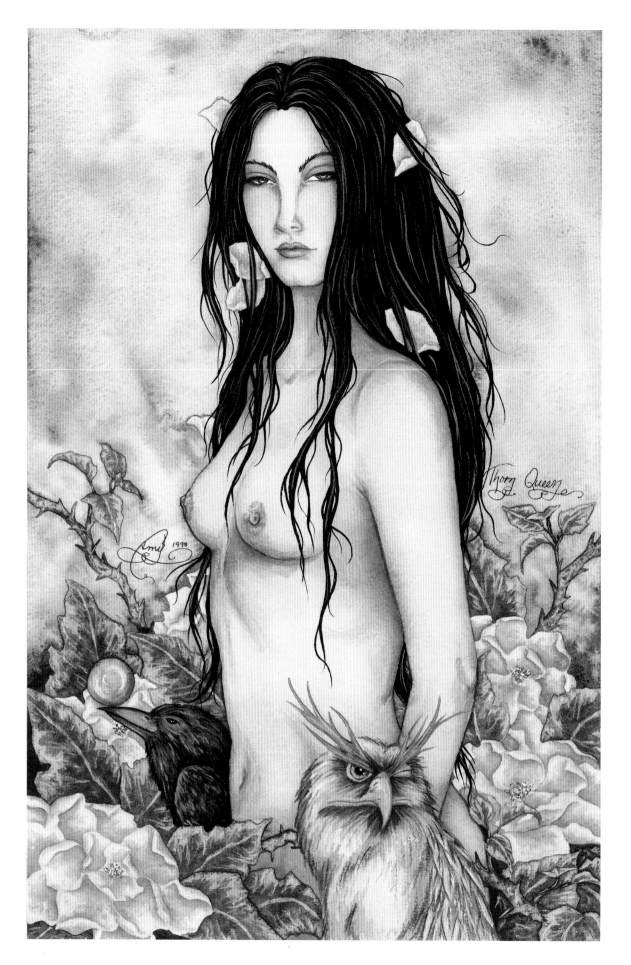

Thorn Queen

I am fond of both ravens and owls. I wanted both birds in Thorn Queen, the raven for cunning and the owl for wisdom.

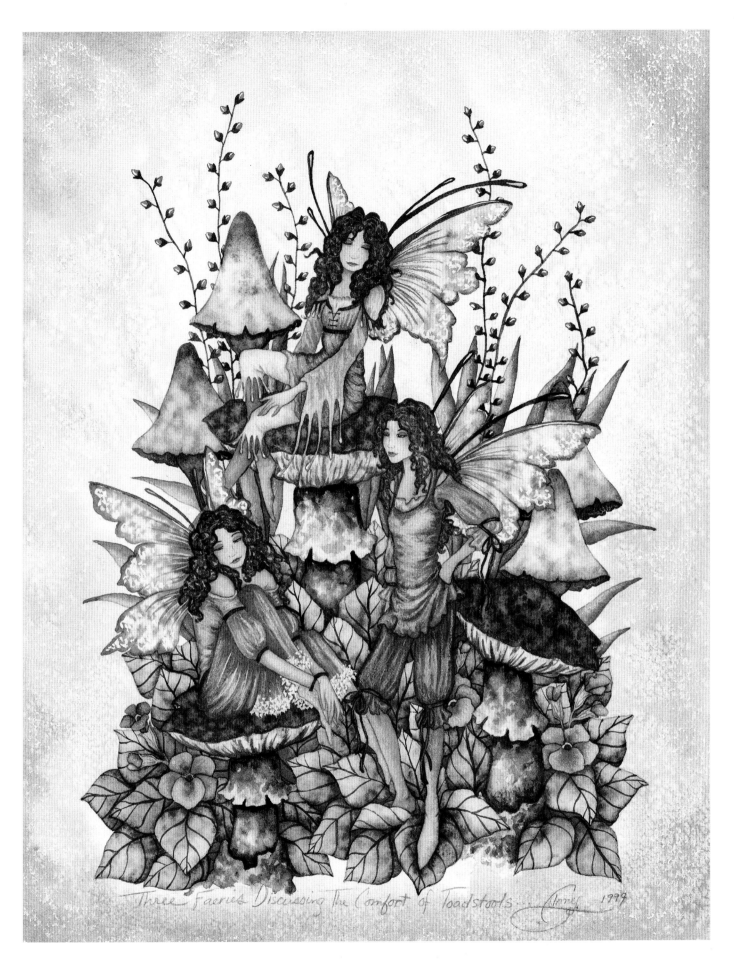

Three Faeries Discussing the Comfort of Toadstools
Three Faeries. The full title, Three Faeries Discussing the Comfort of Toadstools.... I think that says it all.

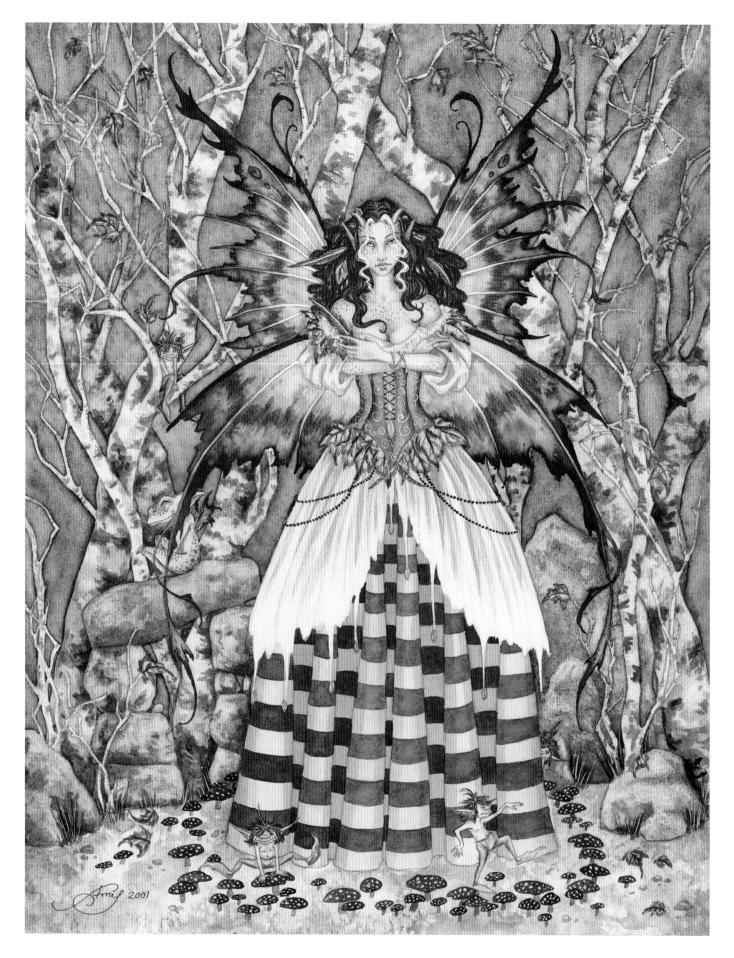

Titania

Titania was an exercise in painting backgrounds. I usually prefer simple backgrounds, so as not to take attention away from the central character, but occasionally I need to challenge myself with something more complex.

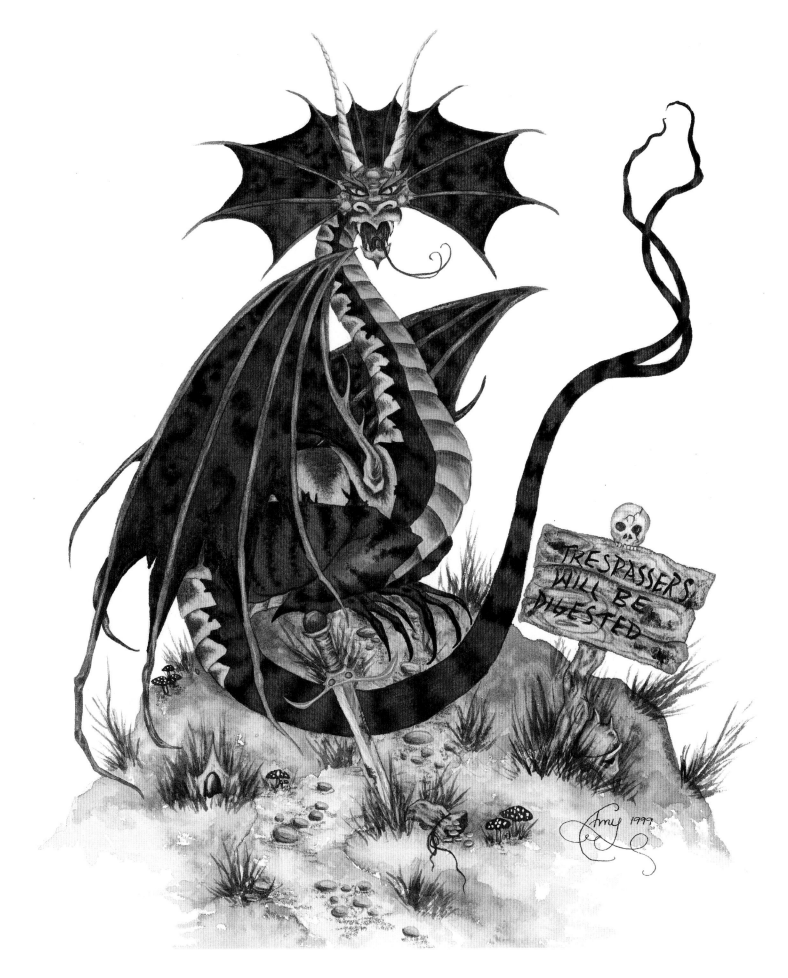

Trespassers Will be Digested

Trespassers Will be Digested was something someone suggested to me as a joke. I could not resist.

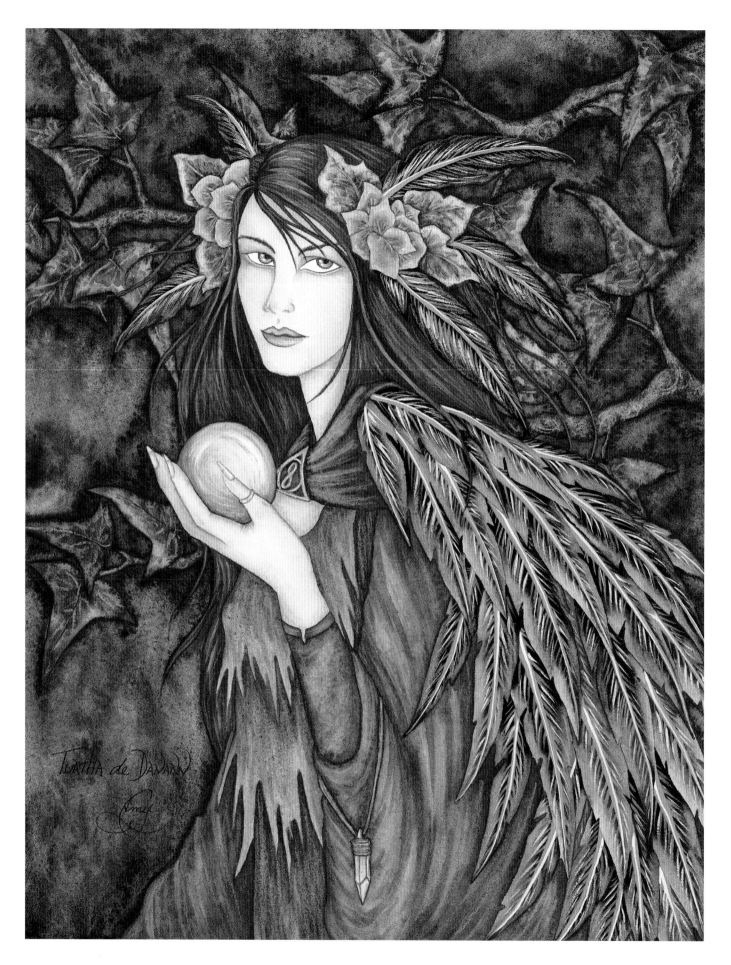

Tuatha de Danann

The Tuatha de Danann were faery folk who often dressed in feathers and sometimes took the form of birds.

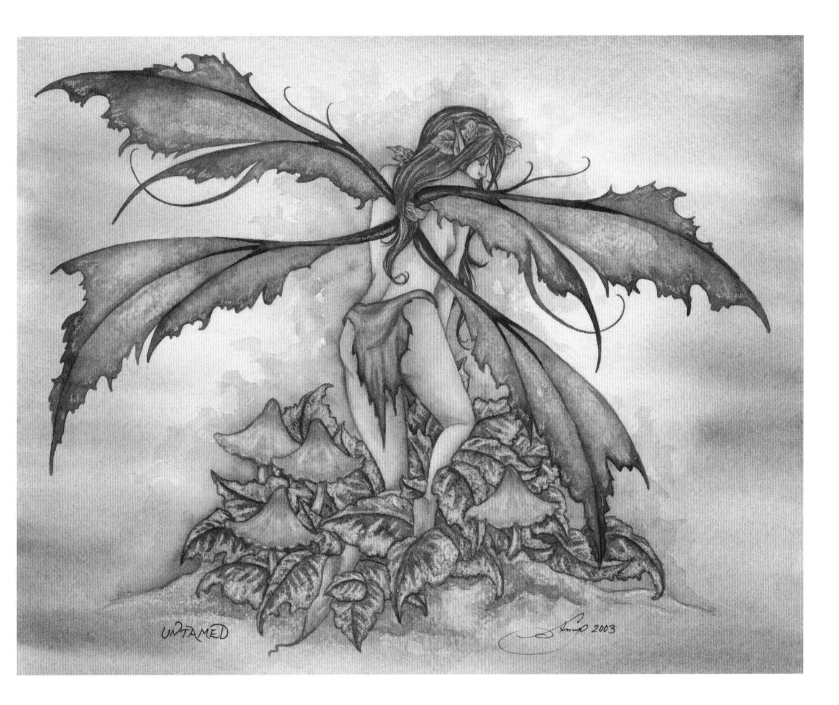

Untamed

Untamed.... a wild faery. I see her living deep in the forest, leaves and tangles in her hair, dirt smudged on her face and limbs, and she cares not a bit.

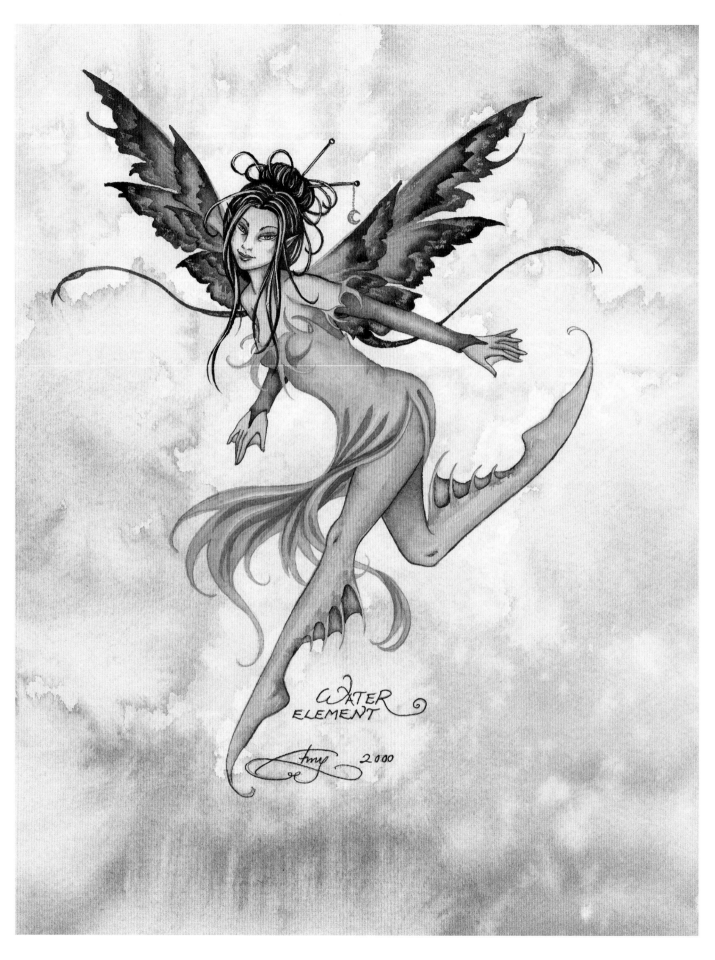

Water Element

Water Element is part of my Four Elements series. Each element has a different ethnic look. I chose an Asian influence for Water.

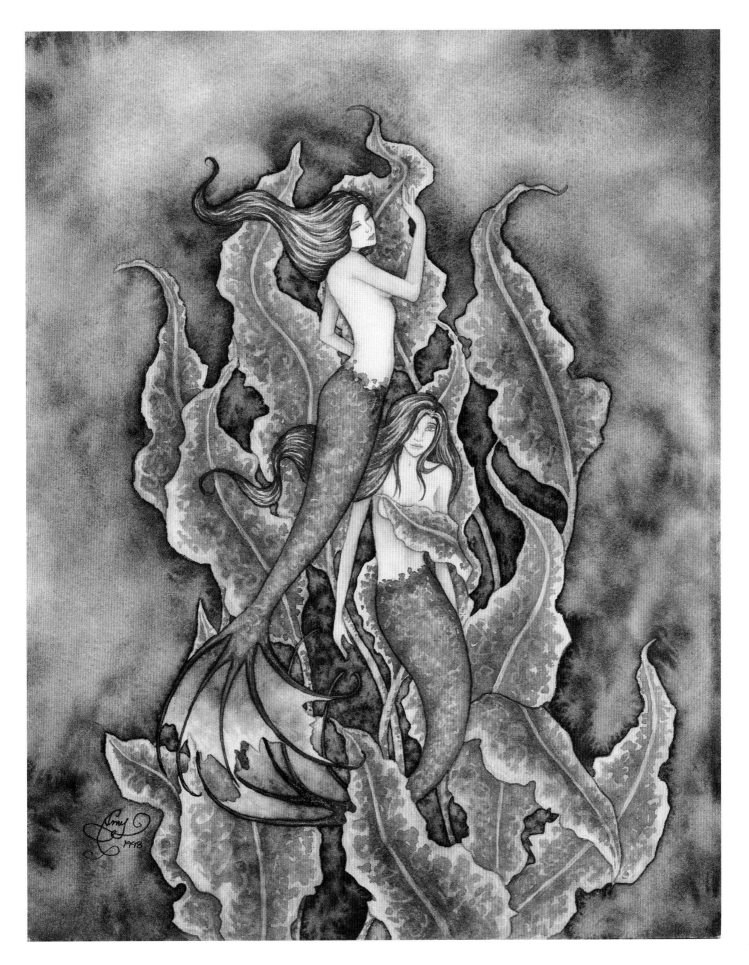

Water Emeralds

Water Emeralds is the second painting in a series of mermaids named after gemstones.

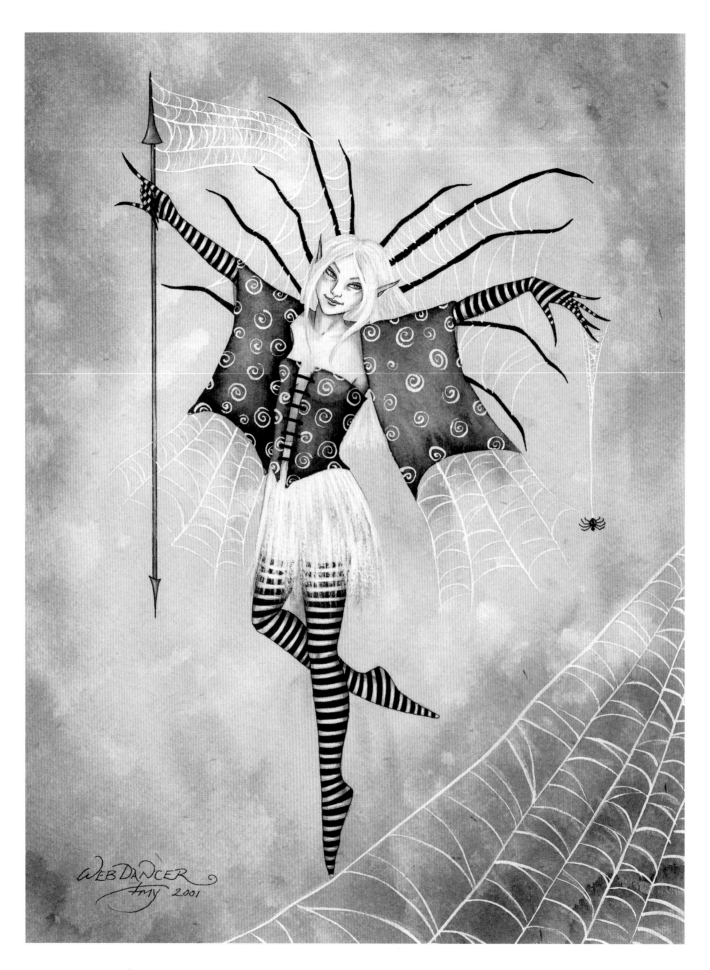

Web Dancer

I painted Web Dancer to try to over come a fear of spiders. Unfortunately, it didn't work.

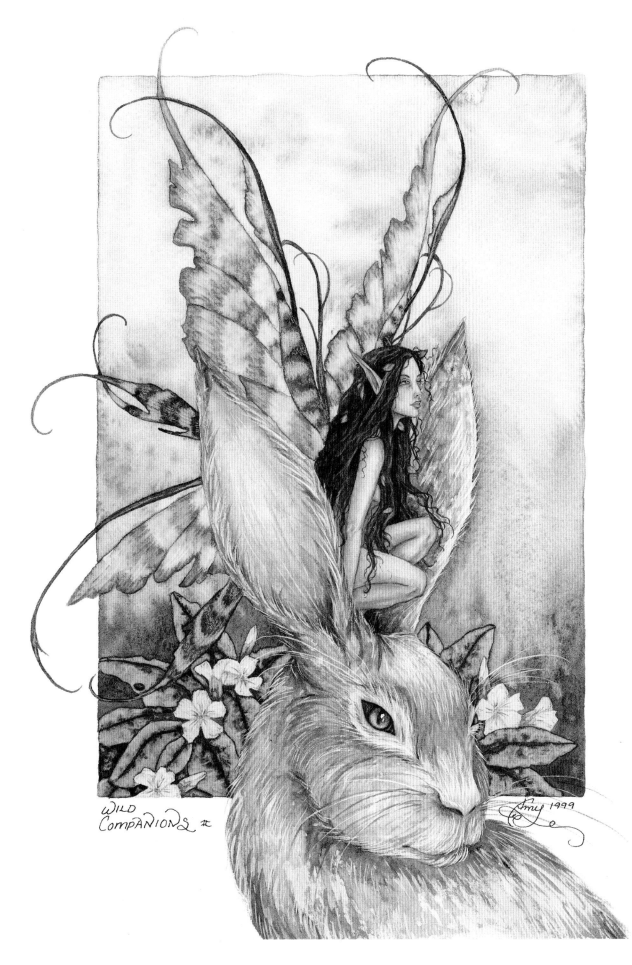

Wild Companions II

In Wild Companions II, I wanted some practice at painting animals. My previous attempts at portraying rabbits had flopped, so I had hoped to redeem myself with this piece.

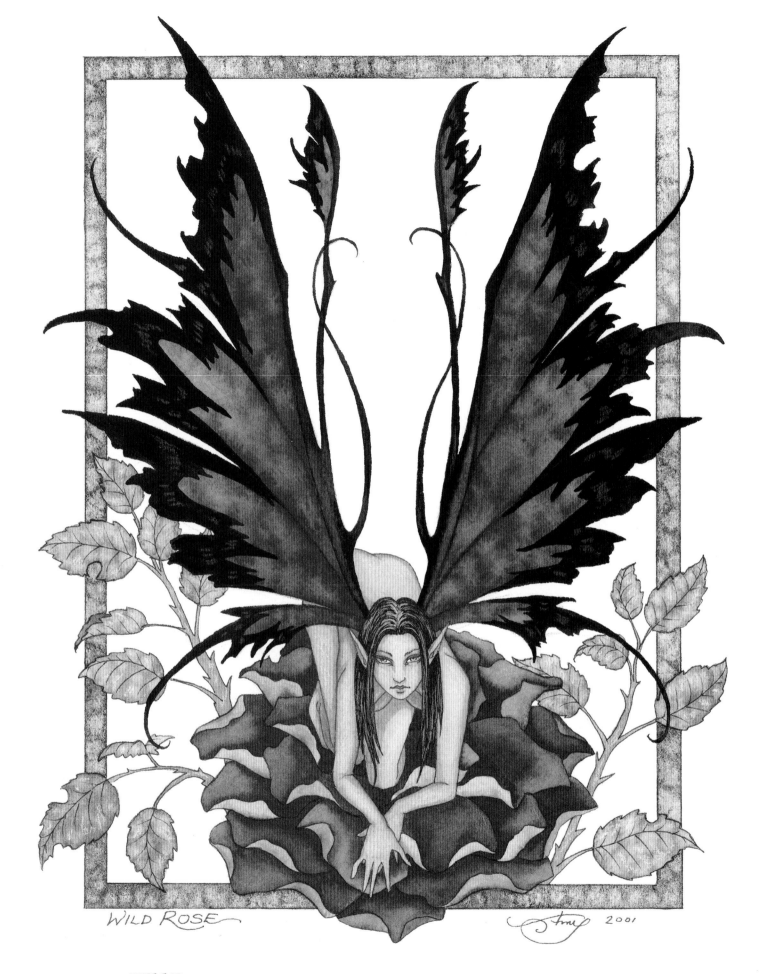

WILD ROSE

Wild Rose

An interesting pose that I keep coming back to. I have used it at least three times now.

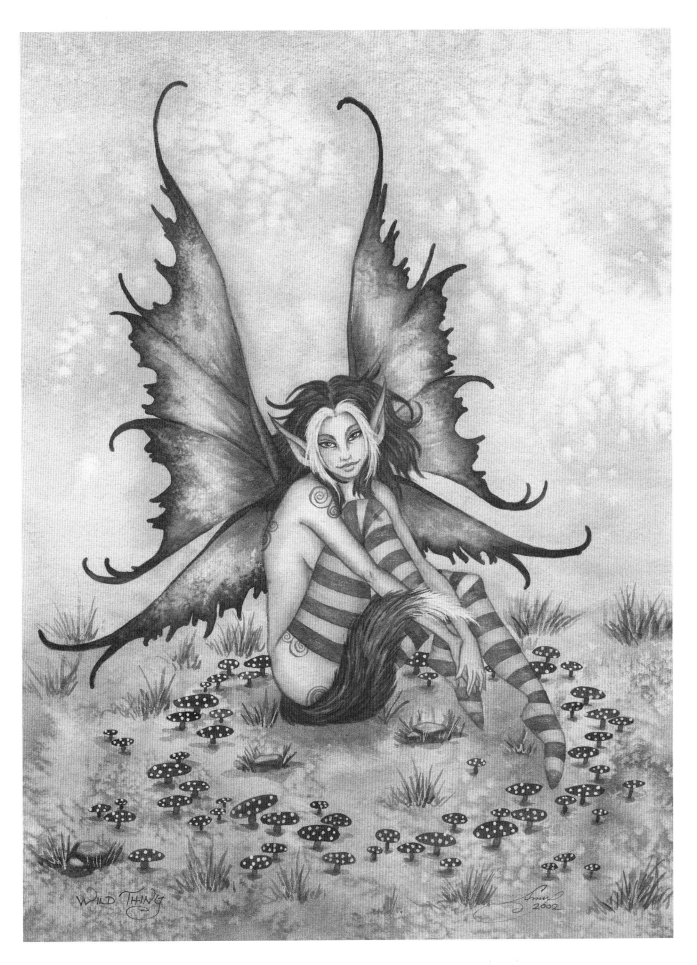

Wild Thing

Wild Thing came about because I wanted to paint a "fox faery." Notice the large ears and foxy tail.

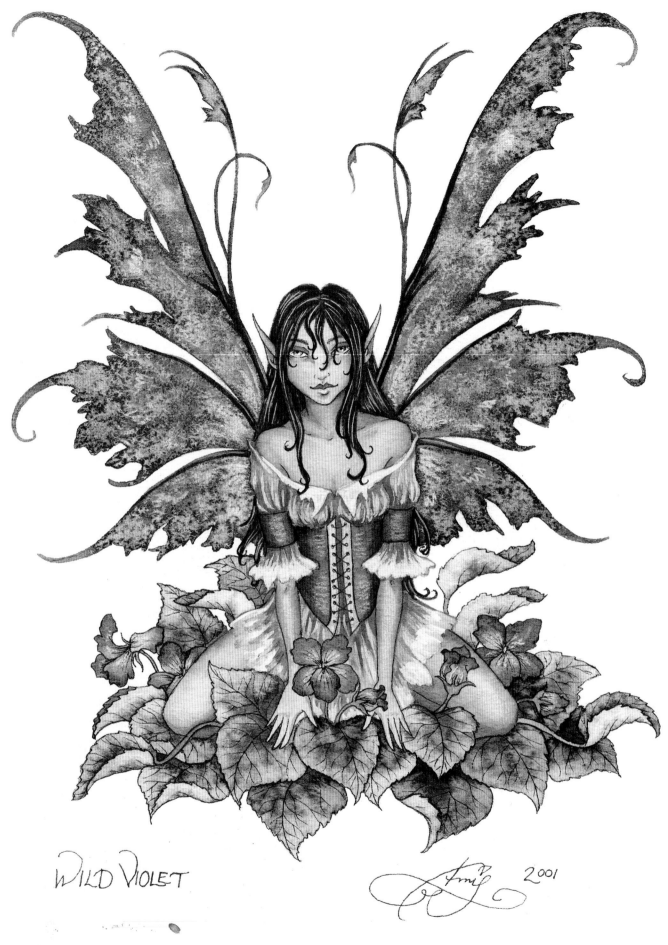

WILD VIOLET

2001

Wild Violet

A cute, sexy little faery.

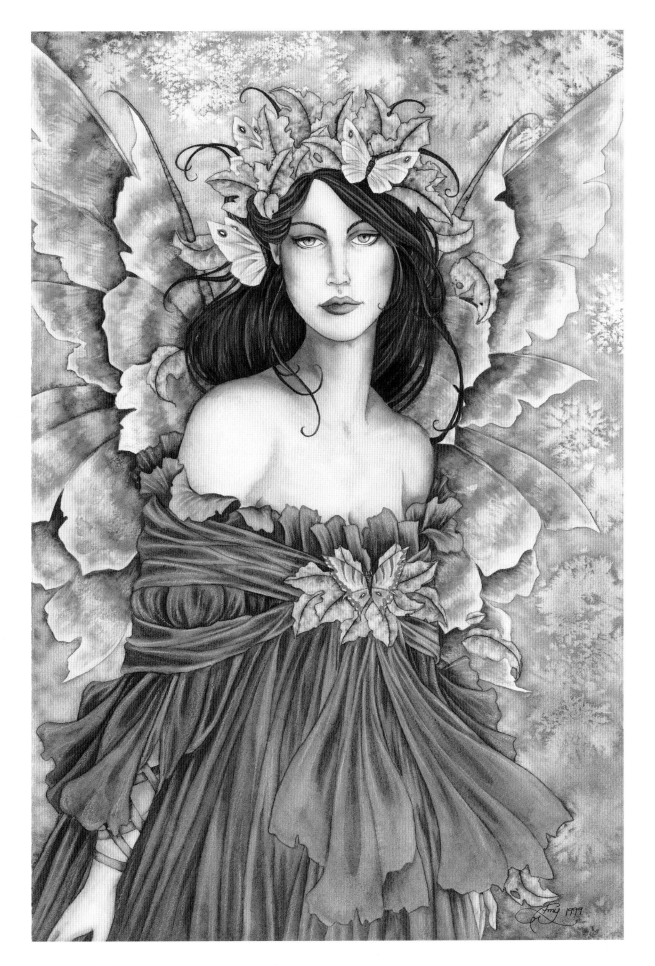

Willow

Willow was an exercise in painting faces. The original is much larger than I usually paint, so it was very challenging for me.

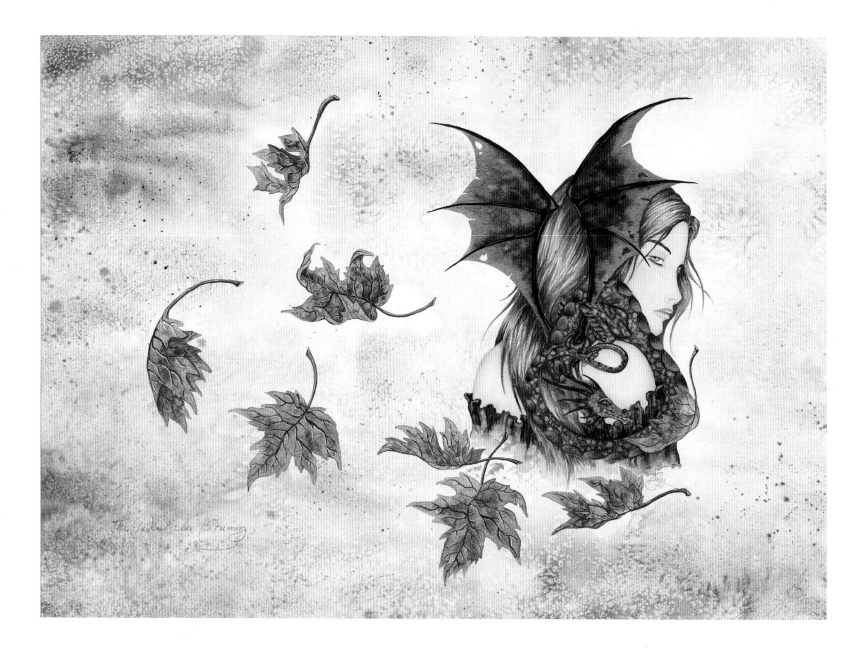

Wind in Autumn

Wind in Autumn was one of the first large paintings I did. As I did not have a way to reproduce larger images at the time, I painted another, smaller version as well.

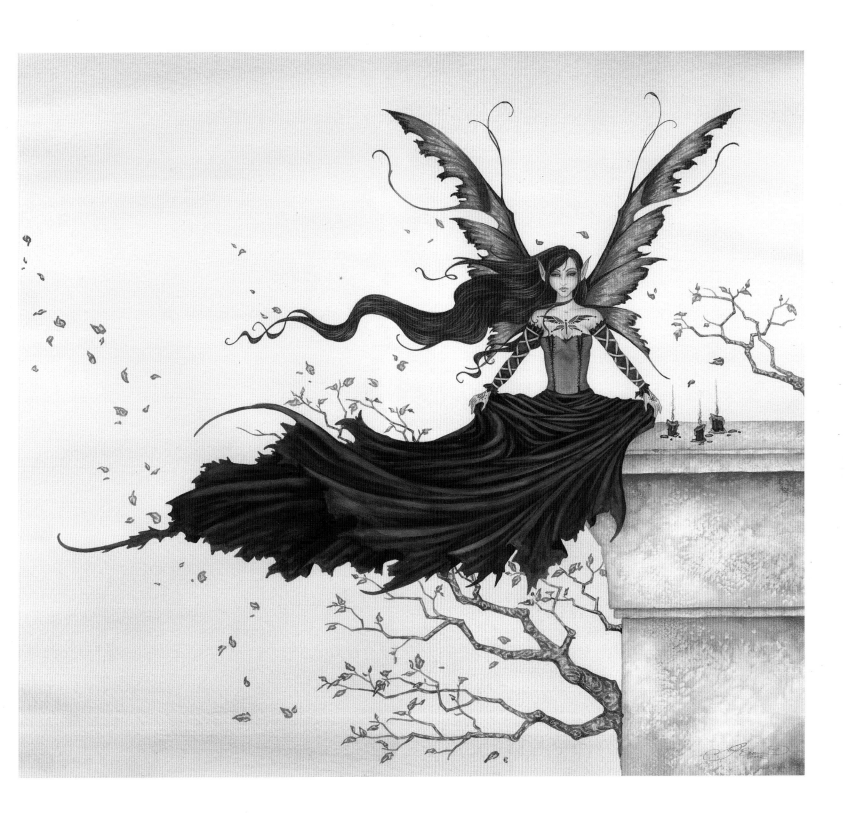

Wind Ritual
Notice the wind does not move the smoke drifting from the magic candles.

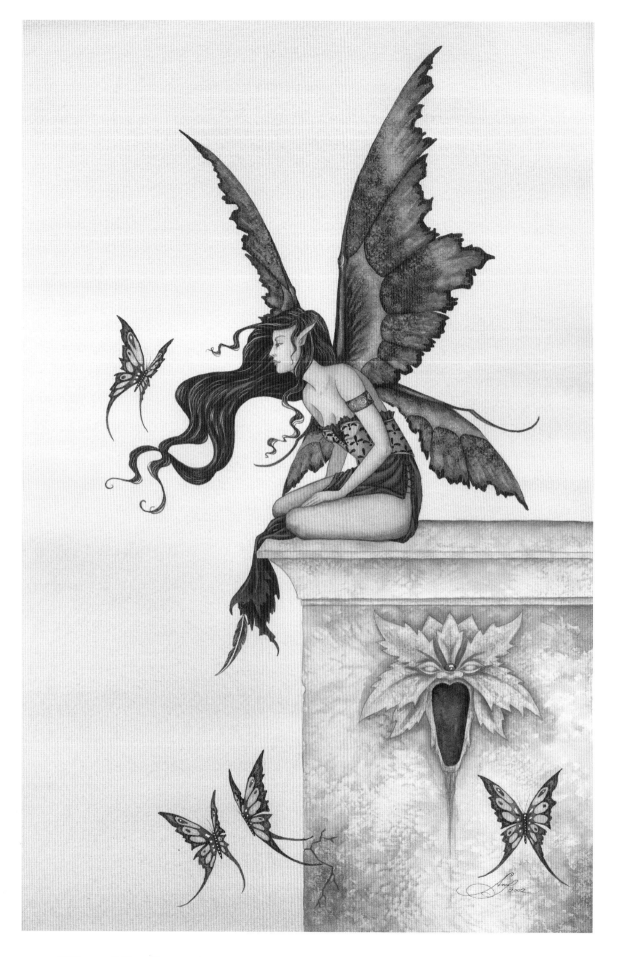

Wings Like Sunsets

I painted Wings Like Sunsets as an excuse to do another gargoyle face. The butterflies were added last for some extra color and interest.

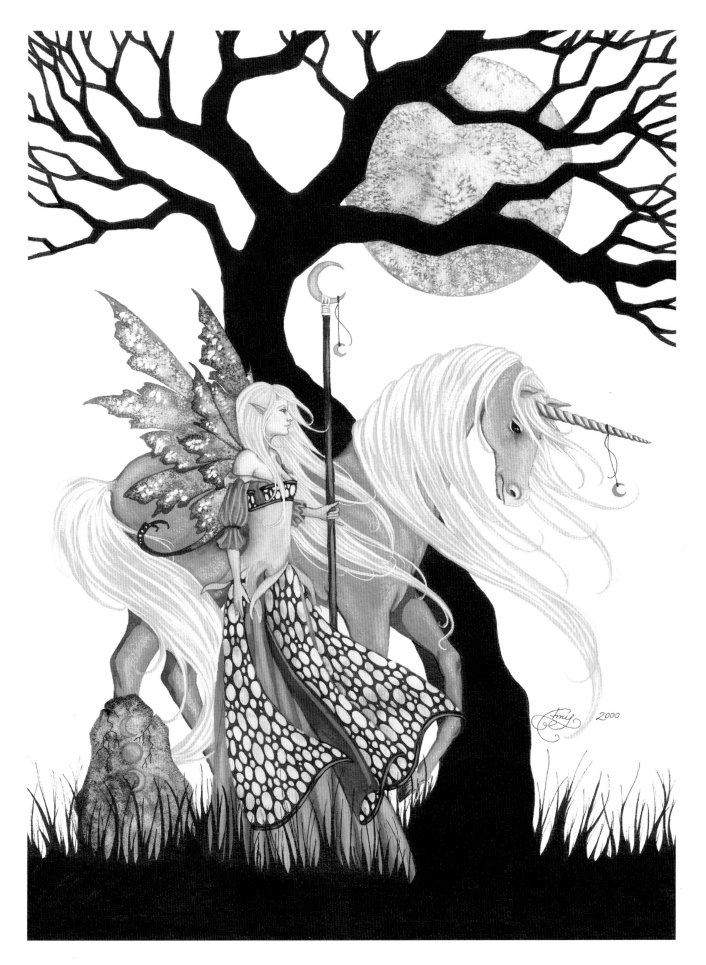

Winter Solstice

Winter Solstice was painted shortly after I did Epona. I liked the black tree silhouettes in Epona so much; I decided to try it again. My husband came up with the title. I knew I married him for some reason...

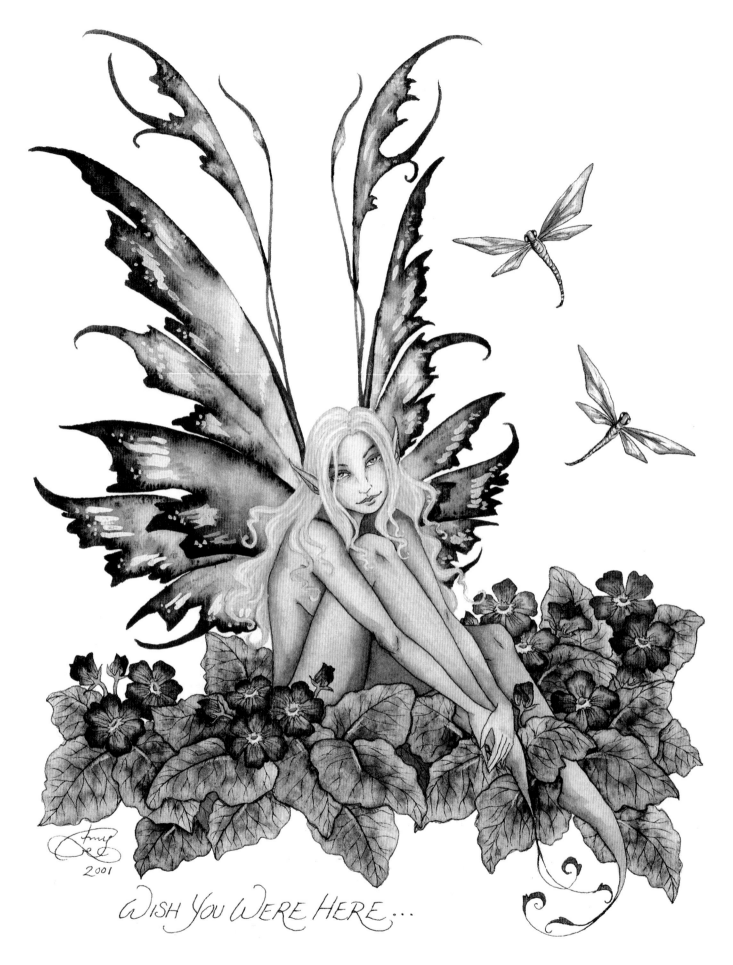

WISH YOU WERE HERE...

Wish You Were Here
Another romantic faery.

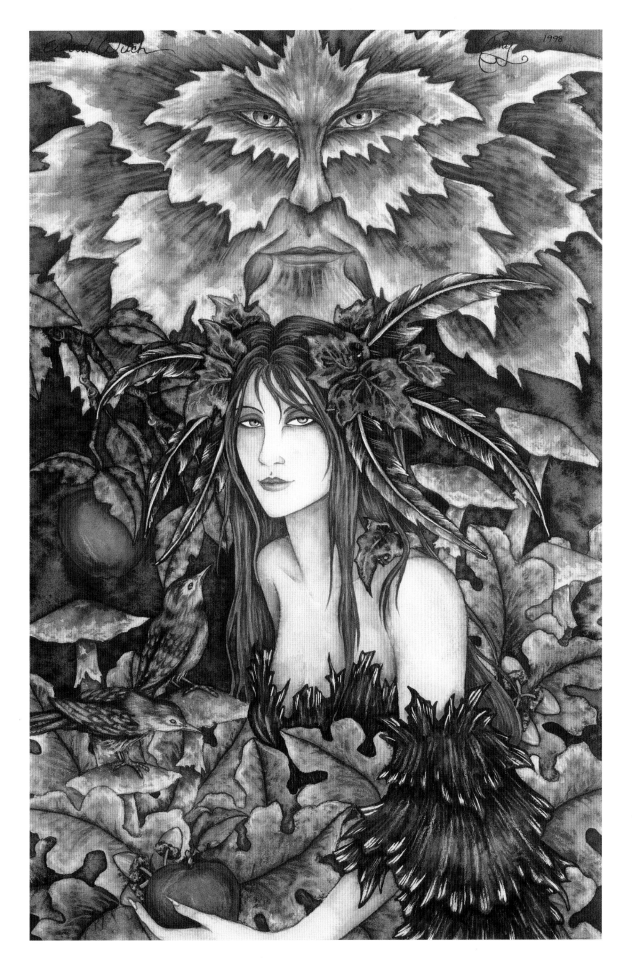

Woodwitch

Someone you might meet if you were to wander too far into the forest.

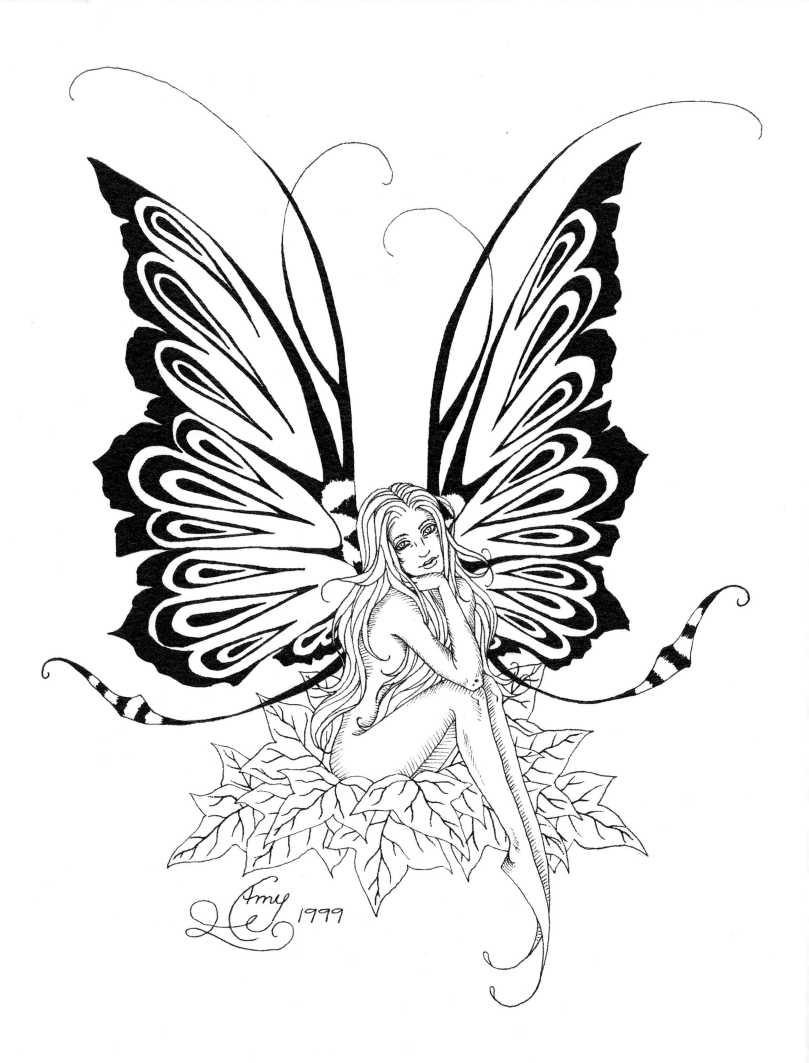

Afterword

People often ask me how I create my images. They begin with an idea, sometimes just the tiniest spark of an idea. It can be triggered by a word heard in passing, a book I might be reading, a song, movie, or the work of another artist. I rarely do preliminary sketches. Occasionally, if the idea I have is too unformed in my head, I will spend thirty minutes or so sketching out the main character and then I will transfer it to watercolor paper via a light table. Usually, I start drawing directly on the watercolor paper, though lightly so I can erase and redraw when necessary.

When I am happy with the drawing, I start to paint. I always do the background first, whether it consists of light washes of color or multiple layers of paint to create a sense of texture. Next I focus on any inanimate objects in the background, including trees, rocks, walls, water. After the entire background is finished I will work on any secondary figures. These might be goblins, pixies, or animals. I prefer to paint the central figure last. I paint the skin tones first. Next comes any clothing, then the wings, and finally the hair.

Each aspect of a painting involves a gradual build up of colors. Background washes can have as many as five or six layers of paint. Clothing usually has at least two layers, while four or five layers are needed for hair. Skin tones require three to four layers. I use white gouache or colored pencil for accents and highlights. Sometimes I will outline the image in ink before I begin adding watercolor washes.

I like to work small. Most of my paintings are smaller than 11x17 inches. I find that I can easily get bored with an image, so I try not to spend more than three days on any piece, whether it's 8x10 inches or the rare 22x30 inches. Normally, I will spend roughly six to ten hours on a small painting. That does not include the drawing time, as some drawings can take days, months, or even years before I am happy enough with them to start adding color. Currently, I have completed close to nine hundred paintings in ten years.

INDEX